Art and Social Movements

ART AND SOCIAL MOVEMENTS

Cultural Politics in Mexico and Aztlán

EDWARD J. MCCAUGHAN

DUKE UNIVERSITY PRESS Durham & London 2012

Printed in the United States of America on acid-free paper ∞
Designed by Jennifer Hill
Typeset in Arno Pro by Tseng Information Systems, Inc.

Library of Congress Cataloging-in-Publication Data appear
on the last printed page of this book.

For Betita Martínez,
in memory of Rini Templeton.
Love + Venceremos

In 1968, before the opening of the Olympic Games [in Mexico City], I got dragged—together with a lot of other people—into the center of the hurricane that was the student movement. . . . Everything suggested that I was on the doorstep of the capital's measly art market. Instead, I fell into the social whirlwind that lasted until the 2nd of October. The atmosphere was so repressive by the end of the year that Martha and I saw no other alternative than to say goodbye to our families. I was 23 and a half when we got on a plane to England together with our two children.
—Felipe Ehrenberg, *Felipe Ehrenberg: Manchuria, visión periférica*

For me, Marxism was the culmination of Western rational thought, but its weakness was that it always insisted on the conscious. Returning to my Zapotec culture was, like my painting, learning how to play with the conscious and the subconscious.
—Nicéforo Urbieta, Oaxaca, 2001

And so the anger, the pride, and self-healing had come out as Chicano art—an art that was criticized by the faculty and white students as being too political, not universal, not hard edge, not pop art, not abstract, not avant-garde, too figurative, too colorful, too folksy, too primitive, blah, blah, blah.
—Carmen Lomas Garza, quoted in Bright and Bakewell,
Looking High and Low: Art and Cultural Identity

CONTENTS

ILLUSTRATIONS

This is a book about artists and three networks of social movements that emerged in North America in the late 1960s: the student movement of 1968 and subsequent activist art collectives in Mexico City, a Zapotec indigenous struggle in Oaxaca, and the Chicano movement in California. It explores the ways in which artists helped shape the identities and visions of a generation of Mexican and Chicano activists by creating new visual discourses. It took me more than ten years to complete the research. Between 1998 and 2010, I interviewed more than forty people; searched some thirty public and personal archives; visited galleries, museums, and community art centers; and attended related rallies, marches, conferences, lectures, and exhibitions in Mexico City, Oaxaca, Juchitán, San Francisco, and Los Angeles.

However, my own political and intellectual relationship with the movements explored in this book began decades earlier. The Chicano student movement was at its height when I started college in 1968, and the righteousness of its cause, along with the deep personal friendships I developed with some of its leaders, led me to work over the years with the United Farm Workers, Mexican immigrant rights groups, and a variety of Chicano and Latino community organizations. Some of the leaders and militants of Mexico's 1968 student movement who went on to found Organización Revolucionaria Punto Crítico were among my most influential political and intellectual mentors in the 1970s

when Peter Baird and I wrote *Beyond the Border: Mexico and the U.S. Today* (Baird and McCaughan 1979). It was the comrades from Punto Crítico who first alerted me to the importance of the Zapotec-based Coalición Obrera-Campesina-Estudiantil del Istmo (COCEI; Worker-Peasant-Student Coalition of the Isthmus), an organization Peter and I wrote about in our book. As a result of my longtime relationship with some of the movements, organizations, and individuals explored herein, *Art and Social Movements* is not the product of a distant, disinterested observer.

As I finished the first draft of the manuscript in the summer of 2008 — exactly forty years after the worldwide student protests of 1968 — I became acutely aware that the process of writing *Art and Social Movements* was marked by struggles to resolve long-standing tensions in my own life about politics, art, and desire. This seems relevant to share with readers, given Stuart Hall's observation ([1990] 2001, 560) that "we all write and speak from a particular place and time, from a history and a culture which is specific."

In writing this book, I've wrestled with sometimes conflicting memories of my own experience in radical movements of the past forty years. In my desire to honor the heroism of those movements, there are memories I would like to trust, even celebrate, such as those recalled by Bruce LaBruce, filmmaker provocateur. He remembers the black, gay, and feminist movements of the '60s and '70s as sharing common goals as "militantly Marxist-influenced movements in opposition to the dominant white patriarchal elite class. It's well documented that Huey P. Newton of the Black Panthers reached out to his gay and feminist brothers and sisters in the struggle against the white bourgeoisie ruling class. Genet famously supported the Black Panthers, solidifying the connection between gay and black outsider opposition to the dominant order, and Angela Davis's strong revolutionary voice dovetailed nicely with feminist radicalism" (Hardy 2009, 104).

Then there are nagging, less heroic memories of sexism, homophobia, and racism within all of the movements that our generation built. The Chicana artist Patricia Rodríguez (2010), for example, shares my and LaBruce's enthusiasm for the struggles of that era, recalling that she "ended up in Berkeley right in the middle of all of the exciting movements: the civil rights movement, the women's movement, the Chicano movement and the Black Panthers." But she also recalls the sexism that she and the other women in the Mujeres Muralistas collective confronted when they were painting their first mural on San Francisco's Balmy Alley: "There were a lot of people that were coming by and harassing us constantly, especially the guys. 'You can't hang, give up, don't

do it, you know you can't hang, you know you're not going to be able to do it.' And even the women in the community were harsh to us, they were really making fun of us, they would come by and say things like, 'You're going to get your nails dirty, you're going to give up next week, you might as well admit it.'"

Until I was reminded of it in an essay by James Green and Florence Babb (2002, 12), I had forgotten a chilling incident of homophobia (and my cowardly silence about it) in the Latin American solidarity movement with which I was active for many years: "In 1975 the Chilean Movimiento de la Izquierda Revolucionaria (Movement of the Revolutionary Left-MIR) held a meeting in the San Francisco Bay Area to decide whether a gay activist who had been an important figure in the U.S. Chile Solidarity movement should be invited to join that organization. The political leader of the MIR's solidarity activities in the United States was unequivocal: 'En el MIR, no hay maricones' (In the MIR, there are no faggots)."

An author's own subject position and personal history inevitably influence the gathering and interpretation of data, and the next few pages are offered as an explicit acknowledgment of the history and memories I bring to this study of social movements and the role of artists in them.

I was a freshman at the University of California, Santa Cruz (UCSC), for less than a month when I first heard the shocking news of the government massacre of student protesters in Mexico City on October 2, 1968. I had traveled to Mexico for the first time that summer—a high school graduation gift from my mother—driving south down the Pacific coast and then back north through the Chihuahuan Desert for several weeks in an old Dodge van with my sister, brother-in-law, and a close high school friend. I was vaguely aware of the Mexican student movement's mass demonstrations, but I was far more taken by the beauty of Diego Rivera's murals in the National Palace. I purchased my first piece of original art on that trip, a lithograph by a Mexican artist that still hangs in my home.

My interest in Mexico was sparked at a very early age by Don Gregorio, Doña Olivia, and their children, a Mexican family who ran the labor camp on a ranch near my family's twenty-acre peach orchard in a small rural community in California's Sacramento Valley. Two passionate Spanish-language teachers encouraged that interest and also opened my eyes to the world of art. Mrs. Galich introduced me to the work of Francisco Goya in the seventh grade, explaining how the artist had managed to make fun of the Spanish nobility even while accepting their patronage. Mrs. Gibson—named Haley after the comet that many believed foretold the coming of the Mexican Revolution of 1910—

had traveled throughout Mexico for many years. She was an artist herself, and she nudged me to buy my first set of oil paints. She also helped convince my mother to let me make my first trip south of the border.

A small-town kid who fancied himself a budding poet and painter, I remember thinking how worldly I must seem, decorating my first college dorm room with the Rivera art posters and reproductions of pre-Columbian figurines purchased on my trip. But I soon felt embarrassingly naïve and self-involved as fellow students and a few of my professors at UCSC began to speak out against the Mexican government's repression. They circulated *Mexico 1968: A Study of Domination and Repression*, the quickly assembled pamphlet published that November by the North American Congress on Latin America (NACLA), with whom I would eventually work. When I went home for Thanksgiving that fall, I was eager to see a hometown friend who was then attending San Francisco State, where I currently teach. I wanted to hear about what I imagined must be his very glamorous life in a city filled with art galleries and museums; instead, he talked only about the San Francisco State student strike organized by the Black Student Union and the Third World Liberation Front. Later that year, I signed up for a course on the history of "Oriental Art" and began attending anti–Vietnam War movement meetings, totally unaware of the ironies.

I traveled to Mexico again in the summer of 1969, this time by train with two would-be artist friends, one a writer and one a painter. I audited painting classes at the university in Guanajuato, too easily setting aside my concerns about the war and the student movement. Back at UCSC as a sophomore, inspired by an anthology of Rubén Darío's romantic verses, I signed up for a Latin American poetry class taught by a new, young professor. Her opening lecture was a Marxist, dependency theory analysis of how the conquest and pillage of Latin America made possible the origins of world capitalism in Europe. We read Pablo Neruda's *Canto General*, César Vallejo's *Poemas humanos*, and Andre Gunder Frank's *Development and Underdevelopment in Latin America*. Politics kept encroaching on art.

Movimiento Estudiantil Chicano de Aztlán (MEChA), the Chicano movement's important student organization, was active at UCSC, and I became close, lifelong friends with two of its leaders, Eddie Escobedo and Olga Talamante. Eddie asked to borrow many of the arts and crafts I had brought back from Mexico to decorate the stage for MEChA's Cinco de Mayo program. Olga, as I recall, gave a rousing pitch to join the United Farm Workers' (UFW) grape and wine boycott, and another friend, Ricardo, sang a sexy version of

"La Bamba." The UFW pitch made me slightly nervous about being the white son of small farmers from a Sacramento Valley town where Cesar Chávez was viewed as the devil himself. And the handsome Ricardo, thick black hair crowned by a red bandana, rattled my still securely closeted sexuality, but overall the evening was a combination of art and politics that caused only minor discomfort. That is, until my Latin American poetry professor unleashed a scathing feminist critique of Ricardo's rendition of "La Bamba." The rarely sung verse that set her off: "cada vez que te miro, se me endurece la pupila del ojo, . . . y otra cosita . . ." (each time I see you my pupil hardens, and a little something else). Cultural nationalist and feminist positions quickly hardened as well, and I was starting to become aware of the dangerously complex politics of representation.

As I became increasingly politicized and active, I tried to remain equally engaged in art, taking classes in sculpture and Latin American art history. Little by little, however, art was being sidelined by politics, especially once I became a full-time activist for about thirteen years in the San Francisco Bay Area's anti-imperialist Left, working first as a staff member for NACLA and then in a Marxist-Leninist cadre organization, the Democratic Workers Party (DWP). The most significant aesthetic debates I recall at NACLA were about how much information we could squeeze onto each page of the magazine before it became completely unreadable. My close friend and NACLA coauthor Peter Baird, himself a talented singer, encouraged the incorporation of political art into our work; he convinced the brilliant Malaquías Montoya and Rini Templeton—both important figures in the movements explored in this book—to create graphics for our publications about Mexico. However, my relations with these artists were sadly strained when I joined the sectarian DWP. The party worked so diligently to destroy my "petty-bourgeois class standpoint" that I thought it wise not to even dabble in the arts anymore.

Although the Stonewall Rebellion in 1969 had already launched the gay liberation movement, my years in the Left stalled my coming out as a gay man as well as my return to art. My own internalized homophobia was reinforced by strong heterosexist tendencies in much of the "new communist" and anti-imperialist Left, fueled by workerist notions of the proletarian family and the Cuban Revolution's efforts to "rehabilitate" homosexuals. Today it's with considerable shame that I remember keeping my distance from the only openly gay member of the NACLA collective. Although NACLA and the DWP had better track records than much of the Left when it came to such issues, NACLA, if my memory serves, kept literature about the gay liberation move-

ment in its "secure" files, and the DWP carried out a purge of "lesbian chau-vinists." The gay author Edmund White (2006, 288) recalls how he and a close friend struggled to resist a therapist's recommendation to "go straight" in the midst of the era's radical social changes:

> We were in the late fall of 1968, a little more than six months before the Stonewall Uprising. We were the last victims sacrificed to the old order, as if we were boys in Peking in 1909 being castrated to be eunuchs in a court about to be extinguished by revolution. . . .
>
> But now, in 1968, when students were holding hostage the president of Columbia and war protesters were immobilizing the capital, when French kids had torn up the paving stones of Paris and soldiers were marching down the Boulevard St-Germain, when blacks and women everywhere were re-legislating their place in society and the citizens of Prague were struggling to throw out the Russians—amid such worldwide changes our effort to hold the knife to our own balls was failing.

Had I known gay activist artists like Edmund White in those days, perhaps I would have read the signs differently. Not that anyone ever said this to me in so many words, but I somehow managed to interpret all these experiences to mean that one could not be a serious political activist and a gay art aficionado at the same time.

It was only as I was completing a book on the paradigm crisis facing the Left in Mexico and Cuba in the mid-1990s (McCaughan 1997) that I became fully aware of the loss of art in my life, intellectually, politically, and person-ally. A number of the seventy-some Left intellectuals I interviewed for that book made references to cultural dimensions of the crisis. Several suggested that the strength of Cuban and Mexican national culture was an important re-source for a renovated Left and referred to the significant work of filmmakers, writers, and other artists. By then I had also come out as a gay man and had begun my relationship with the painter John Kaine. John's budding career thrust me back into the art scene just as my intellectual and political interests in the prospects for a renovated Left were leading me to take a closer look at the role of art in social movements.

Inevitably, my personal history and subject position have mediated the pre-sentation and interpretation of the "facts" offered in this book. My passion for art may tip the balance of my assessment in favor of artists' significance to movements for social change. My appreciation of Mexican and Chicano cul-ture may soften the edge of some critical observations, while the fact of my

white, North American privilege may lend an unintended bite of arrogance to others. My commitment to social justice and equality clearly leads me to identify and empathize with movements on the left, while my unpleasant personal experiences in a cadre party inform my skepticism about Leninist strategies for social change. My feminism and sexuality probably account for the somewhat easier and more open flow of my interviews with feminist women artists: we shared a language and a sexual politics that facilitated communication and understanding. There were occasions during my interviews with some of the men that I hesitated to push a point too far, particularly with regards to the gendered or sexual content of their work: What if he thinks I'm hitting on him? Will he clam up altogether if he thinks I think he's sexist? I've worked hard to recognize and consider these subjective factors in the process of researching and writing *Art and Social Movements*, but ultimately I accept Stuart Hall's ([1990] 2001, 560) assertion: "all discourse is 'placed,' and the heart has its reasons."

ABOUT THE GATHERING AND PRESENTATION OF DATA

Artwork produced in the context of social movement mobilization is often ephemeral, undocumented, and poorly preserved. We are fortunate that much of the graphic art from the Mexican student movement of 1968 was preserved and reproduced by Arnulfo Aquino and Jorge Perezvega. Some work from the *grupos* movement has been documented, and a significant amount of Chicano movement art has been reproduced in various publications.[1] However, very little of the COCEI movement artwork has been systematically documented; floods, fires, and frequent moves by artists and militants avoiding government repression destroyed or scattered many of the Zapotec movement's posters, flyers, banners, paintings, and photographs.[2] Moreover, beyond documentation of the artwork itself, there is relatively little published information about the context in which the artists from all three movement constellations produced and shared their work, their relationships to other movement activists and to one another, or about their understanding of the significance of the work.

Since 1998 I interviewed more than forty artists, movement activists, scholars, and directors of museums, galleries, and libraries in Mexico City, Oaxaca, and California. Several key informants were interviewed on multiple occasions. I also conducted research in more than thirty archives and collections. These included public archives such as those at the Carrillo Gil Museum,

the Instituto de Estudios Estéticas at the Universidad Autónoma Nacional de México, Museo de la Estampa, Centro de la Imágen, Museo Nacional de Arte, the Hemeroteca Nacional, *Siempre!* magazine and the *Excelsior* newspaper, the Instituto de Artes Gráficas de Oaxaca, Centro Fotográfico Alvarez Bravo, Centro de Investigación y Estudios Superiores en Antropología, the Hemeroteca de Oaxaca, and Casa de la Cultura in Juchitán. I also made use of digital archives such as the Smithsonian Archives of American Art's extraordinary collection of in-depth interviews with Chicano and Chicana artists and the Social and Public Art Resource Center (SPARC). Many individuals graciously allowed me access to their own archives and collections; they include Arnulfo Aquino, Demetrio Barrita, Maris Bustamante, Gerardo de la Barrera, Ester Hernández, Oliverio Hinojosa, Sabino López, Delfino Marcial Cerqueda, Natalia Marcial López, Macario Matus, Mónica Mayer, Rogelio Naranjo, Fernando Olivera, Cánida Santiago Jiménez, and Olga Talamante. Additional data were gathered in the process of attending countless exhibition openings, lectures, rallies, marches, conferences, and symposia.

There are many ways I might have organized the huge amount of information and analysis accumulated over more than ten years. I considered giving each movement its own chapter. I pondered the possibility of a chronological presentation. What I settled on is the following. Chapter 1 presents the theoretical framework through which I understand the significance of art in relationship to social movements, summarizes the historical significance of the three main case studies, and describes the ways in which the particularities of each movement were shaped by local variations in the prevailing regimes of accumulation, representation, and signification.

Chapter 2 argues that artists involved in the Mexican and Chicano social movements that formed part of the "world revolution of 1968" played an important role in creating a visual language through which the demands for a more meaningful form of citizenship could be expressed, felt, and enacted. I describe the commonalities and significant differences that appeared in each movement's artwork when addressing the following key elements of citizenship: the meaning of national and patriotic symbols, civil liberties and democratic rights and processes, and anti-imperialism and international solidarity.

Chapter 3 examines how Mexico City, Zapotec, and Chicano movement artists helped to represent and attribute new meaning to collective identities signified in terms of gender, sexuality, race, ethnicity, class, and nationality. I describe how movement artists asserted new collective identities that challenged central elements of the dominant national and ethnic discourses while

often reproducing other gendered, heterosexist, racialized, and class-based inequalities.

In chapter 4 I argue that the projection of a social movement's identity and agenda through art clearly involves formal and other aesthetic considerations as well as subject matter. Mexican and Chicano movement artists from the 1960s on could draw upon a variety of influential art movements, including the Mexican School's social realism, North American abstract expressionism, and newer international, postmodernist trends. This chapter examines the political significance of activist artists' stylistic choices and emphasizes that the full meaning of those choices only becomes clear when we focus simultaneously on local, national, and international contexts.

Chapter 5 describes the ways in which artists affiliated with Chicano and Mexican social movements worked to create counterhegemonic, autonomous spaces and new democratic practices that challenged the state, market, and art-world elite, and sometimes even their allies on the left. They organized activist-artist collectives, created alternative publications, built new institutions, and fought their way into the hallowed halls of established institutions from which they had long been excluded.

Finally, chapter 6 argues that while many movement activists throughout the '70s, '80s, and '90s concentrated on challenging and/or gaining formal political power as the key to realizing imagined utopian futures, many artists associated with social movements advocated for alternative notions of power and social change. They promoted counterhegemonic cultural transformations and fuller ways of knowing the world through the body and spirit as well as the mind. I describe how artists often served as the movements' inner consciousness, reminding us of the powerful countercultural spirit of 1968 that was more profound and lasting than the commonly evoked zeitgeist of sex, drugs, and rock 'n' roll.

ACKNOWLEDGMENTS

Research and writing of this book were made possible by an International and Area Studies Fellowship provided jointly by the American Council on Learned Societies, the Social Science Research Council, and the National Endowment for the Humanities; a Fulbright-García Robles grant; two Loyola University New Orleans Faculty Research grants; a Marquette Fellowship from Loyola University New Orleans; a Senior Faculty Research Award from San Francisco State University's College of Behavioral and Social Sciences; and a grant from San Francisco State University's Health Equity Institute.

Colleagues provided invaluable feedback on the manuscript at various stages. I am especially grateful to my longtime comrade Tony Platt, who critically commented on several drafts, and to accomplice extraordinaire, the artist Maris Bustamante, who offered her unique insights, opened many doors, and provided tequila when it was most needed. I also thank other colleagues who generously gave their time to read and comment on all or parts of the manuscript: Tomás Almaguer, Chris Bettinger, Rosana Blanco Cano, Howard Campbell, Héctor Carrillo, Andreana Clay, Jessica Fields, Velia García, Karen Hossfeld, Alejandra Osorio Olave, Clare Sears, and Immanuel Wallerstein.

I was fortunate to have the assistance of several wonderful student researchers: Alex Brown, Celina Gómez, Jeff Guhin, and Erica Sánchez at Loyola University New Orleans and Alan Gutirrez at San Francisco State University.

The Instituto de Artes Gráficas de Oaxaca, with its extraordinary library, helpful staff, and shady patio made for an ideal workspace, while Gary Titus and Aarón Yaschine welcomed me into their homes during the many months I spent in Oaxaca. Cristina Peredo, Patricia Olave, and Jaime Osorio opened their Mexico City homes to me repeatedly over the ten years it took to complete this book. John Kaine, my partner of twenty years, and Olga Talamante, my closest friend since our raucous college days, endured my emotional peaks and valleys and helped me keep the faith throughout.

Artists helped shape the politics and identities of an international generation of social movement activists forged in the protests of 1968 that shook cities across the globe, from Paris, Prague, and Tokyo to Mexico City, Los Angeles, and San Francisco. *Art and Social Movements* offers a comparative analysis of the role of visual artists in three such arenas of struggle: in Mexico City, the student movement of 1968 and a closely associated network of activist art collectives; in Oaxaca, a political and cultural struggle rooted in the region's Zapotec communities; and in California, the Chicano civil rights movement. Working within these movements, artists helped to attribute new meaning to social phenomena as varied as class, race, gender, sexuality, citizenship, and power.

More consciously than other activists, artists are intensely engaged in processes of representation and signification. In the following pages I describe the ways in which movement-affiliated artists helped to create visual languages and spaces through which people could imagine and perform new collective identities and new forms of meaningful citizenship. Much of the visual discourses created by Mexican and Chicano artists between the 1960s and 1990s remains vital today in social movements demanding fuller democratic rights and social justice for working people, women, ethnic communities, immigrants, and sexual minorities throughout Mexico and the United States.

This book's focus on the work of activist artists coincides with more recent theoretical and empirical developments in the literature on social movements and cultural studies. In the mid-1990s, Alberto Melucci (1996, 68) noted "a renewed interest in cultural analysis which corresponds to a shift towards new questions about how people make sense of their world, how they relate to texts, practices, and artifacts rendering these cultural products meaningful to them." Visual arts produced in the context of social movements are the texts and artifacts explored here. I agree with Lo, Bettinger, and Fan's (2006, 78) assessment that "art's ability to express the shared, yet contentious, understandings of objects and actions make it the vehicle of social movements and social conflict." Such observations are part of a paradigm shift in studies of social movements that influenced my ideas about the potential political significance of activist art. The move was away from previously dominant theories of ideology, organization, and resource mobilization and toward the new social movements perspective on the centrality of collective identity formation, a cultural process involving the construction of meaning (Johnston et al. 1994).

An anthology edited by Sonia Alvarez, Evelina Dagnino, and Arturo Escobar (1998) was especially useful in conceptualizing the centrality of cultural dynamics of representation and signification as they interact with sociopolitical processes in the context of Latin America: "Social movements not only have sometimes succeeded in translating their agendas into public policies and in expanding the boundaries of institutional politics but also, significantly, have struggled to resignify the very meanings of received notions of citizenship, political representation and participation, and, as a consequence, of democracy itself" (2). Not all scholars of social movements agree with this approach. Wickham-Crowley and Eckstein (2010), for example, take issue with Alvarez et al.'s focus on cultural politics and meaning, and they dispute the relevance of "Birmingham-style Cultural Studies, à la Stuart Hall and Raymond Williams," which they regard as having "a fatal predilection for conflating culture with power" (11–12). In their eagerness to reassert the importance of structural theories, Wickham-Crowley and Eckstein mischaracterize the framework offered by Alvarez, Dagnino, and Escobar. To insist on the importance of the cultural dimensions of social movements—such as struggles over discourse and the meanings attributed to social phenomena—is hardly a call to ignore the structural contexts in which such struggles are carried out. On the contrary, the challenge for scholars is to fully understand and explain the

significance of cultural politics that are inevitably enmeshed in specific structural and historical contexts. Whittier (2002, 290), for example, argues for an approach that includes "serious consideration of *structure* (movement organizations, communities, and fields), *strategies and collective action* (challenges, protest events), and *meaning* (collective identities and discourse)." In my own analysis elaborated below, I contend that the political importance of the visual discourses produced by movement artists only becomes apparent when read against prevailing social structures, regimes of accumulation, and systems of representation.

Alvarez, Dagnino, and Escobar (1998, 7) understand that "culture is political because meanings are constitutive of processes that, implicitly or explicitly, seek to redefine social power. That is, when movements deploy alternative conceptions of woman, nature, race, economy, democracy, or citizenship that unsettle dominant cultural meanings, they enact a cultural politics." Their observations made me think more consciously about the ways in which visual discourses produced by artists contribute to unsettling those dominant constructions. I was reminded of a powerful graphic by Adolfo Mexiac created for the 1968 Mexican student movement: a man's mouth had been chained and padlocked. That graphic, widely reproduced and circulated in Mexico and the United States at the time, undermined the image being promoted by the Mexican and U.S. governments of Mexico as a model of stable democracy, development, and modernization. I also thought of the Chicana artist Yolanda López's classic self-portrait in 1978 as a defiant, athletic Virgin of Guadalupe, which challenged patriarchal notions of Chicana and Mexican womanhood. As Amalia Mesa-Bains (1991b, 132) has observed, the work of Chicana artists "does not simply reflect ideology, it constructs ideology."

In a similar vein, Janet Wolff (1990, 1) begins to get at the relationship between art, cultural politics, and the feminist movement when she writes: "Art, literature and film do not simply represent given gender identities, or reproduce already existing ideologies of femininity. Rather they participate in the very construction *of* those identities. . . . Culture is a crucial arena for the contestation of the social arrangements of gender. Cultural politics, then, is not an optional extra—a respectable engagement in one of the more pleasant sectors of political action. It is a vital enterprise, located at the heart of the complex order which (re)produces sexual divisions in society." I agree with Wolff's formulation, but she does not elaborate on the relationship of feminist artists to the movement itself, something I try to do in this book.

Another useful framework for thinking about art, social movements, and

collective identity formation is provided by Stuart Hall's analysis of contemporary Caribbean and black British cinemas. Similar to Wolff's and Mesa-Bains's respective analyses of feminist and Chicana art, Hall ([1990] 2001, 571) reads this cinema "not as a second-order mirror held up to reflect what already exists, but as that form of representation which is able to constitute us as new kinds of subjects." Hall begins with the important premise that "we should think . . . of identity as 'production' which is never complete, always in process, and always constituted within, not outside representation" (560). He then contrasts this to a more essentialist conception of collective identity, evident in many anti-colonial struggles, that is expressed in terms of "the common historical experiences and shared cultural codes which provide us, as 'one people,' with stable, unchanging and continuous frames of reference and meaning" (561). As an example of the latter, Hall cites the "Negritude" poetry of Aimé Césaire and Léopold Senghor.

While recognizing, as did Frantz Fanon ([1963] 1968), the political importance of ethnic pride representations to mid-twentieth-century anticolonial resistance, Hall sees in the contemporary cinema of the black diaspora representations of more fluid, shifting, hybrid identities. Reflecting the social reality of diaspora in an era of economic and cultural globalization, the cinematic representations that interest Hall ([1990] 2001, 562) are those that recognize that, "as well as the many points of similarity, there are also critical points of deep and significant difference which constitute 'what we really are'; or rather — since history has intervened — 'what we have become.'" Hall's analysis provides a framework for thinking about the significance of the Zapotec artist Francisco Toledo's work, which never devolves into the folkloric representations of Mexico's indigenous communities that characterize some Mexican and Chicano movement art. Instead Toledo's years in Paris combine with his roots in Oaxaca's Zapotec communities to produce images that help constitute an evolving, hybrid ethnic identity.[1] From her reading of Stuart Hall, Roberta Garner (2001, 559) concludes that "social movements do not mobilize support bases according to demographic characteristics; they create support bases by their practices of framing and defining identities." That is a process, I argue, in which art making is central.

An example of how activist artists help to frame and define identities is provided by Sánchez-Tranquilino's (1995) case study of a project in the 1970s to paint "Chicano" murals on East Los Angeles walls once marked by "Mexican American youth gang" graffiti. Sánchez-Tranquilino attempts to "shed light on one aspect of negotiating Chicano cultural survival, not only through the

politics of what constitutes 'art' but also through an examination of how identity is constructed as part of the process of making artistic form and content 'readable' in a particular context" (56). He reads the graffiti and the murals as "two signifying systems in which social value is produced in and through their constructed meanings as an integral part of the process of developing the painter's/viewer's subjectivity or identity" (65). By contrasting these two distinct "signifying systems," the author begins to reveal the role of artists in shaping and projecting the then emerging politicized identity of those who saw themselves as part of the Chicano movement.

Other scholars have written about the role of art and artists in processes of ethnic or racial identity formation and nation building, but relatively few of them frame their work within a social movements perspective. Jordan and Weedon (1995), for example, discuss at length the cultural politics of racial and ethnic identity in contemporary Britain. They offer many useful insights into the ways in which art, like "all signifying practices," involves "relations of authority and power" and how, "for many Asian and Afro-Caribbean artists and intellectuals in Britain, whether immigrants or British-born, a key issue is that of establishing an identity that engages with both their communities of origin . . . and the dominant 'White' cultural mainstream" (440, 454). But Jordan and Weedon's analysis of the relationship between artists of color and the dominant culture is not informed, at least not explicitly, by new social movements perspectives on such processes. Bright and Bakewell (1995, 5) attempt to "bring together discussions of aesthetics and anthropology in order to emphasize the social processes and problems of cultural identity negotiated through works of art." But, like Jordan and Weedon's book, this edited volume is not particularly concerned with the role of social movements or social movement-affiliated artists in those processes. The one exception in Bright and Bakewell's anthology is Sánchez-Tranquilino's insightful essay. Another study that looks explicitly at art in the context of social movements is Bruce Campbell's (2003) book on contemporary Mexican muralism, a particularly sophisticated effort to understand the role of art within complex processes of social change. Campbell describes and explains the changing conditions and modalities of contemporary Mexican mural production, including new forms such as graffiti art and *mantas* (mobile images on cloth), but he is primarily concerned with what the new mural practices can tell us about the dynamics of public space, discourse, state power, and civil societal movements.

In *Art and Social Movements* I examine the role of artists and art in Mexican and Chicano social movements by integrating insights from poststructural-

ist perspectives on the cultural politics of representation and signifying processes into an understanding of social movements that remains grounded in the specificity of historical contexts and political economy. The research flows from the premise that art associated with social movements helped to constitute, not simply reflect, the dramatic social and political changes experienced by Mexican and Chicano communities during the twentieth century. The social power of activist artists emanates from their ability to provoke movement constituents and other publics to see, think, imagine, and even feel in meaningfully new ways. "It is the way art simultaneously engages our imaginations, emotions, bodies and intellects," argues Amy Mullin (2000, 128), "that makes it uniquely suited to affect us more deeply than other, more purely intellectual, ways of conveying these ideas." The Chicana theorist Gloria Anzaldúa (2002, 542) argued that creative acts, including art making, allow one "to link inner reflection and vision—the mental, emotional, instinctive, imaginal, spiritual, and the subtle bodily awareness—with social, political action and lived experiences to generate subversive knowledges."

FROM JUCHITÁN TO AZTLÁN: THE CASE STUDIES

Beginning in the mid-1960s a variety of new social movements emerged in Mexico and in Aztlán—the ancient, mythical Mexican homeland, as some Chicanos reimagined the U.S. Southwest.[2] This study focuses on three contemporaneous social movement constellations in which visual artists played a central role. Although each is characterized by its own particular dynamics, reflecting distinctive local histories, cultures, and conditions, I view all three as part of what Immanuel Wallerstein (1989, 431) has called "the revolution of 1968"—"one of the great formative events in the history of our modern world-system, the kind we call watershed events." These movements illustrate several of Wallerstein's theses about the significance of the rebellions of 1968: they involved protest against U.S. hegemony in the world, a critique of the ineffectiveness of "old Left" movements, countercultural sensibilities, an emphasis on the centrality of "minority" groups and women, and a questioning of the "fundamental strategy of social transformation." Several of Wallerstein's "queries" about the lessons of 1968 also arise in my examination of the movements based in Mexico City, Oaxaca, and California: How effective, ultimately, are institutional expressions of formal political power in the pursuit of antisystemic social change? Do alternative forms of social power offer greater

counterhegemonic potential? What is the balance between material and spiritual well-being in our utopian imaginaries?

In Mexico City graphic art became a signature of the student movement in 1968, a watershed event indeed that helped to unleash a series of profound sociopolitical and cultural changes still being played out in Mexico today. At a different historical moment, what began as a series of student protests against bus fares and scuffles between rival student gangs might never have grown into a mass movement capable of mobilizing hundreds of thousands of protesters. However, with Mexico preparing to host the Summer Olympic Games in October, the administration of President Gustavo Díaz Ordaz was determined that order would prevail as Mexico demonstrated to the world its coming of age as a modern, developed, and stable society. The government cracked down on the relatively minor incidents with the heavy-handed force of the *granaderos* (tactical police squads), thus sparking even greater protests by students who were well aware of actions being taken by their counterparts in Paris and elsewhere. Throughout the summer and early fall of 1968, a coordinated network of university and high school student strike committees organized a movement that demanded the repeal of penal codes permitting the arrest of anyone attending a meeting of three or more people, the abolition of the granaderos, freedom for political prisoners (including prominent labor leaders), and accountability and punishment of public officials responsible for the repression. Students at the nation's two leading art academies, San Carlos and La Esmeralda, produced hundreds of posters, flyers, and banners for the movement, using bold graphics to express the demands for civil liberties and democracy. The movement continued to gather strength and support from broad sectors of society until it represented such a challenge to Mexico's long-ruling, state-party regime that government troops were ordered to fire upon a movement rally on October 2, 1968. Several hundred people were killed, and many others were imprisoned, forced underground, or exiled.

A generation of youth was politicized by the student movement and went on to lead a diverse array of social movements, community organizations, and opposition political parties in the 1970s and 1980s that helped advance Mexico's still halting democratic transition. Many of the artists involved in the student movement or politicized by it continued their activism with the formation of political art collectives, known in Mexico as the *grupos* movement. At its height, the movement included more than a dozen artists' collectives in Mexico City and a few others in cities like Guadalajara, which came together

briefly in 1979 as the Frente de Grupos Trabajadores de la Cultura (Front of Cultural Workers Groups). The grupos used artwork to support a variety of other popular movements and to focus attention on social problems, such as urban poverty, repression, corruption, environmental destruction, and U.S. imperialism.[3]

The Zapotecs, an indigenous people centered in the state of Oaxaca in southern Mexico, have a centuries-long history of struggle to preserve their autonomy. They resisted domination by the Aztecs (or Mexica) in the fifteenth century, by Spaniards beginning in the sixteenth century, and by the postcolonial mestizo political elite based in Mexico City throughout the nineteenth and twentieth centuries. Among Zapotecs in the Isthmus of Tehuantepec there is even resentment about historic domination by other Zapotecs based in the Valley of Oaxaca. In the early 1970s a new Zapotec social movement emerged. The most prominent organization representing the new movement was Coalición Obrera-Campesina-Estudiantil del Istmo (COCEI; Worker-Peasant-Student Coalition of the Isthmus), which had roots in both the student movement of 1968 and in isthmus Zapotec organizations opposed to Mexico's long-ruling Partido de la Revolución Institucional (PRI, Party of the Institutional Revolution).

Three significant new trends in social movement organizing intersected in the COCEI. First, it was one of many efforts throughout Mexico in the 1970s to create grassroots worker and *campesino* organizations that were independent of the PRI, whose then faltering hegemony had rested to a significant degree on its corporatist control of labor and peasant federations. Second, the COCEI was in the forefront of new attempts to challenge the PRI electorally by testing the limits of the regime's tentative political opening in the late '70s and early '80s—an opening that was designed to defuse and control the democratic demands given voice by the movement of '68. Finally, the COCEI exemplified the identity-based organizing of new social movements worldwide, with its emphasis on its Zapotec heritage and demands for greater cultural and regional autonomy.

Founded in the early 1970s, the COCEI gained national, even international, prominence when it won municipal elections in the isthmus town of Juchitán in 1981, becoming what many observers regard as the first Left opposition party to win control of a significant local government in Mexico.[4] National support for the COCEI grew when it was forcibly removed from power by the army in 1983 and then regained control of the city through elections in 1989. At the same time, artists, such as internationally renowned Francisco Toledo,

played an important role in developing the movement's much broader cultural project, described by Howard Campbell (1994) as a Zapotec renaissance. Zapotec-identified artists helped to create a unique, hybrid visual discourse to represent an ethnic identity that was rooted in the ancient past but oriented toward a vibrant future. Jeffrey Rubin (1997, 2) argues persuasively that the movement achieved "an empowerment of Indians, including cultural autonomy, relative economic well-being, and political democratization [that] is without parallel in contemporary Latin America."[5]

Artists were also central to the Chicano movement that emerged in the U.S. Southwest in the mid-1960s. The movement was a constellation of civil rights struggles by Mexican American communities on many different fronts, including high schools and universities, agricultural fields, and urban neighborhoods. Racism, affirmative action, bilingual education, police brutality, prisoners' rights, immigrants' rights, women's rights, unionization of farmworkers, community health care and housing, community art, solidarity with Third World liberation struggles, and the war in Vietnam were among the many issues encompassed by the movement's broad umbrella.

As in Mexico City and Oaxaca, 1968 was a pivotal moment for the Chicano movement. It was the year that the United Farm Workers leader Dolores Huerta shared the stage with Bobby Kennedy, signaling the movement's emerging political power, as he claimed victory in the California Democratic presidential primary moments before he was assassinated. It was also the year of the high school "blow outs," when over ten thousand students — including the Chicano artists Patssi Valdez and Harry Gamboa — walked out of fifteen Los Angeles public schools to protest racism and inequality in the school system. Valdez would later recall, "We were angry, rebellious, and disgusted about the racism, police brutality and the things being said about us as Chicanos" (Romo 1999, 11). Many Chicano and Chicana artists engaged in producing murals, posters, installations, performances, and other artwork that became one of the movement's more effective means of constituting and representing its identity and aspirations.[6] Although activist artists were engaged in the Chicano movement throughout many regions of the United States, I have chosen to focus on the work of movement artists in California. Restricting the study to California simplifies the methodological and analytical task of developing a meaningful comparison with the Mexico City and Oaxaca case studies that can highlight the regional factors that contributed to distinct movement practices.

Because these three constellations of social movements were part of the

same international generation identified with the so-called revolution of 1968, they were well aware of one another and of their counterparts in other countries. There were limited but significant moments of shared experience among artists from the different movements. Felipe Ehrenberg, for example, collaborated with the global network of socially and aesthetically progressive artists known as Fluxus when he moved to England in 1968 to avoid repression in Mexico. Inspired by the "happenings," action art, and conceptual approaches popular in the Fluxus circle, Ehrenberg then incorporated those experiences into his work with the grupos movement when he returned to Mexico City.[7] He and the photographer Lourdes Grobet, key figures in the collective Proceso Pentágono, were among several grupos movement artists who also worked in solidarity with the COCEI in Oaxaca. Ehrenberg was also in contact with Chicano artists in the early 1970s, and his exhibition in 1973, *Chicles, Chocolates, Cacahuates,* at Mexico City's Palacio de Bellas Artes "included images of daily urban culture similar to Chicano artistic expression" (Maciel 1991, 116).

Another wave of repression in Mexico City sent three other student movement artists into exile in Aztlán. In 1971 Arnulfo Aquino traveled north with fellow artists Rebeca Hidalgo and Melecio Galván, ending up in California where they worked with Chicano movement artists, including Malaquías Montoya and Chuy Campusano, making silkscreen posters and painting murals in San Francisco and the Central Valley. While there, a romance blossomed between Galván and the Chicana artist Patricia Rodríguez, a founding member of the Mujeres Muralistas collective (Aquino 2007 and 2010, 31–33).[8] After returning to Mexico, Aquino "promoted an exhibit of Chicano posters in Mexico City in 1975 and later painted a mural in a Mexico City preparatory school with themes that were clearly influenced by Chicano art" (Maciel 1991, 116). Aquino, Galván, and Hidalgo would go on to found Grupo Mira.

Internal exile and love also brought together the Mexico City poet and anthropologist Elisa Ramírez Castañeda and the famed painter Francisco Toledo. When Ramírez and a small group of student activists fled from the October 2, 1968, violence, they went south and found refuge in the Oaxacan home of Toledo. The poet and the painter fell in love and collaborated closely for several years in the Zapotec movement (Debroise 2006c).

The Zapotec potter and community activist Carlomagno Martínez (2006) credits María Pinedo, who then worked at San Francisco's Galería de la Raza, with introducing him to Chicano movement artists in California, a formative experience that raised his consciousness about racism and his own ethnic

identity. The California painter Barbara Carrasco (1999), made to feel uncomfortable as a light-skinned Chicana by the movement's Brown Power rhetoric, traveled south of the border to immerse herself in Mexican artistic traditions; she worked with the muralist Arturo García-Busto in Oaxaca and visited the Mexico City studios of the famed art collective Taller de Gráfica Popular. Not all such exchanges between Chicano and Mexican movement artists were positive. Patricia Rodríguez described to me an unpleasant meeting in Mexico City in which Chicano artists felt dismissed as ignorant and unsophisticated by their Mexican counterparts.

At least one artist participated actively in the movements in all three locations. Rini Templeton, born in Buffalo, New York, produced thousands of graphics for hundreds of social justice causes before her untimely death in Mexico City in 1986. She worked closely with Chicano movement activists in New Mexico, where she contributed to the movement newspaper *El Grito del Norte*, edited by Betita Martínez. In California, Templeton created artwork to support a wide variety Chicano community organizing efforts, and it was there that Malaquías Montoya taught her how to silkscreen. She moved to Mexico City in 1974, where she worked with the historic Taller de Gráfica Popular, the Taller de Arte e Ideología (one of the core collectives of the grupos movements), and other community and Left organizations, including Punto Crítico, cofounded by the 1968 student movement leader Raúl Álvarez Garín (Martínez 1987). In Oaxaca in 1980, Templeton worked for six months with the Zapotec artist Sabino López producing posters and banners for the COCEI; according to López (2006), they worked in semiclandestine conditions in the town of Ixtepec to avoid government repression and police harassment in Juchitán, which was the movement's hub.

As these individual stories might suggest, there were significant differences among the movements, despite sharing an international generational experience. Ehrenberg's ability to flee to England and Templeton's ability to move back and forth between California, New Mexico, Mexico City, and Oaxaca were made possible by a modest level of class privilege not typically available to Chicano and Zapotec artists. The dynamics of racism clearly varied: mestizo Mexico's anti-Indian racism can be so commonplace as to seem nearly invisible, as it was, to some degree, for Carlomagno before his encounters with the Chicano movement. Awareness of racism and therefore the need for ethnic pride among Chicanos can be so acute as to make light-skinned Chicanas insecure about their identity, as Carrasco (1999) has described. The level of state repression in Mexico City and Oaxaca was far greater than that experi-

enced by activists in California, although police brutality was (and remains) a widespread problem despite the United States' more deeply institutionalized formal democracy. Moreover, the distinctive discourses and cultural traditions operating in each location meant that the artists often expressed their social experience using different symbolic systems.

REGIMES OF ACCUMULATION, REPRESENTATION, AND SIGNIFICATION

The particularities of each movement were shaped by local variations in the prevailing regimes of accumulation, representation, and signification. I find it useful to think about these differences in terms of Alain Lipietz's (1987) notion that every distinctive regime of accumulation (such as state-sponsored industrialization or high-tech, market-centered capitalism) must be accompanied by a particular "mode of regulation," if it is to reproduce itself successfully. He describes the latter as the "norms, habits, laws and regulation networks which ensure the unity of the process and which guarantee that its agents conform more or less to the schema of reproduction in their day-to-day behavior and structure" (14). I would add to Lipietz's list the symbolic "regimes of representation" and "systems of signification," including the arts, which Janet Wolff (1993, 4) regards as "repositories of cultural meanings." The meanings that we attribute to our social world, including most importantly its core values, are expressed through the symbolic systems of language and visual discourse, which, I suggest, function as part of the mode of regulation.

A ruling class, or historic bloc as Gramsci (1989) preferred, exercises its economic, political, and cultural hegemony when subaltern segments of society come to accept as common sense the meanings attributed by the dominant bloc to fundamental concepts such as citizenship, nationhood, patriotism, well-being, security, freedom, equality, race, family, gender, and sexuality. To the extent that the majority of people inhabit and perform such concepts in a manner that mirrors the dominant system of linguistic and visual representation, we "conform more or less" in our "day-to-day behavior and structure" to hegemonic schema for reproducing the political economy. Counterhegemonic social movements attempt to unfix those meanings and create new systems of signification, a task in which artists can play a critical role. Because distinct regimes of accumulation and representation prevailed in the locale of each social movement examined in this study, movement-associated artists helped develop counterhegemonic visual discourses whose meanings corre-

spond to local particularities as well as to shared international and/or national contexts.

By the early 1940s Mexico's postrevolutionary state was wedded to a nationalist economic development and modernization strategy of state-led industrialization that was popular in several Latin American nations in the decades following the Great Depression. In Mexico's case the mode of regulation entailed a corporatist-populist political system, in which the postrevolutionary society's main social sectors — workers, peasants, and small businesspeople — were organized into national confederations effectively controlled by the ruling PRI and a powerful national presidency. The mode of regulation also involved a carefully constructed cultural nationalism, promoted through the public school system and an extensive public arts program that gave rise to the Mexican School of art. The "Mexican School" label has been used to refer to the figurative, social realist style of art associated with early to mid-twentieth century muralists and painters, such as Diego Rivera, José Clemente Orozco, and David Alfaro Siqueiros, and graphic artists such as Leopoldo Méndez and the collective Taller de Gráfica Popular. Their depictions of the Mexican working class and peasantry, of anticolonial and anti-imperialist heroes, and of Mexico's indigenous cultures became key elements of a nationalist system of representation and signification. The logic of the model was that state-sponsored economic modernization required class collaboration, which was to be facilitated by fostering a shared national identity and unity through the state's cultural policies. That regime was hegemonic through the 1960s when a variety of social movements and political opposition forces began to challenge its authoritarian control over virtually all public institutions, including mass organizations, political parties, universities, the press, and the art world.[9]

Mexico City–based student and grupos movement constituents and artists occupied a particular position within Mexico's then hegemonic system. Politically, university students and young activist artists were largely disenfranchised, unrepresented in the social sectoral framework of the regime's corporatist structure and without a viable opposition political party through which to challenge the PRI's control of the electoral system. As students they had no effective say in the formulation of higher education policies, and as artists they faced censorship and marginalization by the official art world. In social class terms, however, they were in many ways products of the more successful aspects of the regime's economic development strategy: a relatively affluent urban middle class with rising expectations following more than twenty years

of economic growth. Most student and grupos movement activists and artists were also part of the nation's mestizo (mixed Spanish-Indigenous) majority. In other words, they were relatively privileged in relationship to the nation's most impoverished social sectors (indigenous communities, rural peasantry, and urban working class and underclasses), but they were blocked by the regime's authoritarian system of political and social control from meaningful and autonomous exercise of full political citizenship and artistic creativity. And as products of higher education and the radical international politics of 1968, they had developed an acute critical consciousness about the social world around them. Much of the artwork of the Mexico City movements, therefore, primarily projects a new collective identity as fully empowered citizens, rather than in terms of the ethnic and class consciousness found in Zapotec and Chicano movement art.

The Mexico City art world of the 1960s and 1970s experienced a generational divide in which younger artists expressed frustration with the Mexican School and openness to international trends such as expressionism, conceptual art, and pop art. The younger generation's discomfort with the Mexican School of art was closely related to its deep ambivalence about the legacy of Mexico's nationalist revolution, which gave birth to the authoritarian regime and its cultural politics. The ambivalence was particularly evident in the student movement's frequent deployment of formal elements associated with the Mexican School of art despite the relative scarcity of positive nationalist and revolutionary iconography in the movement's graphic art. By the 1970s the break with the nationalist regime of representation was even more pronounced as many of the grupos artists abandoned social realism in favor of conceptual art strategies.

Oaxaca, site of the COCEI and Zapotec movement, is in many regards a peripheral region of Mexico's national regime of accumulation, which experienced an economic downturn in the late 1960s followed by an oil-fueled expansion in the 1970s. In Oaxaca, and especially in the Isthmus of Tehuantepec where the movement was centered, these economic changes spurred urbanization, a disruption of landholding patterns, and an expansion of commercial activities, all of which changed the patterns of economic opportunity and class formation. According to Jeffrey Rubin (1997, 113), at that particular moment of rapid socioeconomic change "COCEI offered concrete help to people who suffered numerous exploitations and had few avenues of recourse."[10] The COCEI was one of several organizations that emerged throughout Mexico in the 1970s to challenge the PRI's corporatist control of organized labor and campesi-

nos. In this regard the Oaxacan case was not altogether unique, but Oaxaca's peripheral status and large Zapotec population made for a very different context than that in Mexico City.

Unlike the largely middle-class and mestizo student and grupos movements, the Oaxacan movement's base was largely working class and identified as Zapotec. In addition to the political disenfranchisement experienced by youth in Mexico City, the COCEI and Zapotec movement was fueled by historic resentments of domination by Mexico City elites, from the Aztecs to the postrevolutionary mestizo politicians. In the cultural politics of Mexico's "mode of regulation," the dominant national narrative is centered in Mexico City from its founding as Tenochtitlán by the Mexica (or Aztecs) to its contemporary role as political, economic, and cultural center of a supposedly unified mestizo nation. Natividad Gutiérrez (1999, 85) notes that Mexican public school textbooks only address Oaxaca's great pre-Columbian Zapotec and Mixtec civilizations in terms of their eventual domination by the Mexica. Zapotec intellectuals such as Andrés Henestrosa and Gabriel López Chiñas were promoting Zapotec cultural expressions in the 1920s and 1930s, but a new generation of Zapotec writers and artists found in the COCEI an opportunity to integrate the cultural movement with a political movement: "For Juchiteco intellectuals, it was no longer enough just to write poems and essays about Isthmus customs and the etymology of Zapotec words; it became crucial to wield the pen and paint brush to promote a political project aimed at redistributing land and wealth and bringing to power local representatives of Zapotec peasants and workers" (Campbell et al. 1993, 208).

Visual artists associated with the COCEI drew upon a system of representation and signification very different from that deployed by their Mexico City counterparts. Economically and politically, Oaxaca may have been a peripheral zone of the national regime, but it was hardly a cultural backwater. Three Oaxacan artistic giants—Rufino Tamayo, Rodolfo Nieto, and Francisco Toledo—had broken with the Mexican School of art's social realism and its association with a Mexico City–and mestizo-centered vision of the nation. The Mexican School's *indigenismo*, which glorified magnificent indigenous civilizations of the past while ignoring the poverty and exploitation of Indians in the present, was offensive to many in Oaxaca, where about half of the population still speaks an indigenous language. Tamayo, Nieto, and Toledo—all of whom received great international acclaim and some national resentment—helped to foster a unique, syncretistic visual style that integrated contemporary international currents with distinctively Oaxacan motifs and

colors. Drawing upon those traditions but now in the context of an integrated cultural and political movement, Zapotec artists in the 1970s, 1980s, and 1990s produced a sophisticated visual language that signified a revitalized, contemporary Zapotec identity—not as "what we really are" but as "what we have become," to borrow Stuart Hall's ([1990] 2001, 562) phrase.

Zapotec writers and painters contributed to a cultural project that was crucial in asserting the movement's autonomy and resisting the historic pattern of intervention by the Mexico City–based regime. Rubin (1997, 235) summarized that project: "COCEI has succeeded in developing a powerful regional presence and keeping the Mexican regime at bay in part by claiming cultural activities for a poor people's movement and making use of them not only to represent and define, but to empower and give pleasure. . . . It is a rare affirmation not only of the value of indigenous life and culture, but of that culture's ability to sustain and reinvent itself and to appropriate the outside from a position of equality and power."

Like its Zapotec counterparts, the Chicano movement and its artists also engaged in a cultural project of ethnic pride and empowerment. However, Chicanos confronted very different socioeconomic, political, and cultural systems in the United States. The prevailing regime of accumulation in the United States in the 1960s could still be characterized as Fordist, although that model was already showing signs of crisis by the late '60s and would give way to what has been described by Lipietz (1987) as a transnational regime of "flexible" accumulation over the next decades. The illusion of the American dream was kept alive, if ever more faintly, through a high-productivity, high-wage, capital intensive manufacturing economy together with a mode of regulation centered on a liberal strategy of maintaining economic and political stability through inclusion, cooptation, and the promotion of a depoliticized consumer culture and arts world.[11]

Unlike in Mexico and even "in contrast to Europe, which had a strong tradition of patronage" of the arts, Stevens and Swan (2004, 123) argue that in the United States the arts were typically regarded as "frivolous and often decadent—and certainly not an essential part of national life." The extensive Franklin Roosevelt government-sponsored arts program of the Works Progress Administration (WPA) was the short-lived exception. The rise of virulent anticommunism helped to squash this brief experiment with large-scale support for public art, and WPA artists were targeted for surveillance as suspected subversives (Stevens and Swan 2004, 132). Other factors, such as the rise of a world art market centered in New York and the influence of formalist

approaches to art criticism, furthered the increasingly conservative, market-oriented direction of the art world in the United States. Tekiner (2006, 31) describes how formalist art criticism, "by its support of the market apparatus," "upheld conservative agendas" and "obscured the relationships of art to social contexts and the socially critical implications of art." Public museums also played an important role in shaping the conservatism of the U.S. art world "by promoting nationalism, the ideal citizen, and capital accumulation" (Davalos 2001, 55).

By the 1960s, when many Chicano artists came of age, challenges to the conservative nature of the U.S. art world had begun to emerge in conjunction with the era's various countercultural movements (Tekiner 2006, 42–43). Moreover, the power of the market and national cultural values of individualism and autonomy were still tempered by the safety net of social welfare and government regulation. Institutionalized racism and the white privilege of dominant Anglo-America seemed to many resolvable through the promise of expanding civil rights legislation. The money-driven, two-party electoral system effectively excluded genuinely antisystemic alternatives, but the Democratic Party's reliance on the support of organized labor, women, and minority communities offered some prospects for political representation.

Chicano movement constituents were largely working class, rural and urban, betting on their or their children's rise into the middle class through a college education and home ownership. Many of the student activists were the first generation of their family to attend college. The Chicano movement artist Gilbert Lujan (1997) described the energy and optimism of a post–World War II United States, where he was able to attend college through the GI Bill: "The United States was in a very incredible period. And that feeling that it engendered in me, growing up, . . . was an expansive one. It was one where you try to do new things, you go out and you learn, you go to college. . . . The whole country was very upbeat. There was a lot of hope."

While some Chicanos were completely disenfranchised due to their immigrant status, others were citizens increasingly active in electoral politics. For many in the movement, then, it was possible to imagine fuller, more equitable participation in the opportunities available from the liberal Fordist U.S. regime if one formidable obstacle could be overcome: racism. Unlike the relative privilege and majority status of their Mexico City movement counterparts, Chicanos were an ethnic minority confronted with the dehumanizing daily experiences of racial discrimination and oppression. Reflecting on her involvement as an artist in the Chicano movement, Judithe Hernández

(1998) described "struggling against the discrimination, against the stereo-types, against the lack of opportunity in education, treatment of immigrant workers. I mean, all of that was part of who we were. . . . And it was the first time that any of our generation had . . . the voice, the ability, and the opportunity all at once to do something about it."

These socioeconomic, political, and cultural realities help to explain Chicano movement artists' overwhelming emphasis on themes of ethnic identity and pride and imagery associated with their indigenous heritage and Catholic spirituality. The previous generation of Mexican Americans' emphasis on acculturation was eclipsed by the 1960s generation's emphasis on cultural resistance in an "Occupied America," as Rudy Acuña (2000) called it, imagined by many in the movement as the ancient homeland of Aztlán. Prideful evocations of the community's indigenous roots and its working-class identity challenged the hegemonic cultural constructions of "America" as white and middle class. Racist stereotypes of the lazy, indolent Mexican peasant asleep under a cactus or of dangerous, criminal urban gang members were countered with images of hardworking communities bound by values of family unity, class solidarity, and religious faith. The materialism and individualism of dominant U.S. society were confronted by projections of religious spirituality and social justice.

In contrast to the situation of their Zapotec counterparts who resisted the homogenizing symbols of Mexican nationalism and of their Mexico City counterparts who rejected those symbols as the signs of an authoritarian regime, many Chicano movement artists appropriated elements of the Mexican School of art as a means of asserting a distinct ethnic identity—and one with claims to a cultural heritage older and arguably richer than those of Anglo-America. Judithe Hernández (1998) expressed her belief that the Mexican muralist tradition "helped to put us on the map. . . . We opened the door by means of reminding people that Latinos and Mexicanos in particular have been the foremost practitioners of the mural art in the twentieth century." The explicitly political tradition of the Mexican School also allowed Chicano artists to challenge the commercial orientation of the mainstream art world in the United States.

Not all Chicano artists readily embraced formal elements of the Mexican School. Many were also exposed to the latest trends of pop and conceptual art, expressionism, California "cool," minimalism, collage, assemblage, installation art, found art, graffiti art, kitsch, and performance art—many of which were being taken up by countercultural artists from other communities (e.g., feminists, environmentalists, and antiwar activists). No one school of art attained

such hegemonic influence in the United States as did the Mexican School of art south of the border (although North American abstract expressionism was a dominating force in the art world of the 1940s and 1950s), and Chicano artists did not have precursors with the status of Oaxaca's Tamayo and Toledo. Another factor explaining the great diversity of formal elements in Chicano art is the movement's own heterogeneity relative to its Mexican counterparts. The Chicano movement was really a loose network of many movements, including students, farmworkers, labor organizers, cultural workers, community activists, prisoners' right advocates, antiwar activists, and lesbian feminists. Throughout the book, I will highlight the importance of these local phenomena in accounting for the distinct representations and meanings produced by artists from social movement constellations that otherwise share many common cultural and generational experiences.

Mexico's logo for the Summer Olympics of 1968, a clean contemporary design, appears underneath the words, "¡LIBERTAD DE EXPRESIÓN!," and Adolfo Mexiac's social realist engraving from an earlier era: the face of a man whose mouth has been chained and padlocked (figure 1). On another black-and-white poster from 1968, an anonymous student from La Esmeralda Art Academy silk-screened a screaming cubist head pierced by a rifle's bayonet; the text asks, "Why? Repression of the desire for democracy" (Aquino and Perezvega 2004, 35).

In the Oaxacan graphic artist Fernando Olivera's engraving, *Resiste, voz libre del pueblo* (Resist, free voice of the people), Zapotec market vendors and *campesinos* crowd together in the plaza of Juchitán, a rebellious town under siege at the time by the Mexican army. The word "Resiste" has been painted on the church wall (figure 2). A large cloth banner designed by Rini Templeton for the Coalición Obrera-Campesina-Estudiantil del Istmo's (COCEI; Worker-Peasant-Student Coalition of the Isthmus) municipal electoral campaign of 1980 proclaims, "Long Live Free Juchitán"; the words are framed by images of an open book, a wheel, a raised fist, a sprouting plant, and the white flower for which the town was named. The only color on the banner is the solitary red star of the COCEI's logo.[1]

A woman artist with long black hair re-chisels the Statue of Liberty into a Mayan-like totem in Ester Hernández's etching from 1975, *Libertad* (figure 3). After Hernández's

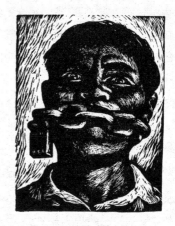

¡LIBERTAD
DE EXPRESION!

MEXICO 68

1 Adolfo Mexiac, *¡Libertad de expresión!*,
 1968. Engraving/poster. Reprinted from
 Grupo Mira (1988).

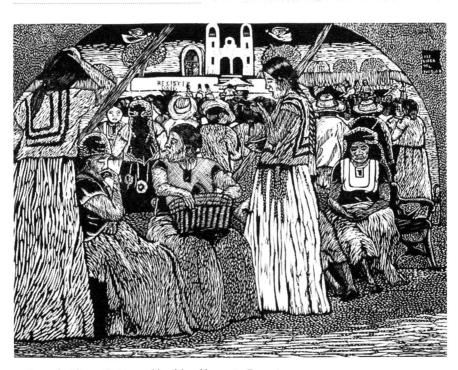

2 Fernando Olivera, *Resiste, voz libre del pueblo*, c. 1989. Engraving.

3 Ester Hernández, *Libertad*, 1975.
Etching.

makeover, the Latina Liberty stood proudly on a base carved to read "Aztlán," just in time for the United States' bicentennial celebrations in 1976. The Chicano artist Rupert García's poster *Right On!* from 1968 offers an early version of the now ubiquitous pop image of Latin American revolutionary Ché Guevara.[2]

These are signs from an era that Immanuel Wallerstein (1989) described as the "world revolution of 1968," as discussed in chapter 1. Around the globe, radical demands for deeper processes of democratization, unbridled freedoms, local autonomy, and community empowerment arose from a generation's disillusionment with the failures of past movements (nationalist, communist, and liberal democratic alike), as well as from its generalized opposition to U.S. imperialism. Evelina Dagnino (1998) has argued that social movements, beginning in the 1970s, helped to formulate a new, broader notion of citizenship evident in much of Latin America by the 1990s. The new citizenship, in Dagnino's analysis, "expresses not only a *political strategy* but also a *cultural politics*" (50): "The new citizenship is a *project of a new sociability*: not only an incorporation into the political system in a strict sense, but a more egalitarian

format for social relations at all levels, including new rules for living together in society (for the negotiation of conflicts, a new sense of a public order and public responsibility, a new social contract, and so on)" (52). Similarly, George Mariscal (2005, 7) describes the Chicano movement as having posed "a serious challenge to all previous models of citizenship, assimilation, and the role of racialized minorities in the United States."

In the Mexican and Chicano social movements that formed part of the revolution of 1968, artists played an important role in creating a language and infrastructure through which the demands for a more meaningful form of citizenship could be expressed, felt, and enacted. For Rupert García (1996), the significance of 1968, "not only in Paris in May and in Mexico, but also at San Francisco State," where he was studying during the famous student strike, is symbolized by the death that same year of the civil rights leader Martin Luther King Jr. and the surrealist artist Marcel Duchamp. Duchamp, in García's words, "upset the perceived notions of what art is supposed to be, what it's supposed to look like, and the procedure for making something called art." The assassination of King and the passing of Duchamp, recalled García, "resonated for me in terms of the challenge that King represented — the social-economic-racial dimension of protest, which, of course, Duchamp was also protesting — more of a cultural protest having with it moments of political ideology."

The visual discourses created in the final decades of the twentieth century by movement-associated artists like García, Hernández, Mexiac, Templeton, and Olivera remain vital today, alive in democratic civic movements throughout Mexico, in the demands for indigenous community autonomy given new force by the Zapatistas in southern Mexico, and in the "we are America" assertions of millions of Latino immigrants *en el norte*.

Each of the three case studies — the Mexico City–based student and grupos movements, the Oaxacan Zapotec movement, and California's Chicano movement — were part of the global wave of social struggles associated with 1968, yet each emerged and evolved within distinct national and local contexts, as described in the previous chapter. As a result, artists from each locale, even when approaching common themes, often signified citizenship in ways that were especially meaningful to their local publics.[3] This chapter describes the commonalities and significant differences that appeared in each movement's artwork when addressing the following key elements of citizenship: the meaning of national and patriotic symbols, civil liberties and democratic rights and processes, and anti-imperialism and international solidarity.

Over the course of roughly 150 years between Mexican independence and the emergence of new social movements in the 1960s, a distinctive iconography came to symbolize the supposed unity and coherence of the modern Mexican nation-state and its history. That iconography included, in part, the eagle devouring a snake while perched upon a nopal cactus (symbol of the founding of Tenochtitlán, now Mexico City, by the Mexica, or Aztecs, which appears on the nation's flag); the Virgin of Guadalupe (Mexico's patron saint and symbol of the nation's syncretistic culture); and the heroes of nineteenth-century anticolonial, anti-imperialist wars (first against Spain, then the United States, and then France) and of the early twentieth-century revolution. Chicanos in the United States—or occupied Aztlán as many activists imagined it—were compelled to engage Mexico's nationalist iconography as well as the powerful symbols of the United States' hegemonic national narrative, such as the stars and stripes and Lady Liberty welcoming the immigrant masses to freedom's shores.

The distinct historical experiences of each of the movement constellations examined here mediated their relationship to the dominant national iconography, and movement-associated artists deployed these symbols in ways that conveyed very different meanings. Artists' sometimes starkly different treatment of such symbols illustrates Homi Bhabha's (1990, 2) observations about the often contradictory feelings provoked by the narratives of nation and national citizenship: "the *heimlich* pleasures of the hearth, the *unheimlich* terror of the space or race of the Other; the comfort of social belonging, the hidden injuries of class; the customs of taste, the powers of political affiliation; the sense of social order, the sensibility of sexuality; the blindness of bureaucracy, the strait insight of institutions; the quality of justice, the common sense of injustice; the *langue* of the law and the *parole* of the people."

Artists associated with the Mexico City–based student and grupos movements only rarely evoked national heroes, with the exception of a few reverential images of the nineteenth-century liberal republican hero President Benito Juárez and the revolutionary Indian peasant leader Emiliano Zapata.[4] The dearth of iconography associated with the revolution, a pivotal moment in Mexico's dominant national narrative, is striking. But in the 1960s, for many of the capital city's largely middle-class, university-educated but politically disenfranchised young artists, most national symbols signified the hegemony of Mexico's authoritarian, single-party state, which, of course, emerged from

AQUI
NOMAS
MI
CHICHARRON
TRUENA
≡GDO

4 Anonymous La Esmeralda Art Academy
 student, *Untitled*, 1968. Engraving / poster.
 Reprinted from Grupo Mira (1988).

the revolution and claimed to embody its promises. This reaction is familiar to many North Americans of the generation that became thoroughly alienated from U.S. patriotic symbols such as the stars and stripes, which came to signify a brutal imperial power during the Vietnam War. In Mexico, "in 1968, there was a sense, a feeling of the breaking of the nation," explained the former student movement artist Arnulfo Aquino (2001); "the movement was anti-authoritarian and it broke with both the nation-state and the Church."

In a move quite startling for its boldness at the time, student movement artists frequently used the iconic eagle and snake as symbols of repression. Take, for example, the menacing image engraved on a movement poster in 1968 by an anonymous artist from La Esmeralda Art Academy: then President Gustavo Díaz Ordaz appears as a bayonet-winged eagle hovering over a snake that seems to speak the president's words: "AQUI NO MAS MI CHICHA-RRON TRUENA" (an idiomatic expression meaning, roughly, "my voice is the only one heard here") (figure 4). In another poster from '68, this one a collaboration between the master engraver Adolfo Mexiac and the student activist Jorge Perezvega, a cigar-smoking eagle, "made in Mexico," forms a shield supported by a police baton and a bayonet (Aquino and Perezvega 2004, 27). In an uncommon exception to using the eagle to signify the government's re-

pressive, authoritarian power, one movement banner displayed two bloodied, shield-bearing eagles pierced by a bayonet (Aquino and Perezvega 2004, 46). Here the eagles retain their common significance as symbols of the nation, but in this case a nation victimized by the regime's brutal and illegitimate power.

Such images were seen repeatedly by hundreds of thousands of Mexicans between July and October of that year. They were carried on protest marches, pasted on the sides of buses, draped from public buildings, and circulated on flyers in market places throughout the capital. They worked to unmask the hegemonic regime by unfixing the meanings attributed to these symbols by the regime's political and cultural agents. Symbols that once served to fuse the interests of the nation and the Partido de la Revolución Institucional (PRI)-controlled state and to represent the regime as benevolent patriarchs of the national "family" were now re-presented by movement artists as signs of unbridled, illegitimate power run amok. Mexican citizenship had long been performed according to a script of humble, obedient clients or children protected and provided for by a benevolent, corporatist state party and its president, patron, or father. As resignified by movement artists, meaningful citizenship demanded that people expose and challenge authoritarian rule, which required, in part, a demystification of the symbols of the state's power and authority.

Demystification entails the critical deconstruction and resignification of myths, "understood as a body of ideas and practices, which by actively promoting the values and interests of the dominant groups in society, defend the prevailing structures of power" (Storey 2001, 65). Roland Barthes attributes the power of myths in part to their ability to hide complexity and dialectics by establishing "a blissful clarity: things appear to mean something by themselves" (Barthes quoted in O'Malley 1986, 5n5). Following Barthes, Ilene O'Malley (1986, 113–14) has carefully documented the process by which the myth of the Mexican Revolution was constructed through language, symbols, and rituals sharing common traits: "the claim that the government was revolutionary; the promotion of nationalism; the obfuscation of history; the denigration of politics; Christian imagery and Catholic values; and patriarchal values and the 'masculinization' of the heroes' images."

Artists active in the new social movements that emerged in the 1960s worked to disturb the "blissful clarity" of such myths, including those associated with the Virgin of Guadalupe, a complex religious icon that managed to retain its power as a national symbol even in a self-proclaimed secular republic. The largely university-educated, urban, middle-class artists who made

up the grupos in Mexico City were more removed from the cultural contexts that made the virgin so alluring to millions of rural, indigenous, and working-class Mexicans and Chicanos. The strong Marxist influence in the grupos movement's early years and then feminist influence in later years encouraged a reading of the Virgin of Guadalupe as a sign of oppression: Marx's religion as opiate of the masses combined with feminist critiques of the virgin as symbol of gender inequality and sexual repression.

For example, an installation by Grupo Suma, described by Liquois (1985a, 29) as evoking a religious *retablo*, includes a large, traditional image of Guadalupe. But unlike the virgin depicted in popular retablos who intervenes to protect the petitioner from harm, this Guadalupe looks away from a life-sized sculpture of a campesino who has been hanged in an act of repression. Below the hanging campesino sits the crumpled *calavera* (skeleton) of another campesino, referencing engraver José Guadalupe Posada's famous use of calaveras in his political and social satires from the early twentieth century. Behind these principal figures, a background collage contains press clippings about police repression, popular culture, and elites from the social pages.

A collage-mural by grupo Taller de Arte e Ideología (TAI) similarly incorporates the virgin into images of gorillas — symbols of the government's brutal violence — and news clips about poverty and government corruption (Liquois 1985a). Alberto Híjar, the leading figure in TAI, explained that the Virgin of Guadalupe was one of the elements used in the installation to signify "the problems of tradition, especially important in a country like Mexico with its particular indigenous problem and prehispanic past." Híjar continued, noting that "the Guadalupana religiosity reveals itself to be supported by concrete subjects, workers and campesinos" (Híjar quoted in García Márquez et al. 1977, no page number).

In an installation piece by the Mexican collective Peyote y la Compañía, traditional images of the Virgin of Guadalupe's face surround the naked lower torso of a male mannequin, which appears to be crawling on its knees like a pilgrim visiting the virgin's shrine (figure 5). The contradiction between public male reverence of the virgin and private male disrespect of real-life women is suggested by a line from an Efraín Huerta poem that has been painted across the back and buttocks of the headless, naked body: "he does not even have respect for the woman he loves so sweetly." Mexican feminist artists of the era in particular tended to view Catholicism's pantheon of virgins as symbols of gender and sexual oppression, as evidenced in an exhibition curated by Mónica Meyer in the early 1980s titled *Silences, Virgins, and Other Feminist*

5 Peyote y la Compañía, *Artespectáculo*:
Tragodia segunda (detail), 1979.

Themes. Images of the Virgin Mary appeared alongside swastikas, phalluses, masturbating women, and the word "rape" (Barbosa 2001, 2). Such images suggested that meaningful citizenship required freeing oneself from notions that the injustices, exploitation, and inequalities of daily life in Mexico were either the result of God's will or could be alleviated by appeals to the nation's patron saint.

In work by artists associated with the COCEI and broader Zapotec cultural movements in Oaxaca, where regional memory trumped national narratives, nationalist iconography referencing the Aztec past or the Virgin of Guadalupe rarely appeared. Given the importance of the movement's campesino base, heroic references to the revolutionary peasant leader Zapata occasion-

ally punctuated Oaxacan movement art of the era and served to link contemporary struggles with the unfulfilled promises of the revolution. One such example is a COCEI poster announcing a national meeting of independent peasant organizations to be held in Juchitán in 1981. At the top of the poster is an image of Zapata offering a rifle to the three campesinos that fill the center of the space (Santiago Jiménez collection).[5] Use of the armed revolutionary's image suggests the movement's then still somewhat ambivalent attitude toward the electoral campaigns that soon came to dominate the COCEI's (and the rest of the Mexican Left's) political strategy in the 1980s — an understandable ambivalence given the regime's fierce repression of the movement. Effective citizenship was represented as something of a dangerous high-wire act, requiring both the refined skills needed to compete in an electoral game still quite new following Mexico's tentative political reforms in the late 1970s and preparedness for possible armed defense if the new game went haywire.

However, with the exception of a few references to Zapata, national iconography associated with the revolution was not commonly deployed by Zapotec movement artists. In an analysis of the COCEI's "web of mythic and utopian imagery," Laurent Aubague (1985, 56) noted an almost complete absence of references to the revolution despite the centrality of that event for the nation's mythology, a finding he attributes to the somewhat unique weight of a local version of history in Oaxaca's Isthmus of Tehuantepec. A central component of the movement's effort to give new meaning to citizenship was its decentering of national history, replacing the dominant national narrative of continuity from Aztec glory though the triumph of the revolution with an Isthmus-centered emphasis on "the continuity of Zapotec resistance to Aztec, Spanish and French invaders, gringo outsiders, and representatives of the Mexican State" (Campbell et al. 1993, 3). Isthmus Zapotecs even emphasize their regional grievances against Zapotecs based in the Valley of Oaxaca. Mainstream history text books focus on the Zapotecs only from the perspective of how they came to be dominated by other powers (Gutiérrez 1999, 85). This perspective is challenged in movement-associated artworks that emphasize Zapotec resistance, such as Sabino López's colorful, expressionist paintings on woven paper: *Camino a Guiengola*, which López (2006) says refers to a stonc hill that served as a fortress for the Zapotecs in their defense against the Aztecs, and *Cosijopi* (figure 6), the name of the last Zapotec emperor (López collection). Another example is a black-and-white woodblock print by Delfino Cerqueda that depicts a "modern" mestizo dressed in suit and tie on the left

6 Sabino López, *Cosijopi*, c. 1994. Ink on woven paper.

and a stylized, typically *indigenista* image of an Indian dancer on the right. In the foreground appears the raised fist of an anonymous observer, middle finger pointing up in defiance of both images (Cerqueda collection).

Tellingly, one of the only figures from the revolution represented visually in the movement's richly illustrated cultural journal, *Guchachi' Reza*, is José (Ché) F. Gómez, whose portrait by Rogelio Naranjo appears on the cover of the journal's September 1983 issue. Ché Gómez led a revolt of Juchitecos in 1911, "the second largest regional insurrection (after *zapatismo*) in Mexico at the time" (Campbell et al. 1993, 7). Francisco Toledo (2006) contends that the COCEI's struggle really began in the early 1970s with an exhibition about Ché Gómez (Toledo's great, great uncle) in Juchitán's Casa de la Cultura, an effort to rediscover and retell the local hero's story.

A remarkably sophisticated example of a Zapotec movement artist's contribution to such resignifying of national history and citizenship is Toledo's forty-eight-piece series about Benito Juárez, an overwhelming historical presence in Mexican history. As president of Mexico in the mid-nineteenth century, Juárez gained fame for his defense of national sovereignty, his commitment to republican ideals, and for passing a series of liberal reform laws that weakened the power of the Catholic Church. But his reforms also broke up

7 Francisco Toledo, *Juárez y el petate del muerto*, 1985. Mixed media on paper.

the ancestral, collective landholdings of Indian communities, and, earlier, as governor of Oaxaca, he even used army troops to crush a Zapotec revolt. As a result, in Juchitán, the early center of the COCEI movement, Juárez is viewed through a more ambivalent lens of local communities' contradictory relationship to their most famous native son and fellow Zapotec.

Toledo's series, *Lo que el viento a Juárez* (Toledo 1986), was created over a period of several years in the early 1980s and includes ironic, mixed-media works such as *The Birth of Juárez*, in which Benito emerges from the womb as fully formed icon; *Oaxacan Types*, an old *costumbrista*-like postcard of an Indian couple with Juárez's larger-than-life head pasted on the man's body; *Juárez Ice-Skating in New Orleans*, a sublime, imagined vignette from the hero's days in exile; and, bringing the icon's story full circle from birth to death, *Juárez and the Dead Man's Straw Mat* (*Júarez y el petate del muerto*) (figure 7).

The series has been interpreted as "demystifying . . . Juárez and juxtaposing official history regarding Juárez with a Juchitán-based view" (Campbell et al. 1993, 223). Carlos Monsiváis (quoted in Toledo 1986, no page number) added revealing nuance to this notion: "There is no way to 'demystify' Don Benito, and his fellow Oaxacan Francisco Toledo is not unaware of this. Who could modify such unquestionable, deeply rooted language? And, since the legend

doesn't give way or even change, Toledo approaches it sideways: he animates surroundings, he includes the Idol in fantastic goings-on. If Juárez is *ad perpetuam* the face/mask, the very mien of protocol, he will never tolerate emendation; then what must be submitted to the vivification of art are his landscapes and his daily activities." Toledo (quoted in Moore 2000, 114) described the series as an attempt to take away the "sacredness" surrounding Juárez, an important lesson in critical-thinking citizenship.

> Benito Juárez was once the governor of the state of Oaxaca and like a good governor, he was unjust to the people of Juchitán. Benito Juárez wanted to end the nonconformity of the Juchitecos and there are documents accusing him of burning the town down. Of course, he claimed he hadn't done it, that it was an accident, or that the guerrilla fighters caused the fire. He privatized the salt mines of Juchitán and sold them to a Spaniard named Echeverría. After that, the people had to buy salt instead of being able to collect it freely. The salt mines were the property of the people of Juchitán anyway. Actions like these created very negative feelings about Benito Juárez in Juchitán. . . . [The series] was really a way to play with a sacred image. I showed Benito Juárez ice-skating in New Orleans; he spent time as a political exile there. . . . It was a way of taking away the sacredness. I started doing other things while I was learning about historical events in which Benito Juárez participated and there were actually things I ended up liking or respecting about Juárez. At one point I praised him. I thought of him as someone who finds a lucky stone in a fish's head that gives him good fortune: I reconstructed various scenes of Benito Juárez's life, that were not a mockery—they were not to take revenge for Juchitecos' anger, but to see him as a character with virtues as well as defects.

Since the late 1990s, unproblematized, heroic images of Juárez and Zapata became a common feature of social movement-related art in Mexico City, Oaxaca, and indeed throughout the country. A full analysis of those developments is beyond the scope of this book, so I make only the following brief observations. The resignifying of citizenship by movements from 1968 on, the regime's uncritical embrace of U.S.-led neoliberal economic restructuring in the 1980s and 1990s, the Left opposition's impressive electoral gains (especially after Cuauhtémoc Cárdenas's watershed presidential campaign in 1988), and the appearance of the new Zapatista movement in Chiapas in 1994 all made possible a neonationalist resurgence in which opposition social movements and political parties could more readily claim traditional national sym-

bols as their own.[6] But during much of the twenty years following 1968, movement artists in Mexico City and Oaxaca either used nationalist iconography to signify the regime's authoritarianism, very selectively appropriated figures like Zapata from that iconography, or critically re-presented icons such as Juárez.

Chicano movement artists, by comparison, tended to deploy the full repertory of Mexican nationalist symbols. The Aztec eagle, the Virgin of Guadalupe, Mexico's tricolor flag, and the pantheon of revolutionary heroes were all used by Chicano artists to signify cultural resistance to the options of homogenizing acculturation or continued marginalization. The former Mexican student movement artist Arnulfo Aquino spent time with Chicano muralists, graphic artists, and United Farm Workers (UFW) activists in California in 1970–71, where he was surprised to discover that "Chicanos were recovering all of the [Mexican] national cultural links and symbols while in Mexico we were breaking with all of that" (Aquino 2001).

In contrast to the way Mexican student artists turned the eagle into a symbol of repression, Chicano artists frequently used versions of the UFW's stylized Aztec eagle to represent ethnic pride and militancy. The UFW founder César Chávez recalled the now iconic symbol's origins: "I wanted desperately to get some color into the movement, to give people something they could identify with, like a flag. . . . The Egyptians had found that a red field with a white circle and a black emblem in the center crashed into your eyes like nothing else. I wanted to use the Aztec eagle in the center, as on the Mexican flag" (Chávez quoted in Sorell 1991, 145). Like the UFW flag, Salvador Roberto Torres's painting *Viva La Raza* reveals how a Chicano artist could evoke feelings of pride and progress with the same symbols of the Mexican nation that spelled repression and stagnation for student activists in Mexico:

> The oil on canvas is made visually effective by its use of the strong color scheme of the Mexican flag: red, green, and white. While the painting resembles a flag with its horizontal bands of color, simple central image, and sparse words, it is, however, an emblem on the move, an emblem in the making. The brushwork is broad and hurried with no concern for tightly defined details. The word "Viva" has the character of a message painted quickly on a wall. The words "la Raza" are scratched into black paint in the freehand style seen on public walls in urban barrios. (Keller 2002, 274–75)

Similarly, the Virgin of Guadalupe appears frequently in Chicano movement art, not as the symbol of oppression seen in Mexico City movement art but as another sign of "Raza empowerment" (Gaspar de Alba 1998, 47).

In Eduardo Carrillo's ceramic tile mural from 1979 in Los Angeles, a woman carries a banner of the Virgin of Guadalupe as Father Miguel Hidalgo leads Mexico's independence rebellion against the Spaniards, just as many UFW strikers carried the virgin's image into battle against California agribusiness (Selz 2006, 175). In Ester Hernández's enduring etching from 1977, *La Virgen de Guadalupe Defendiendo los Derechos de los Xicanos*, a fist-clenching Virgin in black-belted karate tunic and pants delivers a fierce blow with her left leg. As in the traditional portraits of the Virgin of Guadalupe, Hernández's virgin is supported by an angel, but this one appears angry and ready for a good fight. Referring to Hernández's piece, the artist Patricia Rodríguez (2010) explained that "Chicanas dealt with the Virgin in a very political way. . . . We wanted to say that we were the Virgin, we were the Chicanas that were going through the struggle just like the Virgin. And therefore the Virgin had rights and she was liberated. . . . She is not oppressed by the Church because she is smart and she's got guts. Those two positions were very difficult for the Mexican artists/ intellectuals to accept."

In addition to the use of the Virgin of Guadalupe as a sign of the movement's assertions of empowered citizenship, the meanings attributed to her by Chicano artists are onion layered. In Alicia Gaspar de Alba's (1998, 47) words, "the Virgin signifies Mexican racial and religious *mestizaje*. While this is a problematic image for contemporary Chicana feminists, during el Movimiento the Virgin iconographed the biological source of Chicano brotherhood (i.e., the Mexican motherland), and also constituted a symbol of indigenist resistance to spiritual colonization, transmuted by the goals of la Causa into a symbol of Chicano/a resistance to assimilation and territorial conquest." The Virgin of Guadalupe's sometimes contradictory role as a signifier of racialized, gendered, and sexual identities will be explored further in chapter 3.

Chicano artists deployed imagery associated with the Mexican Revolution far more commonly than did their Mexico City or Oaxacan counterparts and rarely with the irony of Toledo's series on Juárez. In Chicano art, revolutionary nationalist imagery is more commonly used as a symbol of the movement's militant demands for justice and equality and its self-proclaimed continuity with Mexico's past revolutionary struggles. Emiliano Zapata in particular "became a symbol of revolutionary resistance in the defense of lands and culture for the Chicano movement," as described in a brochure for the *Chicano Art: Resistance and Affirmation* exhibition (Gaspar de Alba 1998, 53). A Zapatista revolutionary joins a pre-Hispanic warrior and a Spanish conquistador alongside barrio residents in Wayne Alaniz Healy's mural from 1974, *Ghosts of the*

Barrio, painted on a wall of the Ramona Garden Housing Project in East Los Angeles (Griswold del Castillo et al. 1991). Rupert García (1996), who says he has resisted producing "little Diego Riveras, little Orozcos, little Siqueiros" and what he calls "vulgar, reactionary cultural nationalism," offered a quasi-Warholian vision of Zapata in his stark silk-screened portrait of 1969.[7] Another classic is Antonio Bernal's mural of 1968 for the Teatro Campesino Cultural Center in Del Rey, California. Here male leaders of the Chicano movement (César Chávez and Reyes López Tijerina) and the black civil rights movement (Martin Luther King Jr. and a figure that could be Malcolm X) stand shoulder-to-shoulder with Zapata, Pancho Villa, Joaquín Murieta, and, as usual, an anonymous *soldadera* (female camp follower or soldier) from the Mexican Revolution (Sorell 1991, 143).

Some Chicano artists attempted to combine nationalist and patriotic symbols of Mexico with those of the United States in efforts to evoke Chicanos' rightful claims as an oppressed minority to the unfulfilled democratic promises of the American dream. An example of this is Ester Hernández's previously referenced etching of 1975 that shows the Statue of Liberty being transformed into an indigenous "Libertad" (figure 3). But there was ambivalence, even strong disagreements, among movement artists about the use of U.S. patriotic symbols as signs of democracy and justice. María Pinedo (2006), who directed La Galería de la Raza's store in San Francisco for many years, recalled that during the Vietnam War era, for her and many other movement activists, the U.S. flag was unambiguously a symbol of imperialism and oppression, one difficult to assimilate as part of the movement's visual language of collective affirmation. Rupert García's *Black Man and Flag* in 1967, for example, turned the stripes of the U.S. flag into prison bars.[8]

Two alternatively titled versions of a graphic created by Malaquías Montoya in 1989 seem to illustrate how Chicano artists have struggled with the possible meanings ascribable to the patriotic iconography of the United States. In both versions the leaves of a maguey plant poke through holes in a U.S. flag while eyes peer through a barbed wire fence (a symbol used often by Montoya and other Chicano artists to reference the U.S.-Mexico border). One version of the graphic is entitled *The Oppressor* (figure 8) and contains the following text, "The oppressor, who oppresses, exploits, and rapes by virtue of their power, cannot find in this power the strength to liberate either the oppressed or themselves. Only power that springs from the weakness of the oppressed will be sufficiently strong to free both." The other version, reproduced on the cover of George Mariscal's (2005) book, *Brown-Eyed Children of the Sun: Les-*

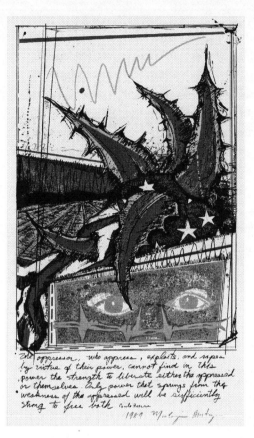

The oppressor, who oppresses, exploits, and rapes by virtue of their power, cannot find in this power the strength to liberate either the oppressed or themselves. Only power that springs from the weakness of the oppressed will be sufficiently strong to free both. Paulo Freire 1989 Malaquías Montoya

8 Malaquías Montoya, *The Oppressor*, 1989. Silkscreen.

sons from the Chicano Movement, 1965–1975, is entitled *Sí Se Puede* (roughly, "yes we can"); the title shifts the emphasis from the oppressor to the power of the oppressed, and Montoya eliminated the accompanying text. Montoya offered the following explanation in Mariscal's book: "These images deal with struggle. I use the maguey plant as a symbol of strength. The plant and its power are the manifestation of the poor represented by the person looking out of the rectangular box" (iv). But how are we to read the meaning of the U.S. flag? Does it simply represent the oppressor, unsuccessful in its efforts to suffocate the poor, symbolized by the maguey and its deep associations with Mexican culture? Or, especially in the *Sí Se Puede* version, might we read the flag as signifying the contradictory nature of the United States as a nation of social inequality, racism, and imperialist aims, yet also a nation of laws and formal liberties that occasionally facilitate the advances of movements for social change?[9]

The world revolution of 1968 frequently met fierce repression. Central to Mexican and Chicano movement art of the era were demands for an end to state violence, for full civil liberties, and for new democratic forms of political participation. Arnulfo Aquino, an artist active in the student movement of 1968 and the grupos movement—and the principal archivist of the student movement's artwork—described the context of brutal government repression in which the movement's key demands emerged. He observed, "These were not academic demands but rather political and social demands: democratic freedoms to create a Mexico that was not only modern but worthy, just, without repression. This is the meaning of the images printed [by artists] and distributed throughout the whole city" (Aquino and Perezvega 2004, 14).

Many activists in all three of the movement constellations examined here were jailed because of their dissent, and calls for the release of political prisoners echo throughout the era's artwork. Demetrio Vallejo, a labor leader imprisoned during the railroad workers' strike in 1959, was still in jail in 1968 and became a *cause célèbre* not only of the students in Mexico City but of militants in Oaxaca as well, helping to expose the common repression faced by students, campesinos, indigenous communities, and labor movement activists. The famed caricaturist Rogelio Naranjo (2001), at the time an unknown artist doing clandestine support work for the student movement, described his delight to find hundreds of copies of his portrait of Vallejo (figure 9), demanding freedom for political prisoners, carried by marchers in one of the students' largest demonstrations. The Juchitán-born artist Delfino Marcial Cerqueda (2006) revealed that the case of Demetrio Vallejo, who was also from a small Isthmus of Tehuantepec town, was one of the key factors in his politicization, eventually leading him to support the COCEI.

Carlos Monsiváis (1984, 5), in a speech defending the COCEI against government repression, noted that not since 1968 had the issue of political prisoners in Mexico been so acute. Jailings, assassinations, and disappearances of COCEI militants, such as Victor "Yodo" Pineda Henetrosa, inspired many of that movement's early posters. Cándida Santiago Jiménez is the widow of Victor Pineda, who was "disappeared" in 1978 during the government's brutal repression of the COCEI. Victor's body was never found. His son still has a T-shirt demanding his father's freedom that he wore as a child: a high-contrast, photographic portrait of Victor silk-screened by the artist Sabino López in

¡LIBERTAD A LOS PRESOS POLITICOS!

9 Rogelio Naranjo, *Libertad a los presos políticos*, 1968. Silkscreen. Reprinted from Grupo Mira (1988).

about 1979. Cándida keeps a collection of the many posters and graphics produced on behalf of her martyred husband (Santiago Jiménez 2006).

Francisco Toledo created a series of graphics in 1978 titled *Libertad a Víctor Yodo*, which he considers his "most directly political" artwork (Abelleyra 2001, 253). In contrast to the stark, simple portraits of political prisoners by Naranjo and Sabino López, Toledo's etchings are filled with disturbing images of a horse playing drums, horses defecating, a pig sporting a policeman's helmet, a man urinating in front of a Mexican flag, limbs of dead human bodies, and the legs of a hanged man (figure 10). The Mexico City–based Grupo Proceso Pentágono also responded to the Victor Pineda case with a collage of images that included women being strip-searched and Lourdes Grobet's photograph of Victor's mother wearing his photo around her neck while on hunger strike in protest of his disappearance (*Guchachi' Reza*, December 1982, inside front cover).

Public awareness of state repression was also heightened by the work of

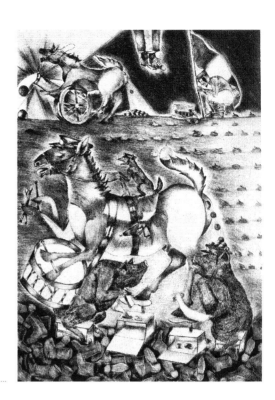

10 Francisco Toledo, *Libertad a Víctor Yodo*, 1978. Engraving.

sympathetic photographers who risked their lives to document government violence. Manuel López Mateos's photos of the army's heavy presence in Juchitán, for example, were incorporated into a poster calling for the army's withdrawal from the isthmus (Santiago Jiménez collection). In Mexico City the famed Mayo brothers and Héctor García provided dramatic photographic documentation of government repression in 1968, which appeared in the few independent periodicals that existed in Mexico at the time, as well as in international publications. According to John Mraz (2009, 179–80), "The violent repression of the 1968 movement was not confined to students, and the Mayos were in the front line. Julio Mayo described how, because the police and soldiers would stop photojournalists in the street and expose the film they carried in their cameras, he began to remove and hide his film in the minute he felt he had made a good image." Héctor García's photographs of 1968, according to Mraz (2009, 187), "were consecrated upon appearing in Elena Poniatowska's famous reconstruction, *La Noche de Tlatelolco*, and Carlos Monsiváis's *Dias de Guardar*." García (Ayala 1998, 10) explained his understanding of photography's significance to the events of 1968:

1968: The students clamor for more Liberty, for more Democracy, for more Justice.

The people support them. The authorities reveal themselves to be severe and paternalistic. There is no solution.

The students are sacrificed. Photography documents everything, fulfilling its mission. "Photography is the irrefutable witness of history," said Balzac. The truth is in the photos.[10]

Chicano movement artists also created works demanding the release of political prisoners, not only those associated with the Chicano movement. Rupert García, for instance, helped put the repression of the Chicano movement in national and international perspective by making posters about Los Siete (seven San Francisco Mission District youths arrested and eventually acquitted on murder charges) (1970), Angela Davis (1971), the "fascism" of Attica (1971), the Folsom Prison Poets (1977), and Nelson Mandela and all South African political prisoners (1981).[11] Malaquías Montoya and Manuel Hernández Trujillo, both of whom participated in the Mexican American Liberation Art Front (MALAF), created several posters demanding the release of the Chicana activist Olga Talamante when she was arrested, tortured, and imprisoned in Argentina from 1974–76 (Talamante collection). Hernández, active at the time in the Southern California chapter of the Olga Talamante Defense Committee, incorporated a line from one of the letters Talamante wrote from prison, urging her family and supporters to "love life enough to struggle." With prison bars in the background, the graphic shows a young woman holding a bird, which is stylized to suggest Huichol Indian art, signifying Talamante's Mexican heritage (figure 11). Captive along with the woman in an Argentine prison, the bird calls to mind the famous migration of swallows who return from Argentina each year to San Juan Capistrano in California—a promise of the Chicana prisoner's return and a reminder of the continental dimensions of the cultural and political forces at play. The Mexico City-based Grupo Proceso Pentágono emphasized the United States' role in repression worldwide. The group's 1977, twenty-five-square-meter installation titled *Pentágono* evoked the atmosphere of a police station after an interrogation, thus referencing the relationship between U.S. domination and Latin American dictatorships (Liquois 1985a).

Such artists not only helped to expose repression and the limits of civil liberties in Mexico and the United States, but they also created images that signified the movements' demands for new forms and processes of democracy.

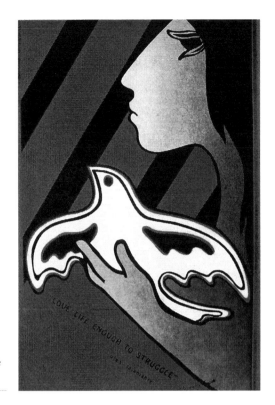

11 Manuel Hernández Trujillo, *Love Life Enough to Struggle*, 1975. Silkscreen.

Here again, 1968 was a watershed moment in the resignification of democracy in Mexico. Many of the student movement graphics called for open, public "dialogue" with the government to resolve the student demands. Democracy, the graphics, banners, and handmade signs insisted, involves dialogue and reason. One popular poster was powerful in its simplicity: an ominous army tank and the words, "this dialogue we do not understand." It can be seen taped on the back of a car in a photograph from 1968 discovered in the *Siempre!* magazine archives. In another *Siempre!* photograph of the student movement, the casual repose of two boys stretched languidly over the hood of a car belies the profound democratic significance of the sign one carries: "We do not fight for victory, we fight for reason."

In the aftermath of 1968, demands for democratic elections and freedom of expression, including freedom of the press, became important subjects for movement-associated artists in Mexico City. The new significance given these themes is evident in the contents of the widely circulated *La Garrapata* (The tick), a political satire magazine founded in 1968 by a group of politi-

cal cartoonists, including Rogelio Naranjo, Helio Flores, Rius (Eduardo del Rio), and "AB" (Emilio Abdala), with the collaboration of other Left intellectuals such as Carlos Monsiváis. The cover of the first issue asked, "do we have a regime of the right [derecha] or of the law [derecho]?" It is illustrated by Posada's early twentieth-century graphic of a man being attacked by dragons representing the seven deadly sins (Berdecio and Applebaum 1972, 58). In La Garrapata's version the dragons have been labeled "police," "granaderos" (a tactical police squad infamous for its brutality), "secret," "army," "rivals," "deputies," and "CIA." The third issue includes a cartoon-essay by Rius, titled "Did They Say Democracy?" It begins with humorous but pointedly simple declarations that democracy is not the tyranny of a minority sustained by state terrorism but a government elected by the majority of the people. The magazine's editors were brave in the boldness of their democratic demands and the ferocity of their critiques of the regime. Naranjo (2001) described how the government sabotaged their efforts through its control over distribution and how Rius was kidnapped and threatened with execution for his outspoken and extremely popular cartoons.[12] As discussed in chapter 3, La Garrapata's radical democratic discourse, like that of the Left generally in those days, was also filled with glaring contradictions, particularly with regard to the magazine's depiction of women and homosexuals.

In the grupos movement, freedom of expression and demands for democratic processes—including the collective creation of art—intertwined with concerns about government censorship, state control of the art world, and the free circulation of art. A key moment in the consolidation of the grupos movement revolved around the Tenth Youth Biennial in Paris in 1977. The sculptor and installation artist Helen Escobedo, who was then director of the Museo Universitario de Ciencias y Arte (MUCA, University Museum of Sciences and Art) at the National Autonomous University of Mexico (UNAM), was charged with coordinating the selection of Mexico's representation at the biennial. She decided to broaden the selection process by including collectively created works, thus allowing the number of participants to grow from four to about thirty artists (Liquois 1985a, 27). Projects by four of the grupos were selected to represent Mexico in Paris: Grupo Proceso Pentágono, Grupo Suma, Grupo Tetraedro, and TAI. Not surprisingly, some in the government and official art world opposed the idea of Mexico being represented by the politically and aesthetically radical artists from the generation of 1968. The ultimately unsuccessful efforts to prevent their participation were documented, with satirical humor, in a publication with a provocative cover that

featured a pistol-wielding thug and the promise of a sinister scandal revealed: "The documented history of a frustrated plot." "Who," the cover text asks, "manipulate the distribution of art? Read this and discover . . . an attempt to put art at the service of the gorillas!" (Grupo Proceso Pentágono 1980).

In Juchitán the Zapotec movement's eventually successful demands for free elections were a bellwether of the national democracy movement that coalesced around the opposition candidate Cuauhtémoc Cárdenas in 1987–88 and that continued to build in 2006 as hundreds of thousands of citizens supporting the Leftist candidate Andres Manuel López Obrador refused to accept the official results of a very close election that gave the presidency to the conservative candidate Felipe Calderón. Similarly, the COCEI's demands for municipal autonomy anticipated by nearly twenty years the neo-Zapatista movement in Chiapas that helped put the issue of indigenous community autonomy on the national agenda. Such demands were represented in movement art, such as Rini Templeton's "Long Live Free Juchitán" banner referenced earlier, and in an anonymous poster of 1979 demanding an "end to impositions," a reference to the PRI's history of imposing its own municipal rulers (Santiago Jiménez collection). In the latter, a high contrast photo of Juchiteco citizens demonstrating in the streets suggests grassroots support for the demands listed in the poster: respect for the people's will, sewers and water, health care, and support for vendors and small merchants. The intense mood of a newly empowered citizenry is palpable in photographs of COCEI marches and rallies by Rafael Doniz, Graciela Iturbide, and Lourdes Grobet, which were seen widely in magazines, newspapers, books, and exhibitions. Grobet's color photographs (figure 12, for example) capture the movement's simultaneous militancy and celebration, as well as its sense of theater and symbolism evident in the color-coordinated red *papel picado* (cut paper) banners, COCEI logos, and indigenous dress of the protesters.

COCEI banners and murals shown in these photographs also highlight the movement's demands for cultural autonomy, including defense of the municipal government's radio station, "the free voice of the people," which included extensive Zapotec-language programming. Movement-associated artists also helped to signify the importance of literacy — in both Spanish and Zapotec — for the full exercise of citizenship. Sabino López's brightly colored silkscreen of 1981, announcing the COCEI's first literacy campaign, drew special attention to the problem of illiteracy among women: a Juchiteca holds an open book while letters fall like rain from the light-filled sky (Santiago Jiménez collection).

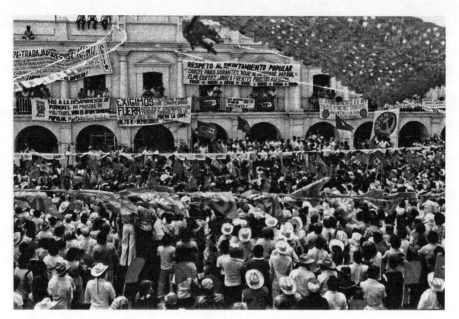

12 Lourdes Grobet, photograph of COCEI rally, Juchitán, c. 1983.

Chicano movement art did not focus much on issues such as free elec-
tions; instead, much of the artwork exposed the limits of formal democracy
in a society marked by extreme racial and class inequality. Anticipating by
thirty years the massive immigrant rights protests in the United States in the
first decade of the twenty-first century, Chicano artists helped to create a new,
still evolving discourse about the democratic and human rights of immigrants
and racial and ethnic minorities. Reminding the public that the United States
is part of the largely Latino American continents, a now classic mural from
1978 proclaimed, "We are NOT a minority!!" Painted in East L.A.'s Estrada
Courts Housing Project by the humorously named Chicano artist collective
CACA (Congreso de Artistas Chicanos en Aztlán), the mural features a por-
trait of Che Guevara pointing his finger in a gesture reminiscent of the "Uncle
Sam Wants You" army recruitment posters (Griswold del Castillo et al. 1991).
Yolanda López created a poster in 1978 for the Committee on Chicano Rights
in San Diego. It features an angry man, coded as indigenous by his headdress,
crumpling President Jimmy Carter's "immigration plans" in his fist. His other
hand points directly to the viewer, seeming to extend beyond the poster's
frame, as he demands to know, "Who's the Illegal Alien, Pilgrim?" "Quite lit-
erally, the image in the poster points to the world outside its own borders and

accuses a specific audience with the intention of provoking social change" (Davalos 2008, 53). In Malaquías Montoya's silkscreen of 1981, *Undocumented*, bloodied clothes are caught in the barbed wire symbolic of the U.S.-Mexico border,[13] and barbed wire is the only image in Rupert García's stark silkscreen of 1973 that demands "¡CESEN DEPORTACION!" (stop deportation!). In 1969 García linked the racism experienced by Chicanos to that faced by African Americans in a silk-screened image from an Uncle Ben's rice advertisement, demanding "NO MORE O' THIS SHIT."[14]

Artists like Andrew Zermeño and Carlos Almaraz helped expose the exploitation of Chicano and Mexican workers by agribusiness, labor contractors, and smugglers from their own community. Zermeño did this with wicked humor in dozens of cartoons published in the UFW newspaper *El Malcriado* and reproduced on posters, as in his drawing of the worker Don Sataco pulling the fat boss (*patroncito*) in a cart while the labor contractor Don Coyote cracks the whip (Goldman and Ybarra-Frausto 1991, 85). Almaraz painted a mural banner for the UFW's constitutional convention in 1973. As described by Victor Sorell (1991, 146), "The composition contained textual references to strike action, while depicting the organization's newspaper, Teamster goons and growers playing in counterpoint to a diminutive Guadalupana placard, and a host of stylized huelga eagles, pulsating with the kind of luminescence given off by neon signs."

The world revolution of 1968 also included an awakening environmental consciousness and a critique of modernity that was articulated by movement artists as part of the evolving language of citizenship and democracy. Meaningful citizenship now included the right to protection from toxic pollutants and the responsibility to be good caretakers of the planet. In Mexico City and Oaxaca artwork attempted to challenge received notions about progress and modernization, lynchpins of the postrevolutionary regime's claims to legitimacy. A banner from 1978 by Grupo Germinal exposed the environmental destruction—polluted water, dead fish—caused by PEMEX, the national petroleum company, suggested it was selling out to U.S. interests, and encouraged people not to be fooled by talk of "progress." Shifra Goldman (1994a, 127–28) provided a vivid description of the banner:

> The name PEMEX is made of stripes which gradually changed to red, white, and blue letters, colors of the United States flag. Two seated figures below represent the U.S. and Mexico: one sports a dollar sign, and the other says "yes, yes, yes" to the deal. On the left a fisherman surveys a body of water

above which rises billowing smoke, and says, "The water is no longer any good; the fish have all died." On the other side an oil worker says to his companion, "Hey man, don't you think they're making fools of us with all this progress?"

An issue of *Guchachi' Reza* (no. 53, July–August 1996), the COCEI-associated journal, featured a lead article about indigenous communities struggling with the tensions between modernity and tradition. The article was illustrated by Verónica Gómez's ominous black-and-white drawings, paintings, and engravings of towering power lines and smoke stacks. In Gómez's engraving titled *Luz, Proyectas Muerte* (Light [or electricity], you project death), electrical towers appear to cast guillotine-like shadows.

Chicano artists highlighted the environmental dangers facing farm workers. Ester Hernández's iconic *Sun Mad* of 1981 features the raisin industry's famous "Sun Maid" turned into a calavera by the deadly chemicals used by modern agribusiness. She was inspired to create the piece after driving past a Sun Maid billboard on her way to visit family in her hometown, where the water supply had become dangerously contaminated by agribusiness pesticides (Hernández 2006). According to Hernández, the piece was so controversial in California's Central Valley, where agribusiness dominates the economy and politics, that it was removed from an exhibition. A silkscreen by Rupert García from 1969 evokes the dangers of crop-dusting by giving us an aerial view of a woman screaming as giant red letters—DDT—threaten overhead.[15] The new citizenship envisioned by these artists included the right to live and work in a clean, healthy, and aesthetically pleasing environment.

ANTI-IMPERIALISM AND INTERNATIONAL SOLIDARITY

Intense waves of revolution and counterrevolution in Latin America, Africa, Asia, and the Middle East rolled across the globe throughout the 1960s, '70s, and '80s. The dominant discourse of core Western states frequently presented these phenomena as part of an epic struggle between two opposing visions of citizenship: the capitalist West's promise of freedom and democracy versus the communist East's nightmare of enslavement and dictatorship. Activist artists involved in Mexican and Chicano movements of the era countered this Cold War interpretation with a North-South vision of international solidarity among oppressed citizens of the Third World against U.S. imperialism, capitalism, and fascism.

Che Guevara was the revolutionary icon of choice for the student movement of 1968, his popularity undoubtedly enhanced by his perceived martyrdom while trying to launch a revolution in Bolivia the previous year. Occasionally Che's image was used specifically to express solidarity with Cuba—and implicitly opposition to U.S. intervention—as in a Mexican Communist Youth flyer calling on students to join a march and rally in support of the Cuban Revolution on July 26, a historic date in the revolution's history (Grupo Mira 1988, 28). But more often Guevara's image in student movement art seemed to signify solidarity with an imagined continental, even universal, demand for human dignity and an end to capitalist exploitation and oppression. In one such example, a high-contrast sketch of the revolutionary carrying a gun appears over a Guevara quote about being tired of having to sell one's labor each day for miserable wages (Grupo Mira 1988, 109). Similar to the Chicano group CACA's use of Che's image to proclaim "We Are Not a Minority!," in one Mexican student movement poster Che's portrait is punctuated by the simple declaration, "This humanity has said, enough!!" (Aquino and Perezvega 2004, 159). One of the more creative renderings of Che Guevara from the student movement appears to have been executed with a computer and printed on continuous-feed computer paper, suggesting that this is an icon for the future, not one associated with some bygone era like the Mexican Revolution (Grupo Mira 1988, 112).

The student movement art of 1968 revealed relatively little concern with U.S. involvement in the region. In one exceptional instance the letters "CIA" appeared alongside a sinister stars-and-stripes eagle among the teaming collage of movement-related images painted by artists on the corrugated tin walls that had been erected around a vandalized statue of the conservative former Mexican president Miguel Alemán at the UNAM (Aquino and Perezvega 2004, 132–53).[16] However, in the years following 1968, revolutionary movements and U.S.-supported military dictatorships contested for power throughout much of Latin America, thus heightening awareness about the role of the United States in sponsoring state violence. As Mexico City became the home to increasing numbers of revolutionaries exiled from Central and South America, their experiences provided one of the dominant themes in the artwork of the grupos movement (Liquois 1985a, 14). Grupo Proceso Pentágono's recreation of an interrogation cell is one such example. Photographer Lourdes Grobet (2006), a member of Grupo Proceso Pentágono, recalled that the group engaged in many different kinds of activities supporting the Cuban and Nicaraguan Revolutions. Grupo Suma participated in exhibitions in support of the

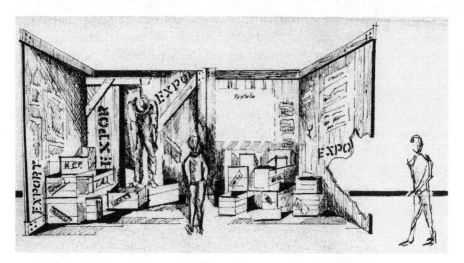

13 Taller de Arte e Ideología, *Export-Import*, 1977. Rendering for installation.

Nicaraguan Revolution in 1978 and 1979 (Grupo Suma n.d.). TAI produced collective works in support of struggles in Central America and Vietnam (Liquois 1985a, 19). Members of TAI and Grupo Germinal traveled to Nicaragua to join activist brigades supporting cultural campaigns promoted by the Sandinista Revolution (Debroise 2006a, 222). Grupos also created work exposing what they viewed as the dangers of fascism in Latin America, as represented by the wave of right-wing military dictatorships. In 1976 TAI created a poster for two events focusing on fascism, culture, and the workers' struggle in Latin America; the stark simple design suggests rifles as prison bars and bayonets piercing the name "América" (Liquois 1985a). In 1977 Grupo Suma participated in the exhibition *Against Fascism in Latin America* at MUCA (Grupo Suma n.d.).

In its sophisticated *Export-Import* installation for the Paris Biennial of 1977, TAI combined a diverse array of objects that the group understood as "signifiers of colonialism." An artist's rendering of the installation's design is shown in figure 13. According to TAI founder Alberto Híjar (García Márquez et al 1977, no page), the artists' intention was to suggest for audiences—including the other artists participating in the biennial—the complex relationships among artistic production, the exploitation of Latin America's people and resources through its unequal exchange with the United States and Europe, poverty, quotidian realities, cultural phenomena such as religion and sports, and Latin America's "repressed liberating possibilities." Many issues of *La Garrapata*

also expressed solidarity for revolutions in Cuba and Central America and opposition to dictatorships and U.S. intervention in the region.

For a variety of reasons, particularly in the early stage of the movement, some Chicano activists distanced themselves from revolutionary struggles in Latin America and from open critiques of U.S. foreign policy. I recall heated debates among Chicano students, faculty, and staff at the University of California, Santa Cruz, in the late 1960s and early 1970s about the proper stance for the movement to take regarding Marxist guerrilla movements and the Cuban Revolution. Some older Chicanos had lived through the repressive anticommunism of the McCarthy years and reasonably feared association with radical causes. Some were justly proud of their or their parents' service in the U.S. armed forces during World War II and the Korean War and grateful for the educational or housing opportunities afforded by the GI Bill and an expanding economy. Most were products of a public education system less inclined to foster critical thinking than to reproduce hegemonic myths about the American dream. The artist Gilbert "Magu" Lujan (1997), a central figure in the L.A.-based art collectives Con Safos and Los Four who was able to attend college because of the GI Bill, described how he experienced some of the contradictory realities of California's post–World War II, pre–civil rights era, before he became politicized: "We were, in this country, flexing our new victory with the atomic bomb and the conquering of the Axis. . . . And a Mexican had a role to play in this society, and I fell into place like every other Mexican. And when gringos came around I had to keep quiet, back up, and be conservative while they took over and controlled and were in charge and had the greatest social stature or status, just by being white."

However, as the Chicano movement grew and was radicalized by the experience of Vietnam and awareness of U.S. intervention and revolutionary struggles in Latin America, many movement artists worked to foster a critical consciousness among Chicanos as international citizens. After 1975, observed Goldman and Ybarra-Frausto (1991, 83), there was a "changing perception of the Chicano role in the United States and in the international arena, a perception that brought an end to separatism for most Chicanos and a closer alignment with the Third World, especially Latin American, struggles." The artists Malaquías Montoya and Lezlie Salkowitz-Montoya (1980, 5–6) wrote about this aspect of Chicano movement art:

> The plastic arts, theatre, poetry and dance have helped propel the struggle and have brought the Chicano Movement into international focus. They

have created unification specifically with Latin America and other nations of the Third World. Through increased understanding of domestic issues, Chicanos have been able to empathize with the people of Vietnam, Angola, Nicaragua, South Africa and other countries. Artwork, especially the poster, began to serve as a bridge between those struggles. Chicano people who viewed these visual expressions began to recognize that within this perspective Chicanos were not an isolated culture that had failed within this imperialist society, but one in unity with others, who, in varying degrees, were also oppressed. The Movement came to mean the struggle of all Third World and oppressed people.

The Chicana muralist Juana Alicia (2000) expressed a similar view: "I think that during the late seventies and into the early eighties we became much more of an international people. We understood that the anti-apartheid movement, . . . the liberation movement in Angola, the non-aligned nations, the struggles of Cuba and Nicaragua and El Salvador—all of these were very central, coming out of the anti-Vietnam war movement, very central to our survival as a people." Juana Alicia, like other Chicano artists, put these sentiments into practice: a mural in Managua, Nicaragua, painted in solidarity with the Sandinista Revolution, is among her many collaborative projects (Juana Alicia 2006).

"One continent, one culture," proclaimed a poster for a Chicano theater festival's "First Latin American Encounter," held in Mexico City in the early 1970s. A map of the Americas is decorated with the Aztec's plumed serpent and footprints traveling north and south (Aquino collection). A similar sense of continental unity and solidarity was captured in the Mujeres Muralistas' mural from 1974, *Panamérica* (originally titled *Latinoamérica*) (figure 14). Imagery from Bolivia, Venezuela, Mexico, and other Latin American nations surround a multiracial group of contemporary San Francisco Mission District residents. Devils appear as one of colonial European Christianity's contributions to indigenous América (Rodríguez 2011).

Other expressions of the Chicano movement's sense of solidarity and antiimperialism include many silkscreens by Rupert García. He created a vibrant red and blue poster announcing a Galería de la Raza exhibition about Chilean and Brazilian murals (1971), and a solemn black and white poster commemorating the death of Chilean President Salvador Allende (1973), who was overthrown by a U.S.-backed military coup in 1973. A poster from 1987 by Malaquías Montoya uses delicate colors not typical of his work to evoke "A Free

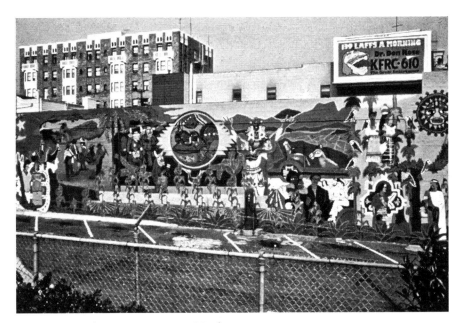

14 Mujeres Muralistas, *Panamérica*, 1974. Mural.

Palestine," emerging like flowering vines from the barbed wire. Both García and Montoya created powerful posters about the Vietnam War. In García's silkscreen produced for the Chicano Moratorium against the Vietnam War in Los Angeles in 1970 (Sorell 1991, 147), a brown face against a black background screams the bright yellow words, "¡Fuera de Indochina!" (Out of Indochina!), and in his version from 1972, the same face rises behind dinosaur-like soldiers and screams in English, "U.S. Out Now."[17] Montoya's classic silkscreen of 1972, *Vietnam Aztlán*, uses the space, images, and text (in Vietnamese and Spanish) to emphasize the parallels between the colonial experiences of the Vietnamese and Chicanos (figure 15). A Vietnamese man and a Chicano stand back-to-back, the text is separated by different colored arms bumping fists, and the word "Fuera" anchors the piece at the base.

Chicano opposition to the war culminated in the massive Chicano Moratorium antiwar march and rally in Los Angeles in August 1970, where police attacked and dispersed protesters with tear gas and killed the *Los Angeles Times* reporter Rubén Salazar (Mariscal 2005, 140; Gaspar de Alba 1998, 149). Those events inspired Willie Herrón and Gronk's *Black and White Mural* (discussed further in chapter 4). Also known as the *Moratorium Mural*, its collage of portraits of police and protesters, screaming faces and bleeding bodies, helped

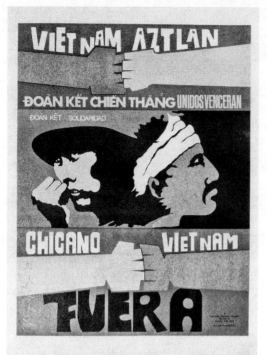

15 Malaquías Montoya, *Vietnam Aztlán*, 1972. Silkscreen.

to assure collective memory of Chicano participation in the antiwar movement when it was painted at the Estrada Courts Housing Project in East Los Angeles between 1973 and 1980. Frank Romero's *The Death of Rubén Salazar* (1985–86), an expressionist canvas, shows riot police firing into the bar where Salazar died, reminding viewers that the repressive apparatus of the U.S. state was unleashed at home as well as abroad (Gaspar de Alba 1998).

Mexican and Chicano movement artists also worked to foster solidarity among their own people, divided by colonialism's legacy of territorial and social borders. In Mexico City, Grupo Suma spray-painted stencils of migrant workers on city walls, with text warning that the United States was tightening its control of the border in an effort to keep out "illegals" (Grupo Suma 1979). A vibrantly colored Malaquías Montoya poster from 1983 imagined a continent of unity, without borders ("sin fronteras"), embodied in a woman farm laborer who gracefully lifts a basket of fruit. In stunning contrast, Montoya's black and white *Abajo la migra* (Down with the border patrol) from 1981 features a meat cleaver wielding Statue of Liberty with a Mexican migrant impaled on her crown.[18]

Zapotec artists spoke in interviews about the importance of solidarity with the Chicano movement and Central America's revolutions, but relatively few examples of artwork reflecting these themes have survived the ravages of isthmus floods, humidity, and the precarious conditions of activist life in Oaxaca in the 1970s and 1980s. At least two Zapotec artists described being inspired by their contacts with the Chicano movement. Carlomagno Pedro Martínez (2006), a ceramic sculptor and printmaker from San Bartolo Coyotepec, Oaxaca, explained that Chicano movement artists in San Francisco and Chicago were a significant influence on his "toma de conciencia" (consciousness raising) about racism and indigenous identity, the latter being the central theme of his art. A few of Carlomagno's engravings incorporate a map of Mexico in ways that suggest a concern with the nation's territorial and cultural vulnerability vis-à-vis the United States. Demetrio Barrita (2006), another Zapotec artist, talked about the six months he spent working with Chicanos and Latino immigrant workers in Seattle on a mural that he described as reflecting their "almost Bolivarian vision of all united as brothers." The workers asked him "to include Arabs, Asians, American Indians, and all the flags of the Americas." However, Barrita recalled, "at the same time I encountered examples of the migrant workers themselves disparaging the indios of Oaxaca, which really offended me."

Barrita also cited the struggles in Central and South America as a major influence on his politicization. He especially remembers the impact of hearing the protest music of artists such as Atahualpa Yupanque and Violeta Parra while he was a university student in the 1970s. Like the Chicana artist Juana Alicia, he worked on murals in Nicaragua during the Sandinista Revolution: "Through Don Sergio Méndez Arceo, then the Bishop of Cuernavaca, I was encouraged to become a *brigadista* in Nicaragua. I spent six months working for the revolution. I would pick coffee during the days, until about 3 p.m., and then spend the afternoons and evenings working on many other things, including creating murals out of whatever material we could find" (Barrita 2006). But while these experiences influenced his development as a political artist, the themes of international solidarity and imperialism were not central to the movement-related artwork he created in Oaxaca. Rather, while working with the popular church in the Isthmus of Tehuantepec in the 1980s, he was creating posters, banners, flyers, and logos requested by indigenous groups related to their local struggles.

Similarly, when the artist Sabino López, a COCEI supporter, and Cándida Santiago, the COCEI organizer and widow of disappeared militant Victor

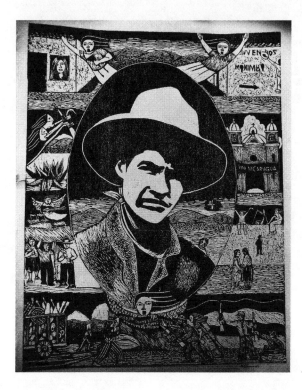

16 Fernando Olivera, *Sandino*,
c. 1989. Engraving. Collection
of the artist.

Pineda, showed me posters from the height of the movement in the late '70s and early '80s, they made several references to solidarity with revolutionary struggles in Central and South America, such as when Santiago attended international meetings with other families of the disappeared. But themes of solidarity with other revolutionary struggles and opposition to U.S. imperialism were not reflected in the posters themselves. Despite the artists' expressed solidarity with Central American revolutionary struggles, Fernando Olivera's engraving of Nicaragua's anti-imperialist hero Sandino (figure 16) is one of the few Oaxacan movement works of art I found that explicitly reference such solidarity.

The cover art from a mimeographed COCEI songbook, *Oaxaca en pie de lucha* (Oaxaca in struggle), illustrates the somewhat curious disconnection between the movement's awareness of other revolutionary struggles—in this case the Cuban Revolution—and the absence of explicitly expressed international solidarity in Zapotec movement-related art. The principal image on the front cover—a photograph of a campesino on horseback carrying a COCEI flag—is strikingly evocative of Raul Corrales's classic photograph from 1960,

Caballería, of a Cuban cavalry.[19] In both photographs a flag punctuated by a single star—red in the COCEI banner and white in the Cuban—unfurls over the head of a horse-mounted "revolutionary." The songbook's back cover uses an adapted version of a widely reproduced Cuban graphic from 1970 by Asela Pérez that depicts the continent of South America as a hand clutching a rifle. Yet the text makes no specific reference to the Cuban Revolution or any movement other than the COCEI, almost as though the songbook's designer is giving a big wink to the COCEI activists who presumably understand the need to avoid explicit statements of solidarity that could provoke anticommunist repression.

Local indigenous identity, local culture, local history, and local demands for the full exercise of autonomous, democratic citizenship remained the core of most Zapotec movement art in the 1970s and 1980s. This in spite of factors that might have suggested a stronger emphasis on the international dimension of citizenship: the movement's strong Marxist and socialist influences, the international stature and experiences of Francisco Toledo, several Zapotec artists' personal experiences with Chicano and Central American movements, and the considerable presence of international scholars who went to the region to study the movement. Factors other than the previously discussed weight of the isthmus' regional version of history likely account for why anti-imperialism and international solidarity were less evident in Zapotec movement art than in the work of artists from the grupos and Chicano movements. Like the student movement of 1968, which also gave less emphasis to international perspectives than did the successor grupos, the COCEI movement faced fierce, constant state repression. And charges of communist subversion were used by the government to justify its actions against both movements. In such circumstances the risks of openly expressing solidarity with revolutionary movements were far greater than during the relatively less repressive conditions confronted by the grupos in Mexico City or by Chicano movement artists in California in the 1970s and 1980s. The latter movements were also much more broadly focused than either the COCEI or the student movement. Artists in the grupos put their talents and energies at the service of a wide variety of struggles—local, national, and international. And the Chicano movement was in many ways a broad front of various smaller movements organized around issues as varied as land rights, labor conditions, bilingual education, community health, racism, police brutality, and cultural resistance. In working with such varied movement constituencies, Chicano and grupos artists were perhaps more inclined to emphasize the connections and solidarity

among movements than were artists working with the more tightly focused COCEI and student movements.

As we have seen, Mexican, Zapotec, and Chicano artists created a new visual language that permitted their publics to envision and perform a new model of citizenship that demystified patriotic national symbols, rejected authoritarianism, protested state violence, called for fully democratic rights and processes, defended local autonomy, and expressed an international solidarity against U.S. imperialism and support of a universal humanity. Yet, as chapter 3 documents, these new visions of citizenship were often compromised by the movements' internal contradictions. Fault lines of class, race, gender, and sexuality threatened the integrity of the projects initiated during the world revolution of 1968.

In Crispín Alcázar's silk-screened poster for Mexico City's student movement of 1968 a shirtless man clasps a rifle in his left hand while his right is held high, clenched into a fist, revealing sculpted pecs and abs (figure 17). In another graphic created by a La Esmeralda Art Academy student, a male silhouette appears fearless as he shakes his fist in the face of a soldier who lunges menacingly with a bayonet. A prisoner's strong masculine hands defiantly grip the bars of his cell in a poster by another anonymous movement artist, and in other graphics from '68 male protagonists literally point the way forward toward freedom and victory over the state's repressive forces.[1] If all identities are constituted within representation, as Stuart Hall ([1990] 2001, 560) asserts, then the identity of the Mexican student movement was masculine and heroic. In the vast majority of the movement graphics compiled by Arnulfo Aquino and Jorge Perezvega (2004), the student protesters and victims are represented as men whose masculinity is fixed as firmly as the eternal gaze of Che Guevara, the students' virile hero of choice.

Despite photographic and testimonial documentation of women's extensive participation in the movement, only about ten of the hundreds of movement graphics preserved by Aquino and Perezvega include images of women. Of those, only three represent women as militant protesters, while four depict mothers grieving the loss of their martyred sons.[2] Identities may be constituted within representation,

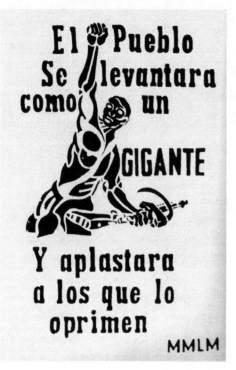

El Pueblo
Se levantara
como un
GIGANTE
Y aplastara
a los que lo
oprimen
MMLM

17 Crispín Alcázar, *Untitled*, 1968.
Engraving / poster. Reprinted from
Grupo Mira (1988).

but representations are constructed within history, and the events of 1968 un-leashed dramatic historical changes, including the emergence of feminist and gay liberation movements. As Jean Franco (1989, xxi) has noted, women, as feminist intellectuals, would increasingly take advantage of the critical space created by 1968 to tell their own side of the story and "to show the articula-tion of patriarchy and nationalism." Indeed, changes in the representations of women and sexuality by social movement-associated art evolved gradu-ally throughout the 1970s, 1980s, and 1990s. Women and gay activist artists in Mexico City who had been politicized by the student movement began to construct new representations of themselves as agents of radical social change that challenged the masculinist iconography of '68. By 1982, for example, an exhibition of feminist art that politicized issues of sexuality and eroticism was included in the Leftist Festival de Oposición organized by the United Socialist Party of Mexico (PSUM), a recently renamed and reconfigured manifestation of the Mexican Communist Party. The exhibition included work by several artists active in the *grupos* movement, among them Rowena Morales, Maris Bustamante, Mónica Mayer, and Magali Lara (Barbosa 2001, 2). That same

18 Maris Bustamante / No Grupo,
 ¡Caliente! ¡Caliente!, 1982.
 Performance.

year, in No Grupo's performance piece *¡Caliente! ¡Caliente!*, Maris Bustamante wore a fake penis on her nose while deconstructing Freud's theory of penis envy (figure 18) — a far cry from the solemn, if homoerotic portraits of student heroes created by Crispín Alcázar and his fellow artists a decade earlier.

This chapter examines how Mexico City, Zapotec, and Chicano movement artists helped to represent and attribute new meaning to collective identities signified in terms of gender, sexuality, race, ethnicity, class, and nationality. I describe how movement artists asserted new collective identities that challenged central elements of the dominant national and ethnic discourses while often reproducing other gendered, heterosexist, racialized, and class-based inequalities.

GENDER, SEXUALITY, AND THE "HEROIC LEFT"

While the student movement of 1968 broke important ground in recasting the meaning of the Mexican state and citizenship, as discussed in chapter 2, its representations of itself and of the protagonists of social change remained

largely trapped in the (hetero)sexist discourse of revolutionary nationalism shared by the authoritarian regime and much of its Left opposition. Cultural histories and culturally focused social science studies have analyzed how particular representations of gender, sexuality, and/or ethnicity came to constitute the central elements of a broadly accepted notion of *mexicanidad* or Mexicanness that were central to the modern regime's hegemony.[3] Ilene O'Malley (1986), for example, documents the ways in which the institutionalization of the postrevolutionary state entailed a conscious effort to convert the heroes of the Mexican Revolution into politically indistinguishable macho rebels or benevolent patriarchs.

Mexican muralists, who created an extensive inventory of public art in the first half of the twentieth century, contributed to the linking of mexicanidad, machismo, and nationalist power with their larger-than-life portraits of Emiliano Zapata, often depicted with a smoldering, virile sexuality, and Francisco Villa, the bad boy of the revolution. The muralists were founding fathers of a uniquely Mexican version of modernism that shared with European modernism a privileging of the public sphere of men, masculine sexuality, and male experience with war (World War I for Europeans, the revolution for Mexicans), all themes that tended to marginalize women's experiences.[4] While the Mexican Revolution's male heroes were turned into world-famous icons, the women who populated the murals remained largely anonymous, noble, and quietly enduring mestizas or exotic Indian princesses. In Siqueiros's famous *The Revolutionaries*, for example, several male heroes of the revolution are easily identified among the armed insurgents, while generic, unarmed, shawled women cling to their men on the margins.[5] This despite the fact that thousands of women participated in the revolution, most as camp followers (the now iconic *soldaderas*) but many as combatants and several as officers (Salas 1990).

The most important exception to the anonymous female in the murals was the frequently portrayed Malinche, the multilingual Indian woman who became the conquering Cortez's interpreter and mistress, and thus the symbolic mother of the mestizo nation. Malinche also became the national symbol of betrayal and her story a Mexican version of the biblical lesson of Eve: beware smart women who act independently and seek knowledge. To this day a traitor or sellout in Mexico is called a *malinchista*.

The artwork of the early twentieth century also conveyed lasting lessons in what constituted inappropriate male behavior. For example, Jose Guadalupe Posada's caricatures of the forty-one men who were arrested in 1901 at a pri-

vate party in Mexico City (where many of them were dressed as women) were a central component of the extensive media coverage of the infamous scandal that would help establish public discourse about homosexuality in Mexico for decades to come (Irwin, McCaughan, and Nasser 2003). One Posada broadsheet about the scandal includes a drawing of the men, half of them in ball gowns, dancing together, and a ditty about the "pretty and coquettish *maricones* (faggots)." The identification of male homosexuality as effeminate, sexually provocative, and objects of derisive humor would stick and be reproduced widely in cartoons published in Mexico's City's satiric working-class penny press[6] and in Leftist newspapers like *El Machete*.[7]

Such imagery in murals, broadsheets, and cartoons combined with the work of filmmakers, writers, criminologists, political leaders, and others in the first half of the century to associate Mexican culture, and thus power, with the construct of heterosexist, phallocentric machismo. Given Octavio Paz's stature as one of the great writers of the twentieth century and as a semiofficial intellectual of the Mexican state, the publication of his famous *The Labyrinth of Solitude* helped to elevate such constructs to the level of official national discourse. Using highly sexualized language, Paz's (1961) social psychological essays on Mexican character described what he understood to be the essential characteristics of Mexican men and women. The Mexican man never "cracks," never "opens himself up," never "allows the outside world to penetrate his privacy" (30). The "passive" homosexual Mexican male is thus regarded as "an abject, degraded being" (39). The inferiority of Mexican women is "constitutional and resides in their sex, their submissiveness, which is a wound that never heals" (30). In the hegemonic culture as summarized by Paz, the Mexican woman is also denied any agency, sexual or otherwise: "How can we agree to let [woman] express herself when our whole way of life is a mask designed to hide our intimate feelings?" (38). As for the woman who does assert her own will, she is the *mala mujer*, or bad woman, "hard and impious and independent like the *macho*" (39). She is also dangerous, and in Paz's sweeping analysis, all of these national traits and behaviors stem from the social psychological trauma suffered by the Mexican people as a result of Malinche's betrayal of her people.

Following Carlos Monsiváis's analysis, Héctor Carrillo (1999, 225) suggests that such acutely *machista* representations of Mexican identity are in part the result of nationalist responses from Mexico's Leftist intelligentsia and its socially conservative elite to the growing influence of North American cultural values in the first decades of the twentieth century. Their reaction "helped

construct what, in the decades to come, promoted the association of Mexico and *mexicanidad* with machismo. Mexicans' resistance to the cultural invasion from the north, and the defense of traditional values, symbolized the kind of strength and stoicism that Paz identified as masculine qualities of the Mexican macho."

Thus by midcentury, the hegemony of Mexico's postrevolutionary regime was shored up by widely diffused, oft-repeated cultural norms (shared by much of the Left opposition) that linked the most intimate aspects of daily personal life with sweeping historical narratives and civic lessons. A heterosexist, phallocentric, machista culture worked simultaneously to obfuscate the politics of the revolution, to mystify the nature of the postrevolutionary regime, to marginalize homosexuals, and to restrain women's agency in both private and public life.

A testament to the enduring power of Mexican nationalism's sexist discourse is the fact that while the student movement of 1968 and its art helped expose repression, authoritarianism, and restrictions on freedom of expression, little effort was made to link those issues with gender oppression or the repression of women's and gays' sexuality. Telling examples of this contradiction can be found throughout the pages of *La Garrapata* (The tick). A bold, irreverent magazine of political satire and critique, *La Garrapata* was founded by a group of activist artists shortly after the government's massacre of student movement participants on October 2, 1968. Before government repression and censorship forced the editors to stop publication (Naranjo 2001), the magazine bravely took on issues of press censorship, government repression, corruption of the Partido de la Revolución Institucional (PRI) and the media, and U.S. intervention in Latin America. At the same time, *La Garrapata*'s astute political satire often took a form that faithfully reproduced the (hetero)sexist discourse of the dominant culture. A regular "cultural section" of *La Garrapata*, illustrated with images of nude, large-breasted women, was called "Cultura y Ganadería" (Culture and livestock), a pun referencing one of the government's corrupt ministries, Agricultura y Ganadería. Photographs of long-haired, effeminate, foreign men, including Oscar Wilde, were used to illustrate (and apparently add humor) to an article that skewered the phony democracy of Mexico's "elected" congressional representatives (*La Garrapata*, no. 7, c. 1968). Titled "Our Democracy Agonizes for Lack of Authentic Deputies," the editors clearly play on the public's commonsense understanding that effeminate men and homosexuals could never be "authentic" representatives of the Mexican people. That same issue of the magazine, ironically,

featured a piece by the essayist Carlos Monsiváis, who went on to become a prominent gay rights advocate.

Some evidence of a more critical discourse on gender and sexuality and of feminism's growing influence on Mexico City's activist artists can be seen in the work of the grupos movement, but feminist and/or gay artists who participated in the movement, such as Maris Bustamante, Magali Lara, Monica Mayer, Carla Rippey, and Oliverio Hinojosa, spoke in interviews about the difficulty of exploring issues of sexism, gender, and sexuality within the grupos. Sexuality apparently was not a comfortable topic of discussion within the grupos. In fact, in Magali Lara's (2001) words, to the extent that people did talk about issues like sex and the representation of sexuality, it was practically "an underground discussion." "The theme of the body," she explained, "was still viewed as in poor taste, as inappropriate." "Men didn't talk about sex when women were present in the 60s and 70s, so related issues would not have been discussed within the *grupos*," recalled artist José Luis Cuevas (2001), who helped break the domination of the official Mexican School of art in the 1960s by incorporating new styles and exploring themes of sexuality. Maris Bustamante (2001a) encountered angry responses from some audience members when she playfully encouraged them to lighten up about sex during her *El Porno Show* in the early 1980s.

In one of the rare cases when male grupo artists did incorporate representations of sex and sexuality — in Peyote y la Compañía's magazine *La Regla Rota* (The broken rule) — it was done with a juvenile humor that was very offensive to women, according to Lara (2001). Carla Rippey (2003), a former member of Peyote y la Compañía, agrees that "the magazine did have a lot of second-class juvenile drool-type graphics." But Rippey managed to inject a feminist component into the magazine's second issue: "Their second cover was a drawing of mine of a woman in a fifties bathing suit blithely shooting a shotgun at 'Guernica,' which, since I was very aware of Picasso's tyranny of women, was really a potshot at him, for me. I got a lot of comments like, 'What have you got against wonderful old Picasso???' Actually, Picasso tends to be an excuse for a lot of male tyranny ('What do you mean you don't like Picasso?! Are you demented?')." It is unclear whether the male editors of *La Regla Rota* understood which rules were being broken by Rippey's sly critique.[8]

With regard to representations of women in the grupos movement, Grupo Suma's work includes more (and more varied) images of women than did the graphics of 1968, though their images of poverty, homelessness, and oppression rely predominantly on male figures. Moreover, there is relatively little

attention given to the specifically gendered aspects of these social problems or to the patriarchal nature of Mexican culture. One interesting though ambiguous exception in Suma's work is a shopping bag that bears the burned imprint of an iron, out of which peers a woman's face (reproduced in Liquois 1985a). The shopping bag and the iron are clearly symbols associated with women's traditional domestic roles, burned into the fabric of society, and the wistful expression on the woman's face perhaps suggests her longing to escape. Ambiguous and unrepresentative as it is, this piece reflects what was a slowly emerging consciousness among Mexico City–based social movements and their affiliated artists of the dominant sex and gender system. Other examples of this change can be found in issues of *La Garrapta* after it began to publish again in the late 1970s: the back cover of one issue (no. 26, July 16, 1980) featured a haunting visual vignette about women in poverty by Ahumada, while in another issue (no. 24, June 18, 1980) the cartoonist Sergio Arau took on the issue of women's reproductive rights by exposing the fact that tens of thousands of women die each year as a result of unsafe, underground abortions.

Grupo Proceso Pentágono's work often focused on issues of militarism and repression, such as the twenty-five-square-meter installation entitled *Pentágono*. As discussed in chapter 2, the piece referenced the dictatorships in Latin America and the reality of U.S. imperialism and domination. However, at a time when feminists and gays in the Southern Cone dictatorships were emphasizing the link between military dictatorship and violence against women and gays (Chinchilla 1991; Green and Babb 2002), Proceso Pentágono's work made no such connection. According to the Proceso Pentágono member Víctor Muñoz (2001), the group's "central, most urgent concern was the issue of human rights, torture, and disappearances in the 1970s." Yet there were few attempts to explore these themes from a feminist lens that might have made the connection between the violence of the state and the patriarchal violence of the home or perhaps incorporated the subjective, emotional dimension of repression. "In Mexico," Magali Lara (2001) observed, "disappearances were treated as a purely political thing."

Mónica Mayer (2001a) remembered that "there was very little discussion within the *grupos* about feminism and women's issues; in fact, there was a process of pushing women out. In the Left [with which the groups identified] it was considered bourgeois to discuss feminism." Lara (2001) related this problem to the characteristics of what she describes as the "heroic" Left, that is, a male-dominated Left with masculinist ideas about the nature of social conflict, struggle, and change. Social change was imagined as the great historic

class struggle—in the streets, in the factories, on the battlefields—over the "big" questions of control over the means of production and the state. "Quotidian themes and women's issues were seen as petty bourgeois issues," Lara (2001) recalled.

Ironically, the same feminist artists who felt themselves pushed out of the male-dominated grupos also encountered ridicule from some in the Mexican feminist and women's movement. As described by Mónica Mayer (2001a), "if in the Left it was considered bourgeois to discuss feminism, within the feminist movement it was considered bourgeois to discuss art." "Serious" feminists, like "serious" Leftists, seemed to regard the artists' work as frivolous. Maris Bustamante observed that "the feminists who were not visual artists or who didn't come from the arts were very solemn" (Arias et al. 2001, 279). Mayer also noted that the leading feminist journals in Mexico, such as *Debate Feminista* and *Fem*, have given relatively little attention to women's art over the years.[9] One important exception to this apparent lack of support for artists from other feminists was noted by both Lara (Arias et al. 2001, 279) and Mayer (2001b, 13): feminist artists have established a mutually supportive working relationship with feminists in the mass media.

In general, however, aside from asking women artists to produce work such as women-themed calendars and date books for fundraising projects, the women's movement in Mexico appears to have shown relatively little appreciation for the importance of the arts in the process of social change. Bustamante (Arias et al. 2001, 279) commented that "often times we found that our work didn't echo with feminists, either because they didn't understand it or because they weren't interested. The feminists didn't approach the artists." Mónica Mayer (Arias et al. 2001, 279–80) agreed with Bustamante's observation and added:

> I feel that there has been a very big gap between the feminist political groups and the artists. . . . There is no one in any of the gender studies centers who studies the visual arts. They study film and literature, but there's always been something of a blockade against the visual arts. There has been no systematic theoretical work done [about feminist art], neither by those who study gender issues nor by those dedicated to art criticism. This seems odd to me, because feminism has had a tremendous influence on art criticism at the international level, but not here.[10]

Nor has support for feminist artists been forthcoming from women artists who do not identify as feminists. According to Mayer (2001a), "the more

conservative women's groups only invite conservative artists to participate." Bustamante (1998) recalled that in 1982, when she and Mayer tried to form a feminist artists group, "the other women were not interested either because, (1) they saw no problem being women in this society, or (2) men wouldn't allow them in the galleries if they were identified as feminists, or (3) their compañero wouldn't like it." Some women artists and other women in the art world appear to be fearful and/or dismissive of what they regard as the "confrontational" aspects of feminist art. This was illustrated by a comment from Rita Eder, an important art historian and critic who has written about women artists and the grupos movement (Eder 1984). Dismissing what she described as *"feminismo a la gringa,"* Eder (2001) observed: "Women in Mexico have had their space in the work force, in politics, etc., since the nineteenth century. But they achieved this through their abilities rather than through confrontation. And feminism has a confrontational discourse. Here in Mexico, one should not confront; it's a strongly macho and authoritarian country." Carla Rippey (2003) noted that Mexican discomfort with a confrontational style is also related to Mexico's colonial heritage: "[There's] always that old colonial custom of not letting the boss know what you're really thinking. I have a lot of trouble with this, because I'm very direct."

As a result, with few exceptions and without much support from other feminists, most feminist artists had to leave their grupo to form new women's groups or to work as individuals before developing the themes about gender and sexuality that most concerned them. Their efforts included informal discussion groups of feminist artists, the organization of formal feminist art collectives, collaborative art projects by two or more feminist artists, group shows of women artists, and the creation of new galleries and cultural spaces. Mónica Mayer organized the first exhibition of work called "feminist art" in Mexico in 1977, which included her then quite controversial collage, *Ilusiones* (figure 19) (Barbosa 2001). A woman's face stares forward; behind her head a parted curtain reveals enlarged photographs of a penis and a vagina. Text in the lower right reads, "sometimes my own feelings and fantasies frighten me." In a similar vein, "Magali Lara explored channels of intimate communication, weaving together domestic and dream imagery, texts and fetishes, attempting to create a feminine language about desires and feelings" (Debroise 2006a, 183). Lara frequently collaborated with other feminist artists, such as the poet Carmen Boullosa, the photographer Lourdes Grobet, the actor and playwright Jesusa Rodríguez, and the composer and singer Liliana Felipe "to

19 Mónica Mayer, *Ilusiones*, 1977. Mixed
 media. Photograph by Víctor Lerma,
 Archivo Pinto mi Raya.

define the feminine identity of the artist, in opposition to the macho *imagi-naire*" (Debroise 2006a, 183).

Maris Bustamante and Mónica Mayer pioneered the formation of feminist artist collectives when they organized Polvo de Gallina Negra (Black Hen's Powder) in 1983. For ten years they staged what they termed "montages de momentos plásticos" (montages of visual moments) on a wide variety of women's issues, ranging from the stereotypes of motherhood to rape. Some of their work, such as a "mother of the day" performance in 1987, aired on television, allowing them to reach millions of viewers (Bustamante 2000a, 236–37). Bustamante (2000a, 239) described this playful take on gender assignation in which a man was "impregnated" by two feminists:

> Since both Mónica and I were really pregnant, we had toyed with the idea that the methods used by the group were really scientific. In order to address the issue of motherhood, we needed to be really pregnant, something we were able to accomplish within a period of four months in 1987, "with the support and solidarity" of our husbands. We decided to choose a

very high-profile media personality, so we approached Guillermo Ochoa, a journalist who is very well known for his news broadcasts on Televisa. . . . He agreed to be part of the action and to put on an apron with a fake pregnancy tummy underneath for about twenty minutes, not only for national broadcast, but international as well (about 200 million viewers). Ochoa became the first Mexican man ever to become pregnant by the only Mexican feminist art group. The phone lines were jammed with calls, many of them against the event, which they considered to be disrespectful of motherhood. Since then, Mónica and I have shared the feeling that we were able to take a stab at one of the strongest archetypes in our culture. At the very least, we were able to leave a scratch.[11]

Feminist artists have worked to deconstruct the gendered and sexualized representations of Mexican culture. Magali Lara, for example, collaborated with Bustamante on a performance in 1982 that explored the differences between Mexican men's and women's erotic codes (Bustamante 2001a). Bustamante's work has used two common symbols of mexicanidad, the taco and the nopal, to play with what she considers the phallocentric (not simply patriarchal) nature of Mexican culture (Bustamante 1998). In *Patent for the Taco* (*Patente del Taco*), one of her early (1979) "social performance pieces," as she calls them, she addressed a variety of issues related to Mexican cultural identity. A huge, vertical image of a taco, accompanied by slogans such as "Dare to commit an erotic act: eat a taco" and "We use it as an arm of Cultural Penetration," made explicit the phallic nature of the nation's most basic food item and also recognized the erotic in daily life. The performance also dealt with the commercialization of Mexican culture, as Bustamante went through the bureaucratic steps of applying for a patent for this ancient culinary staple. At the center of Bustamante's *Nopal* installation was an inflatable twenty-five-meter tall nopal cactus, a central element in the symbol of the founding of Tenochtitlán (now Mexico City), and thus of the Mexican nation, by the Aztecs. And, like the taco, the nopal is also a common food item. Bustamante turned the opening of the installation (at the Museo Universitario del Chopo, known as El Chopo Museum) into a performance piece by inflating the sculpture before the public, thus causing the cactus to grow to its full length and girth before the dazzled eyes of the audience.

Politically active gay artists such as Nahum Zenil and the late Oliverio Hinojosa (a member of Grupo Suma) also worked to "unfix" mexicanidad from its heterosexist moorings, but they had to do so outside the confines of

the straight male-dominated grupos movement. Gay movement concerns, as well as feminist issues, were seen by many on the Mexican and Latin American Left as bourgeois (Green and Babb 2002). Hector Carrillo (1999 and 2002) has written extensively about male homosexuality in Mexico. He recalls a pamphlet published by the PSUM in the early 1980s describing homosexuality as a bourgeois vice (Carrillo 2008). According to Carrillo (2008), gay Mexican writers were creating gay-oriented literature and theater in the 1980s, and after the earthquake of 1985, a group of gay men participated in the rescue efforts, leading them to form a gay organization.

Nahum Zenil was a key protagonist in the founding of the annual Semana Cultural Lésbica-Gay (Lesbian-Gay Cultural Week) and its accompanying art exhibition at El Chopo Museum. The annual exhibition is an important forum for visual art by queer artists and their supporters. Zenil (1999) incorporated many symbols of the national culture, both secular and religious, into his *Circus* self-portraits. In one, which evokes Mexico's popular religious art form, the *retablo*, he appears as San Miguelito. Saint Michael the Archangel is a complex symbol for gay men. On the one hand, he was the leader of God's army and the patron saint of battle, soldiers, paratroopers, police officers, and security forces. As such, he potentially represents religious and state repression of homosexuals. On the other hand, Saint Michael is also the patron saint of artists, bakers, haberdashers, milliners — professions more compatible with the sensibilities of many gay men. And Michael is also the patron saint of dying and sick people, of ambulance drivers, paramedics, and medical technicians — figures of no small importance for the gay community in the era of AIDS. In portraying himself as Saint Michael, Zenil perhaps suggests that he, like most gay men and, indeed, like the national culture in general, embodies all of these contradictory impulses: to oppress and to protect, to destroy and to create, to kill and torture and to heal.

In another Zenil self-portrait, he appears on a lottery card as *La Rosa*. Zenil (2009) explained that he chose this image because the rose is card number forty-one in the popular children's game of *lotería*, and forty-one has been a symbol of male homosexuality in Mexico since the previously mentioned scandal in 1901 in which police arrested forty-one men, some of them cross-dressers, at a private party in Mexico City (Irwin, McCaughan, and Nasser 2003). In *La Rosa*, Zenil seems to remind us that homosexual identities emerge early in life, are as natural as children at play, and are as much a part of the national culture as lotería.

In *Oh Santa bandera* the Mexican flag stands erect, planted firmly in the anus of a naked, bent over Zenil (figure 20). The artist explained that he painted this as a homage to Enrique Guzmán, a painter he regards as an important precursor of what art scholars refer to as "neo-Mexicanism" (Zenil 2009). The flag in Zenil's painting is taken from Guzmán's painting from 1977 of the same name. Guzmán committed suicide in 1986 while still in his thirties. Like Zenil, much of Guzmán's work included portraits of his own body combined with symbols of the nation. In an essay on homosexuality and neo-Mexicanism, Osvaldo Sánchez (2000, 138–39) writes, "The deliberate appropriation of this symbolic body by neo-Mexicanism sought to make explicit on a political level the discourse of the body as a bearer of individual identity. This was a denationalization—taking something away from the dominion of the Nation-State—of the representation of the body, and a reappraisal of its iconic value, now seen as one's own body, self-legitimized, set in the field of public discourse."

How are we to read Zenil's homage to Guzmán? Is the artist the victim of painful rape by his homophobic culture or a willing participant in the pleasurable sex associated with Mexican men's complex experience with hidden, macho bisexuality? The artist's face is inscrutable (as in all his self-portraits), revealing nothing except, perhaps, the ambivalent feelings of gay men about the phallocentric nature of Mexican society. In any event, the image speaks to the fundamental connection between national identity and constructions of gender and sexuality.

In a final example of gay Mexican artists engaging with symbols of the national culture, Oliverio Hinojosa (1998) explained that his homoerotic *Sacrifice, Cinnabar, and Jade* series was inspired by a tomb at Palenque, a major pre-Hispanic Mayan site whose symbols, images, and forms have been incorporated into modern representations of Mexican identity. Unable to explore themes of homosexuality within the grupos, gay male artists such as Hinojosa also collaborated frequently with feminist artists in group shows such as *Propuestas Temáticas* (Thematic proposals), one of the first mainstream museum exhibitions to deal with themes of intimacy, sexuality, eroticism, and memory from a feminist perspective. Shown at the Carrillo Gil Museum in Mexico City in 1983, the exhibition was also notable for including the work of men, both gay and straight (Museo Carrillo Gil 1983).

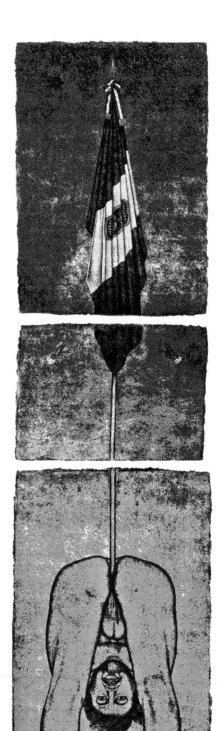

20 Nahum Zenil, *Oh Santa bandera* (*a Enrique Guzmán*), 1996. Triptych, mixed media on paper.

If women artists active in the Mexico City–based movements were ridiculed as bourgeois for pursuing feminist themes in their art, Chicana artists who did so risked ridicule for being "too white" or not authentically Chicana. Cultural nationalism was a powerful discourse within the Chicano movement as it sought to strengthen the Mexican American community's pride in its Mexican history and cultural traditions as sources of resistance and empowerment in the largely white supremacist, Anglocentric U.S. society. George Mariscal (2005, 45) provides a useful definition of cultural nationalism as "the strategic deployment of key features of Mexican and Mexican American history and culture in order to fashion individual and collective subjects capable of asserting agency and demanding self-determination. Otherwise known as 'Brown Pride' or 'Brown Power,' cultural nationalism was at work to varying degrees within all sectors of the Movement."

Indeed, as described in chapter 2, nationalist and distinctly Mexican cultural iconography was deployed effectively by artists as diverse as Salvador Roberto Torres, Antonio Bernal, Rupert García, and Ester Hernández to convey the Chicano movement's passionate demands for a fuller, more meaningful citizenship. At the same time, however, as María Teresa Marrero (2000, 132) observed, the "then necessary nationalism . . . excluded a diversity of sexualities." Laura Pérez (2007, 9) writes that Chicana women often experience "racialized gender and sexual identity inequities . . . in the patriarchal ethos of both Mexican American and mainstream U.S. cultures," an experience that informs the work of Chicana artists. Mary Karen Davalos (2001, 57) illustrates this point in her incisive reading of the Los Angeles artist Laura Aguilar's triptych *Three Eagles Flying*: "At the center of the triptych, Aguilar's dark body is bound by thick rope and her face is covered by the Mexican flag. The American flag covers her lower torso, leaving her breasts and arms exposed. On either side of Aguilar's body is the American flag (left) and the Mexican flag (right), representing U.S. and Chicano nationalism, respectively. In short, Aguilar's work articulates the desire on both sides of the geopolitical border to abuse, bind, and gag the illegal alien, and the misogynist and racist desire to rape the brown-skinned woman." Davalos (2001, 58) continues to unpack the work in terms that emphasize some Chicanas' discomfort with cultural nationalism: "The Mexican flag, symbolic of Chicano and Mexican culture, blinds her eyes and prevents her from seeing the person who retrained her

body, thereby preventing her from seeing her oppressor or the object of her desire."

In his history of the Chicano movement, Mariscal (2005, 41–43) cautions against what he views as broad-brush characterizations of Chicano nationalism as sexist and homophobic; he emphasizes that the movement's cultural nationalism was also a source of empowerment for women and men. True enough, but for Chicanas to express their newly empowered selves on their own terms, free of the constraints of their community's deep patriarchal traditions, often required tremendous courage and creativity. As the artist Juana Alicia (2000) remembers:

> There were certain stereotypes that we lived with and felt pride in, and also I think many of us felt oppressed by having to fit during the sixties and seventies — whether it was the brown beret or the low-rider or la Güisa del Revolucionario, the girlfriend of the revolutionary. . . . Well, I mean women very much took leadership in the Chicano movement and were very much unacknowledged and took a back seat in term of acknowledgement . . . and that definitely — definitely — applies to women artists. Women were not welcomed as muralists for the most part by our colleagues, though there are some outstanding exceptions. . . . You know, there were men in the Chicano movement who were very, very supportive of us as women, but there were a lot of men that were like, "Get back in the kitchen. You don't belong on scaffolding. You're too ambitious. You're taking our limelight. Sit down and shut up." And also as gay people, many of us felt very excluded and marginalized.

Laura Pérez identifies various strategies used by Chicana artists to navigate their way through the minefields of cultural nationalism. One was to destabilize the use of pre-Columbian iconography in "Chicano masculinist nostalgia" (Pérez 2007, 3–4). As Goldman and Ybarra-Frausto (1991, 88) note, "Neoindigenism served a positive function: pre-Columbian motifs instilled pride and a sense of historical identity in the Chicano artists and the communities they addressed." However, *indigenista* images associated with the early twentieth-century Mexican mural movement often made their way into Chicano murals in the form of half-naked male warriors, exemplifying the "masculinist nostalgia" identified by Pérez. A classic example is Wayne Alaniz Healy's *Ghosts of the Barrio*, a mural painted at the Ramona Gardens public housing complex in Los Angeles in 1974. An Aztec-like warrior with a rippling

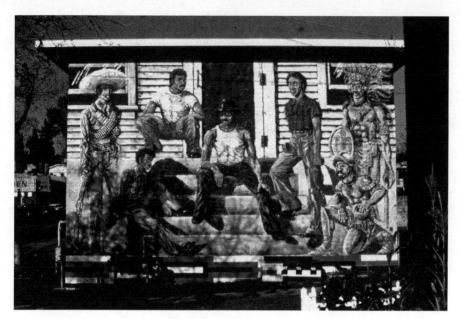

21 Wayne Healy, *Ghosts of the Barrio*, 1974. Mural.

abdomen holds a spear and shield. He joins the conquistador Cortez, the revolutionary Zapata, and four muscular homeboys on the porch of a barrio house (figure 21). The patrilineal ancestry of working-class *vatos* is traced directly back to Aztlán through a line of male warriors. "The problem with Aztlán," wrote Alicia Gaspar de Alba (1998, 43–45), "is that it continues to be dominated by a patriarchal cultural nationalism that embraces the symbolic ideology of *indigenismo* and restricts its activism to race and class struggles. Gender and sexuality . . . are taboo issues in the kingdom of Aztlán."

Nevertheless, some Chicana artists attempted to infuse the iconography of Aztlán with a dose of feminism. In Judith Baca's *Uprising of the Mujeres* from 1979, for example, an Indian-featured woman with large, sturdy hands and braids that echo the geometric motifs of pre-Columbian art stares confidently and directly at the viewer (Griswold del Castillo et al. 1991). Baca's woman is far removed from the exotic, coquettish Aztec maidens and stooped, often faceless Indian flower vendors of Diego Rivera's repertoire. Yolanda López attempted to restore the centrality of the powerful Aztec female deity Cuatlicue in *Nuestra Madre* (1981–88). Cuatlicue, a fierce and fearless "mother of all mothers" figure attired in a skirt of snakes, was also known by the Nahuatl-speaking people of the Aztec capital as Tonantzin; she was worshipped on

the hillside where the Virgin of Guadalupe made her legendary appearance in 1531. As Davalos (2008, 96) explains, "Tonantzin is known for her capacity to create and extinguish life; she was a formidable deity that inspired fear and awe. More important for Chicana womanhood, her power is autonomous and is not defined by her relationship to men. Coatlicue, She of Serpent Skirt, is the Aztec creation goddess who gave birth to the moon and stars." In López's *Nuestra Madre* (Our mother), Guadalupe's star-studded blue cape is draped over the powerful shoulders of the snake-skirted goddess. "The syncretic revival of Cuatlicue/Tonantzin in conjunction with the Guadalupe," wrote art historian Shifra Goldman (1994b, 404), "pays tribute not only to the racial and religious affirmations of the Chicano movement but to the particular idols of feminist artists as well." In her essay "The Ancient Roots of Machismo," Ana Castillo (1995) describes once powerful female deities like Cuatlicue being demoted, re-presented in masculine terms, and/or written out of history as Aztec society grew more hierarchical, patriarchal, and militaristic.

By bringing Cuatlicue, Tonantzin, and Guadalupe back together in *Nuestra Madre*, López also helps to undermine rigid, masculinist gender representations that can limit the ways Chicanas are seen and see themselves. In doing so, her work illustrates another strategy of Chicana artists noted by Laura Perez (2007, 3–4): to reinterpret traditional symbols that had been used historically to control female sexuality. A famous example is Yolanda López's *Portrait of the Artist as the Virgin of Guadalupe* from 1978. The brown-skinned, athletic artist is running, skirt flying up to reveal muscular legs. She is smiling broadly while her right hand fearlessly clasps a snake and her left hand holds Guadalupe's star-studded blue cape over her shoulder. Referring to an earlier, controversial portrait she created of the virgin with short skirt and high heels, López explained why she started working with the image of Guadalupe: "She was the most popular female political image used by the United Farm Workers. . . . Looking at the image closely, I discovered that her dress was so long that it gathered at her feet, so I trimmed the cloth to let her feet and legs move. I felt that I had removed her from bondage, from having been trapped in her clothing" (quoted in Keller 2002, 80). Davalos (2008, 81) notes that "López was fascinated by the image because of its contemporary power, not because she found this apparition of the Virgin Mary personally or spiritually meaningful. Her intent was not to explore Guadalupe's divinity but to deconstruct the image 'to see how we represent ourselves.'"

Similarly, Ester Hernández (2006) recalled how she was originally motivated to create her *La Virgen de Guadalupe Defendiendo los Derechos de los Xica-*

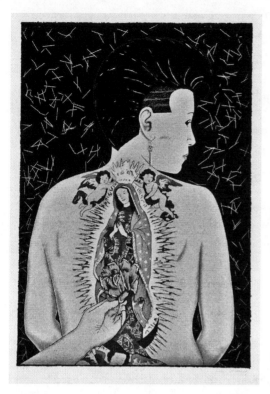

22 Ester Hernández, *La ofrenda*, 1988.
Screenprint.

nos (discussed in chapter 2) in 1977. Hernández's grandmother—who "raised sixteen children, worked in the fields by day, danced all night, and had a hard life"—had just died. A prayer card with the traditional image of the Virgin of Guadalupe was handed out at her funeral. Hernández, who was taking karate lessons at the time, explained that she was not comfortable with this "narrow" representation of the virgin, which contrasted so with the real-life woman who was her grandmother. Thus was born Guadalupe as kickboxer. A little more than a decade later, in Hernández's erotically charged silk screen *La Ofrenda* (The offering, 1988), the imagery of Cuatlicue/Tonantzin/Nuestra Madre/ Guadalupe reappears, this time as what might be read as "Our Lady of Lesbian Desire" (figure 22). The naked back of a punk-coiffed woman has been tattooed with the traditional image of the virgin, while another woman's hand offers a pink rose, presumably an *ofrenda* to the virgin and to the woman.

Amalia Mesa-Bains has noted that even before the "revolutionary images" of Guadalupe created by López and Hernández, Patssi Valdez transformed herself into the dark-skinned virgin, "dressed in glitter, chiffon, and black net-

ting as she marched down Whittier Boulevard" in a "walking mural" by the Asco collective in Los Angeles in 1970. For more than thirty years, Valdez has worked with such images in performances, photographs, installations, and paintings. Looking back on the whole of Valdez's work, Mesa-Bains (1999, 37) writes, "What appears as the connective thread throughout the Dark Madonnas works is the personification of a racialized beauty. In an era when most representations of beauty were white, the artist produced her own discourse on desire through paintings and installations depicting virgins and queens. . . . Mixing her images of the sacred and the profane has allowed the artist to reclaim a dark-skinned beauty while questioning the issues of race, gender, sexuality, and spirituality."

The high-wire act of juggling ethnic pride and belonging with feminist critique and sexual longing was captured brilliantly in a play written and produced by the Latina Theater Lab of Oakland, California. An early scene in ¿¡Qué Nuevas!? What's New!? The Immaculate Conception shows the Virgin of Guadalupe giving birth to six or seven Latinas, whose most striking feature is their dissimilarity. Throughout the play, Guadalupe herself is brought down to earth, quite literally. At one point she appears at a dance club attired in a black leather mini-skirt. This Guadalupe is not confined to the sacred altars of church and home, nor is her "look" restricted to the *Mona Lisa*–like, virginal beauty of her most famous portrait. This Guadalupe is ready (and appropriately attired) for action where and when her sisters most need her.

The play's central theme is that thorny question of ethno-national identity and authenticity. It presents Latinas in many manifestations: the virgin, a revolutionary, a would-be "Barbie" cosmetologist, a prostitute, a lesbian, a homeless woman, an angel. But perhaps the most striking character is the ominous Salsa Police, whose duty is to verify the authenticity of these Latina women by putting them through their dance paces. "Why," the play's program notes ask, "are we all expected to know how to salsa dance?" (McCaughan 1998, 321).

Davalos (2001, 10) has observed that "radical/lesbian Chicana feminism forces the complexities and ambiguities of Mexican-origin representational practices into view, allowing scholars to rethink 'the community,' the 'alternative' characters of arts organizations, 'authenticity,' and Chicana artists." Referring to Las Mujeres Muralistas, a collective of Chicana artists who began working together in the early 1970s on a series of feminist-influenced murals in the San Francisco Bay Area (Ochoa 2003, 33), Davalos (2001, 65–66) notes that their work, by "reconfiguring traditional icons, challenging gender roles,

and asserting women's power, . . . complicated the image that Chicano nationalists tried to create and practiced a notion of 'Chicano' that did not presume unity based on race."

As a result of such efforts, Chicana feminists often faced censorship and ridicule within the movement and within their communities for challenging their culture's deep-rooted patriarchal values and practices. Judith Baca's proposed mural for an East Los Angeles housing project was rejected, apparently because it offered a critique of male-based power and violence, including that of gang members and revolutionaries. "The rejection of her mural," writes Sánchez-Tranquilino (1995, 71), "had the effect of proving once again to Baca what she had learned to be suspicious of: that the Chicano Movement, and Chicano art in particular, was directed by men who were unwilling to recognize the opportunity to open supposedly revolutionary social structures to greater participation by women."[12]

One strategy for silencing Chicana feminists was to question their cultural "authenticity." A mural by Diane Gamboa, for example, an artist whose work includes sexually provocative images, was whitewashed in the early 1970s for "not being Chicana enough" (Keller 2002, 256). The painter Judithe Hernández (1998) recalled how another well-known Chicana artist was "mocked" by other Chicanos because "she was not a hundred percent Mexican." In a profile of Barbara Carrasco, Sybil Venegas (2008) notes, "Like many artists of color in the United States, Carrasco has dealt forcefully with skin color and oppression, most specifically the impact of color hierarchies in the Chicana/o community. Growing up in Mar Vista Gardens — a predominantly Mexican American and African American public-housing community in Los Angeles — she was called 'white girl,' 'green eyes' and güera (light-skinned), hurtful names that challenged her identity as a Mexican American. Yet she was also told by both Anglos and light-skinned Latinos to take advantage of being light-skinned, and witnessed the discrimination experienced by her much darker-skinned sister."

Carrasco (1999), who worked for some years with the United Farm Workers (UFW) movement, says she developed "a complex about being light skinned. I could do a whole book called, 'Being a Güera.'" Carrasco continued, "I remember Brown Power and I kind of felt left out of the Brown Power. I remember Chicanos referring to their women as Aztec goddesses. And there was a lot of little phrases like that, real chauvinistic phrases." Carrasco thinks she may have become "really involved in the Chicano art scene and worked with the UFW because of this desire to like prove that I'm Mexican." She also con-

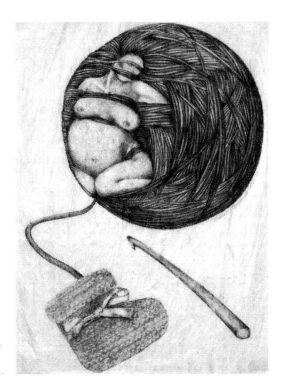

23 Barbara Carrasco, *Pregnant Woman in a Ball of Yarn*, 1978. Lithograph.

sciously sought to immerse herself in Mexican artistic traditions by working with the muralist Arturo García-Busto in Oaxaca and by visiting the Taller de Gráfica Popular studio in Mexico City.

Proving herself to be sufficiently Mexican was complicated by Carrasco's passion to express feminist convictions through her artwork. She described the challenges of addressing issues of abortion, contraception, and sexuality: "I mean nudity in itself has been a real problem. It's even been a problem among Chicano artists. One of my works was almost censored [by one of the curators] in the CARA show because it depicts female breasts that are exposed" (Carrasco 1999). Carrasco is referring to *Pregnant Woman in a Ball of Yarn* (1978), a lithograph showing a naked, pregnant woman who has been bound and gagged by the ball of yarn she is using to crochet a baby's slipper; the crochet hook is aimed at her womb (figure 23). The piece, explained the artist, "portrays an oppressed pregnant woman trapped by the fear of fighting her oppressors" (Goldman 1994b, 205).

Too white and too feminist for some Chicanos, Carrasco's work was apparently too Mexican for the Los Angeles establishment in the early 1980s.

Her mural *L.A. History: A Mexican Perspective* "was to be ready for the Olympics held in Los Angeles in 1984, but it was judged too controversial by the Los Angeles Community Redevelopment Agency that sponsored it and was never installed" (Keller, Erickson, and Villeneuve 2004, 96). That experience inspired Carrasco's *Self-Portrait* in 1984 in which the artist-as-sprinter breaks through the finish line's red ribbon, gasping in horror as a paint roller whitewashes the grid in the background; like the Olympic torch, she holds a paint brush inscribed with the name Siqueiros, the famed Mexican muralist whose Los Angeles mural was whitewashed in 1932 (Keller, Erickson, and Villeneuve 2004, xiv).

In Carrasco's (1999) sometimes painfully self-revelatory interview, she also owns her homophobic past. There was a time, she acknowledges, when she was even reluctant to look at the lesbian artist Laura Aguilar's work. And she initially felt very conflicted when the UFW leader César Chávez asked her to organize people to go to a gay pride march. She had a difficult time convincing more than about five UFW staff people to go, even though Chávez himself told her, "You know, all the time the gay community has always supported farm worker rights. And I want to send a delegation of people to support them in their demonstration." She was embarrassed because her family would see her at the march on television. She also recalls her anger at being asked if she were a lesbian because she wouldn't date any of the Chicano artists.

"The kingdom of Aztlán," to use Gaspar de Alba's (1998) phrase, was not always an especially comfortable space for queer Chicano artists, and examples of movement art addressing gay men's concerns are few. A number of prominent Chicana lesbians—Gloria Anzaldúa, Ester Hernández, Cherríe Moraga, and Monica Palacios, for example—"came screaming out of the closet," in the words of Tomás Almaguer (2008), author of one of the classic essays on Chicano male homosexuality (Almaguer 1991), in part because they were able to find some support from other Chicana feminists. Gay men, however, found virtually no space or support within the Chicano movement, as Almaguer (2008) and the Chicana feminist academic Velia García (2008) recall. My own experience confirms their observation. A close friend from my undergraduate days at the University of California, Santa Cruz, was a leader in the Chicano student organization Movimiento Estudiantil Chicano de Aztlán (MEChA) and later a prominent affirmative action advocate as a university administrator. Although we had been friends for nearly two decades, he only came out to me as a gay man a few months before his untimely and preventable death. Despite close ties to a large activist circle of family and friends, this

gregarious Chicano movement veteran died alone and untreated, having revealed his illness to no one because of the stigma of AIDS and homosexuality.

Los Angeles–based artists Gronk (1997) and the now deceased Carlos Almaraz (1987) described how the few models they found for making a life outside the confines of compulsory heterosexuality primarily came from outside the Chicano community. Gronk, a founding member of the Chicano art collective Asco (Spanish for nausea), hung out at the "queer table" in high school, where gay kids were ostracized. It was through a foreign film that he first learned about lesbianism, and it was the Milwaukee "mail artist" Jerry Dreva who introduced him to the gay club scene in L.A. in the 1970s, where Gronk often found himself to be the only person of color. Almaraz, who worked with the art collective Los Four in the 1970s, was critical of what he considered the very "macho oriented" and "male dominated" art groups, such as ConSafo and Mechicano. He cited artists and writers such as David Hockney, John Rechy, and especially Christopher Isherwood and his partner Don Bachardy as "an inspiration . . . to many gay people." Not that the Southern California art scene was gay friendly. Until the 1980s a misspelled "Fagots—Stay Out" sign hung above the bar at Barney's Beanery, the favorite West Hollywood wateringhole for the strictly heterosexual male "California Cool" artists associated with the famous Ferus gallery (Nelson 2008).[13]

Gronk's work with Asco, as well as his individual work as a painter, was far removed from the formal style and iconography typically associated with much Chicano art. "I don't do Virgins of Guadalupe. I don't do corn goddesses" (Gronk 1997). Influenced by the punk scene, films, and urban culture, Asco and Gronk took an irreverent approach to religious themes and infused their work with playful, glamorous sexuality. In 1978 Gronk used a male model to portray Frida Kahlo as a disco queen in photos used for one of Asco's *The No Movie* series. Very early in the AIDS epidemic, Gronk cowrote with Harry Gamboa Jr., directed, and starred in *Jetter Jinx* at the Los Angeles Theater Center in 1985. "Conceived as a commentary on HIV/AIDS, the play centers on the archetypical, fast-living jetter (portrayed by Gronk), who is persuaded to commit suicide after his invited party guests fail to materialize" (Benavides 2007, 47). Gronk (1997) explains his *Josephine Bonaparte* series of paintings in the '80s as being inspired by overhearing "two Catholic schoolgirls talking about men." "And the seven-year-old says to the eight-year-old, 'Men—they're not worth it.' I thought, 'She's right. . . .' And I said, 'You know, that bone of contention starts at a very early age. I'm going to start doing pieces that have these bones dangling between people and sort of this ten-

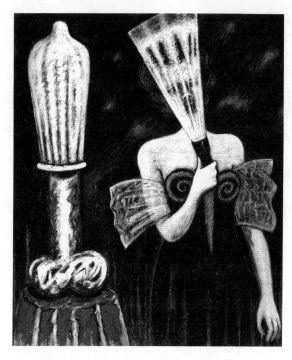

24 Gronk, *Josephine Bonaparte
Protecting the Rear Guard*, 1987.
Acrylic on canvas.

sion.'" Thus the "bone" in paintings such as his *Josephine Bonaparte Protecting
the Rear Guard* (1987), in which a phallic bone covered by a condom doubles
as a table lamp next to Josephine who holds a flashlight like a fan in front of
her face (figure 24). Another recurring figure in Gronk's work is La Tormenta,
an elegant figure in black evening gown and gloves who we only see from the
back. Benavides (2007, 65) reads La Tormenta as "a metaphor for life's unfath-
omable enigmas," including the enigma of sexual identity.

Because Gronk and Asco took their art in such directions, Gronk (1997)
claims that they were "rejected and ridiculed," even "sort of thought of as drug
addicts, perverts" by a lot of other Chicano groups. Almaraz (1987) recalled
that "the Asco group were thrown out [of Mechicano] rather quickly after one
important show; they were kicked out because they were just too way out for
them." Yet, in what is clearly a recurring story, while Asco was not sufficiently
Chicano for some Chicanos, they were too Chicano for the L.A. County Mu-
seum of Art (LACMA) in 1972, when Asco was reportedly dismissed by the
museum director because, "Well, Chicanos don't make art." In response, Asco
artists spray-painted their names on the museum's entrances and exits (Gronk
1997; Gamboa 1991). Gronk eventually was given a show at LACMA twenty

years later, but gay Chicano artists still face homophobia in their own community. Galería de la Raza in San Francisco's largely Latino Mission District was vandalized twice in three weeks in 1997, apparently because it exhibited a series of paintings by the gay artist Alex Donis that included an image of César Chávez kissing Che Guevara and Madonna kissing Mother Teresa (Mathis 2002).

Referring to her community's sexism and homophobia, Gloria Anzaldúa (1987, 22) once wrote, "if going home is denied me then I will have to stand and claim my space, making a new culture—una cultura mestiza—with my own lumber, my own bricks and mortar and my own feminist architecture." That is what the artists highlighted here have attempted to do—contribute to the creation of a new culture with visual discourses that offer ways for Chicanas and Chicanos to inhabit their ethnic identity proudly without having to conform to rigid, suffocating notions of gender and sexuality.

REPRESENTATION WITHOUT REPRESENTATION:
SEXUAL TENSIONS IN THE ZAPOTEC IMAGINARY

In Zapotec Oaxaca, images of strong women and playful, fluid sexuality are actually central to the representation of "authentic" ethnic identity. The cultural renaissance associated with the new Zapotec social movement that emerged in the late 1960s has been described as "the most outstanding experience of restitution of the community's identity in contemporary Mexico" (Moreno Villareal 2000, 19). It was a movement in which the "mobilization of symbols" converged with the "creation of new spaces of identity" (López Monjardín 1983, 5). Intellectuals and artists allied with the movement in a collective effort to exercise "the right to an identity in the face of the failures of cultural homogenization" (Rita Eder in Fréot 1992, 25–26). In representations by artists and writers working within or supporting the movement from outside, Zapotec women—particularly images of the Isthmus of Tehuantepec's voluptuous but sturdy market vendors—were seen as the "embodiment of ethnic pride" (Campbell 1993, 226).

Tehuanas (women from the Isthmus) and Juchitecas (women from Juchitán, the center of the movement in its earliest days) were revealed to the world as militant activists and hardworking, sensual earth mothers by famous photographers such as Graciela Iturbide, Lourdes Grobet, and Rafael Doniz, who were invited by Francisco Toledo to document the movement, as well as by lesser known local photographers.[14] One of Grobet's photographs captures a

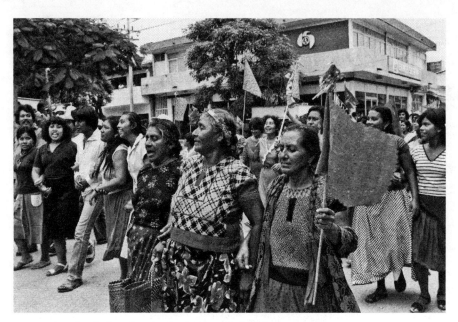

25 Lourdes Grobet, photograph of COCEI march, Juchitán, c. 1983.

line of mature Juchitecas in a Coalición Obrera-Campesina-Estudiantil del
Istmo (COCEI) march: they carry red paper banners and are dressed in tradi-
tional red and black blouses (*huipiles*) and flowing skirts (figure 25). Natalia
Marcial López, whose parents were both movement activists and whose
own earliest political activity was in the COCEI's children's brigades (*escua-
drones de mosquitos*), has kept a collection of the hand-loomed and embroi-
dered huipiles that her mother wore in marches and rallies. She explained
that the women color coordinated their clothing to match the red and black
of the COCEI logo, revealing their self-consciousness as embodiments of their
people and its movement (Marcial López 2006). Describing women gather-
ing for a COCEI rally, the famed author and oral historian Elena Poniatowska
(1993, 133–34) wrote:

> You should see them arrive like walking towers, their windows open, their
> heart like a window, their nocturnal girth visited by the moon. You should
> see them arrive; they are already the government, they, the people, guard-
> ians of men, distributors of food, their children riding astride their hips or
> lying in the hammocks of their breasts, the wind in their skirts, flowered
> vessels, the honeycomb of their sex overflowing with men. Here they come

shaking their wombs, pulling the *machos* towards them, the *machos* who, in contrast with them, wear light-colored pants, shirts, leather sandals, and palm hats, which they lift high in the air as they shout, "Long live Juchitec women!"

The graphic artist Fernando Olivera (2007) was first inspired to work on behalf of the movement when he witnessed a protest march of Juchitecas pass through the city of Oaxaca on its way to the national capital. Since then he has created many engravings and woodblock prints in solidarity with the movement, including his previously referenced *Resiste, voz libre del pueblo* (Resist, free voice of the people), in which traditionally garbed market women dominate the scene of daily street life (figure 2). The title refers to the name of the then besieged COCEI radio station and is echoed in unfinished graffiti on a church wall in the background. Olivera's piece demands that we focus our attention on the women, suggesting they are the more important "voice of the people." Olivera has also preserved a collection of posters created by other artists in solidarity with the movement, more than a third of which feature militant images of Zapotec women.

Militancy, however, is only one element of the complex representation of women in movement-related artwork. Tehuanas are also depicted as feisty, fun loving, and irreverent, often drinking a bottle of beer, in paintings and graphic art by Olivera, Modesto Bernardo, and others. Women are also represented as sexual beings, seductive, and comfortable with the naturalness of sex and the body. The Juchitán-born artist Delfino Marcial Cerqueda began to create work in support of the movement in response to a call by Macario Matus, then director of the Casa de la Cultura in Juchitán (Marcial Cerqueda 2006). Cerqueda, as he signs his work, emphasized the sensuality of Zapotec culture in many drawings. One depicts a naked couple making love in a hammock, another shows Tehuanas in revealing, transparent skirts, and a third offers a night-time beach scene where lovers embrace, a woman squats to urinate, another figure defecates, and a dog howls at the moon (figure 26).[15] The activist Oaxacan artist Luiz Zárate's work has been described as a "true sexualization of reality" (Fréot 1992, 121) and as "plots in which archetypes of virility, such as bulls and horses, are woven in with female nudes in an eternal fertility rite" (Geldzahler 1994, 4). The Zapotec artist Nicéforo Urbieta (2001) says, "all of my painting has a coital character, it tries to be spontaneous and sensual."

The artists insist that such images are integral to their individual and collective identity—authentic representations of their Zapotec culture, known

26 Delfino Cerqueda, *Juchiteca orinando*, 1989. Ink on paper.

for its strong women, open sexuality, and a "third gender" category of female-identified, biologically male "muxe."[16] According to Nicéforo Urbieta (2001), "Catholicism is sexually repressive but Zapotec culture is traditionally much more open and free sexually; few Zapotec children haven't seen their parents having sex." The late Zapotec activist artist Jesús Urbieta (1996) once explained, "we paint everything that is fauna, flora, and sensual; the sexual freedom that women and men have in Juchitán is very natural." Howard Campbell (2008), a long-time observer of isthmus politics and culture, suggests that Macario Matus's many volumes of erotic poems and short stories were likely one source of encouragement to the painters' playful, comfortable approach to sex. Campbell claims that Matus was, in many ways, "the most important mentor" to the Zapotec artists gathered around the Casa de la Cultura and the COCEI.

Francisco Toledo, renowned for the sexual content in much of his work, claims that he first started making erotic images while in Paris but that "it all comes together with the culture of the people of the Isthmus" (Moore 2000, 116). Toledo's imaginary is populated by animals with erect human penises, Benito Juárez copulating with a frog, and a photographic self-portrait of the artist as a sexually aroused crocodile (figure 27). The late art critic Olivier De-

27 Francisco Toledo, *Mues inmóviles 1*, 1993.
Photograph.

broise (2006c, 253) suggested that Toledo's encounter in 1968 and subsequent relationship with the feminist poet and activist Elisa Ramírez Castañeda had something to do with the very contemporary, liberated sensibility with which the artist expresses sexuality:

> His childlike brushstrokes and selection of informal materials, his inconsistent supports and his play with sexuality (something that became more explicit from 1970 on) were all still there, but now they seemed to be engaging directly with feminism, with the beginnings of what would be called queer studies, incorporating Lacanian perspectives, rhizomatic platforms, and other poststructuralist philosophical systems. The zoophilia that was cultivated—at least in theory—by some of his mentors in Paris, and based, according to some scholars, on Zapotec oral traditions, moved to the center of the work, even if visually diluted through his use of gouache, textures, and intertwined forms. The work turned out to be provocative mainly for urban, mainstream collectors, delighted by having discovered some sort of sexually unleashed Walt Disney: they shamelessly exhibited and acquired

Toledo's subtly immoral watercolors and oils for the simple reason that in the 1970s, just to talk about sex was to be modern.

Campbell (2008) doubts the significance of Ramírez Castañeda's feminist influence on the sexual content of Toledo's work. He suggests that Toledo's thinking about sex and gender is more related to the influence of his Zapotec relatives and women who were active in the COCEI and "is connected to the Zapotec penchant for laughing about sex in daily life." Campbell believes that Toledo's images of "pagan pantheism" and "anarchic sexual freedom" are "also a result of the influence of [the Juchitán-born] Andres Henestrosa's writing and the work of [Miguel] Covarrubias and other famous artists Toledo admired."[17]

Guchachi' Reza (Iguana Rajada), the premier journal associated with the political and cultural movement that arose around the COCEI, contributed significantly to fostering an image of contemporary Zapotec identity as a hybrid of ancient traditions and modern sophistication reflected in its representations of sexuality. The very name of the journal illustrates this phenomenon. As explained by Víctor de la Cruz (1988, 49), a former editor of the journal and former director of Juchitán's Casa de la Cultura, *guchachi' reza* in the Zapotec language *didxazá* means "sliced iguana" (*iguana rajada* in Spanish) and was chosen as a symbol of resistance. Iguana meat and especially iguana eggs have been an important part of the Zapotec diet since pre-Hispanic times, especially during festivals and special celebrations. The iguana, de la Cruz slyly notes, has two sex organs so that it can alternate between one and the other as it tires, thus allowing for almost constant sex and reproduction—a theme central to some of the artists just discussed. Some poor Zapotecs who make their meager living gathering and selling iguana eggs will slice open the stomach of the female iguana, remove her eggs, and then sew her back up so that she may return to her sex life and produce more eggs. In de la Cruz's telling, the "sliced iguana" becomes a symbol of the Zapotec culture's constant adaptation, resistance, and survival.

Guchachi' Reza illustrates its articles dedicated to the recovery of Zapotec history and culture with sophisticated contemporary artwork. The June 1984 issue, for example, which features de la Cruz's critique of work done by foreign social scientists in the Isthmus of Tehuantepec, is accompanied by José Luis Cuevas's provocative drawings of "burgueses y burguesas" (bourgeois men and women) sitting on a toilet, masturbating, urinating, crying out, or gasping for air. The March 1984 issue, which is filled with historical analysis

and documents, including an interview with the famed railroad union leader Demetrio Vallejo, is boldly illustrated with artwork by Nahum Zenil, one of Mexico's most famous gay artists. Known for his self-portraits, Zenil reveals himself on the cover as a *china poblana*—an iconic nationalist representation of Mexican womanhood—and simultaneously as a masked devil with erect penis. In another drawing Zenil transforms himself into a Tehuana market vendor; her skirt is hiked up mid-calf and dozens of fish flow out from under her skirt. In another, a naked Zenil sits on a chair and stares at the viewer from inside an opened armoire, perhaps inviting readers to consider the ramifications of opening homosexuality's closet.

Compared to the representations of gender and sexuality found in much of the work that came out of the student, grupos, and Chicano movements, those produced in the context of the Zapotec movement would seem to offer a collective identity more comfortably reconciled with feminist and queer sensibilities and demands. The reality, however, is that the movement's more positive and varied representations of women and sexuality were not accompanied by women's and homosexuals' representation within the movement's formal leadership hierarchy. According to Jeffrey Rubin (1997, 232),

> COCEI's male leaders claimed a feminism that was at odds with women's actual social and political roles. COCEI leaders spoke repeatedly of Juchitán's egalitarian gender relations and about the equal participation of women in the movement. . . . However, . . . women did not hold positions of leadership within COCEI and generally did not participate in the artistic and literary activities that were central to the movement's cultural project. Furthermore, Juchitecas suffered enduring forms of exploitation and subordination on a day-to-day basis, including sexual double standards, limited educational opportunities, responsibilities for both household and money-earning activities, and domestic violence.

Rubin's observations are confirmed by other scholars who note that women's "access to formal leadership roles is restricted to particular spheres (e.g., the teachers' movement, market women's organizations, and the cantina owners' association), and there are no women on the COCEI Political Commission or among the top leadership" (Campbell et al. 1993, 151). Elisa Ramírez Castañeda, the feminist poet and anthropologist who lived with Toledo for eleven years and bore two of his children, may have influenced Toledo's gender politics, as Debroise suggested, and, according to some sources, she

played a role in the early founding of the Casa de la Cultura in Juchitán and in editing early issues of *Guchachi' Reza*.[18] However, I did not see her name listed among the editors in the journal, and her role in the movement is not mentioned in studies of the COCEI by Campbell (1994) and Rubin (1997). Campbell (2008), who has been going to the isthmus since 1981, said that while Elisa Ramírez Castañeda was "important in the early years of COCEI . . . I never saw her nor did people ever talk about her much." It seems possible that her political and intellectual significance may have been taken less seriously because of her personal relationship with Toledo. Ramírez Castañeda studied the Zapotec language and researched indigenous oral traditions, but she recalls the snide whispers, "Look at Toledo's woman, doing silly little things" (Abelleyra 2001, 59).

Elena Poniatowska's exuberant feminist description of Juchitecas cited earlier has been challenged by the Oaxacan native Obdulia Ruiz Campbell (1993, 140) as representing an outsider's romantic gaze that wants to turn Zapotec women into Amazons and ignores the harsh reality of their lives as women: "At an early age, I realized that Zapotec women suffer from the temperament of their demanding, scolding, abusive, and drunken husbands. Isthmus men frequently beat their wives and children. Without intending to disturb the memory of my two grandmothers, I recall that they suffered a great deal from mistreatment by their adulterous husbands until the days of their deaths."

In testimonies collected by Marta Bañuelos (1993, 177–82), COCEI women recall having been jailed and tortured. "There have been compañeras who have died in the struggle," recalled Vicenta Pineda, such as Lorenza Santiago "who was shot down in protest against vote fraud." Yet of the many posters and graphics I found decrying repression of the movement, only one depicted women as the victims: In Fernando Olivera's graphic depicting military repression in Juchitán, a hulking military policeman stands over the prone body of a woman dressed in a traditional huipil; her right hand clings firmly to a banner while her left hand struggles for control of the policeman's bayonet (figure 28). Yet even here, the image is of an anonymous, generic Tehuana, who stands again as a symbol of her people's strength and resistance, not as the representation of a particular, real-life woman militant.

"Zapotec culture in Juchitán exhibited forms of difference and ambiguity regarding male gender roles that were also absent from COCEI's artistic and political narratives," noted Rubin (1997, 232–33), who went on to explain:

28 Fernando Olivera, *No pasarán*, c. 1983.
Engraving.

Men publicly identified in both Zapotec and Spanish by the Zapotec word
muxe played a prominent role, distinct from those of both women and
other males, in economic and ritual activity. Boys often took up this iden-
tity in adolescence and went on to perform economic roles associated with
women, such as food preparation and marketing, to reside in their mother's
houses, and to dress in ways that were partly, though not entirely, asso-
ciated with women. Muxe also played particular public roles in the division
of labor at fiestas, where they also sat among women and danced as women,
while exhibiting body forms, dress, and adornment that mixed common
"male" and "female" characteristics. At the same time, prominent men ru-
mored to be homosexual who did not adopt the muxe identity were spoken
of pejoratively, and there was strong public sentiment against either men or
women living together as couples.

Campbell (2008) doesn't deny instances of homophobia within the move-
ment, but he also notes that "homosexuality if not always praised was some-
how always present and understood as part of the culture and community, not

some bizarre deviation." This seems to be less true in the city of Oaxaca, where Zapotec cultural traditions are not as strong as in the isthmus and in smaller pueblos of the Valley of Oaxaca. Gerardo de la Barrera is a Oaxacan artist involved in AIDS activism who has produced a series of exquisite male nudes done as intaglios and a series of landscapes as metaphors for the female body. De la Barrera (2001) says, "It's not that hard here [in Oaxaca City] anymore to be openly gay as long as you're not 'flamboyant' or a transvestite." Nevertheless, de la Barrera (2009) says it look him a long time to overcome his fear of addressing erotic themes, "because I was raised in a very conservative environment." He describes his decision to create and exhibit erotic work as a necessary step toward "liberation," a declaration that "this is what I am." But when asked about other gay artists, he said there are very few who are out of the closet, and he was reluctant to reveal their names, which suggests a less-than-safe atmosphere. Felipe Morales is another Oaxacan artist who has created an extensive body of erotic work, including homoerotic paintings and prints. Like de la Barrera, he has also supported local AIDS activism. Morales (2009) says his erotic work has sold very well to tourists in some of Oaxaca City's best galleries but that homosexual themes remain a "taboo" among many locals.

Moreover, despite the relative comfort with which many activist artists in Oaxaca approach the human body and the centrality of sex, I found little evidence of a feminist consciousness about such issues. For example, when I pressed the Zapotec artist Nicéforo Urbieta (2001) about his frequent use of the female body to signify fertility and maternity, he hesitated some, apparently disturbed by the observation, and then responded that there was also an important erotic element in his painting of the female body, which he associates with the more open sexuality of his Zapotec community. I then pointed out that he usually paints female nudes alone, not with male figures, and that the erotic content or charge in his work seems focused on the female body rather than on the male or even a couple. He admitted that this was true but said he had not analyzed it and wasn't able to explain it. Perhaps my outsider's eye lead me to misread Urbieta and his artwork, but the lack of a critical perspective on gender from this otherwise sophisticated, highly analytical activist artist seemed striking.

As noted by Rubin, Campbell, and other observers of the Zapotec movement, there were very few women active among the movement's core group of artists and writers. The most prominent women artists associated with the movement, such as the photographers Graciela Iturbide and Lourdes Gro-

bet and the poet Elisa Ramírez Castañeda, were not from Oaxaca. When I interviewed Marcela Vera, a Oaxacan, mestiza painter who, together with her Zapotec compañero, is involved in grassroots community organizing in the Zapotec town of Zegache, I found that many of her paintings contain a nude female figure. But she was reluctant to claim a feminist reading of her work. In one of her large-scale paintings, the central figure is a reclining female nude, which is also a landscape. A small, olive-green airplane is flying over the body, appearing to me as a sinister, alien force invading the body or territory. Transparent blood-red paint drips over the body. When I suggested a relationship between military and state repression or control and patriarchal, sexual control, Vera (2001) said that she liked that reading but that's not what she had in mind. Then, why the airplane? "I felt the painting needed that particular green in that portion of the painting, and the airplane was simply the figure I used to add the green."

Thus while Zapotec artists helped to represent the movement's indigenous identity through images of powerful women and erotically fluid sexuality—and movement publications and cultural centers featured work by feminist and gay supporters from Mexico City—the movement appears not to have fostered much space for Zapotec women and homosexuals to articulate a critical consciousness about gender and sexuality and to exercise meaningful leadership within the COCEI. Unlike the Mexico City and California movements, gendered and sexual contradictions within the Zapotec movement did not give rise to self-organized feminist groupings of artists. Ironically, this is perhaps explained in part by the fact that positive images of women figured so prominently in the movement's representation of itself, thus masking women's actual political and intellectual marginalization. At least three other factors likely help to explain the absence of a self-identified group of feminist artists within the Zapotec movement. First, in isthmus Zapotec communities, women's prominent position in commercial activities ameliorates other manifestations of gender inequality. Second, the long tradition of an institutionalized third gender—the muxe—makes the overall experience of "doing gender" somewhat less confining. And finally, the poverty and underdevelopment of Oaxaca, relative to Mexico City and California, means there are far fewer opportunities for everyone—men as well as women—to pursue higher education, be exposed to alternative discourses such as feminism, or to make a living as an artist.

CLASS ACTS: SOLIDARITY VS. IDENTITY

The work of activist artists also reveals a great deal about each movement's relationship to the working class. Imagery of both rural and working classes appears much more frequently in Zapotec and Chicano movement art than in Mexico City movement art of the era. More revealing than the frequency of such imagery, however, is the quality of social class identification conveyed by the artwork. With some important exceptions, the Mexico City–based movement art tends to portray working-class people as a somewhat abstract "other," whereas Zapotec and Chicano artists tend to present themselves and their movements as of the working class.

In several of the graphics from the student movement of 1968, small, cartoon-like figures of people coded as urban working class or *campesino* by their dress appear dwarfed and overwhelmed by the gigantic, fierce presence of the state's repressive apparatus (Grupo Mira 1988). In these graphics a working-class woman is typically shown with an apron covering a swollen belly, while the urban male figure evokes the tragicomic *pelado*, a standard caricature of the urban poor in twentieth-century Mexican graphics, theater, and film (the most famous example in film being Cantinflas). In student movement and grupos art, the working class is a social sector viewed sympathetically if not empathetically, whose struggle merits our solidarity, a group to be pitied and perhaps won over as an ally for the student struggle, or as an abstract oppressed class whose exploitation should be exposed and protested. An example of the latter is Grupo Suma's repeated use of the stark silhouette of a stooped male worker whose posture suggests years of hard physical labor or perhaps resignation. The image was stenciled on walls in Suma's street art and in installations. In one example, titled *El desempleado* (The unemployed), the worker's silhouette is stenciled over what appear to be computer punch cards (figure 29). Suma's street art and installations often included high-contrast photographic images of the urban poor, such as one of a young street urchin. The image suggests hunger; the boy is dressed in over-sized pants, his right hand, perhaps holding a scrap of tortilla, is raised to his mouth. In Suma's work, images like this were sometimes combined with the silhouette of a man dressed in a business suit and carrying a brief case. The images starkly convey a sense of Mexico's extreme class inequality, but they do not project an empathetic identification with the subjects.

The grupo Tepito Arte Acá worked to develop a more organic relationship with the urban working class. As early as September 1973 the group of visual

29 Grupo Suma, *El desempleado*, c. 1978. Stencil on computer punch card.

artists who would eventually form the collective created "a large environ-ment, incorporating photographs, texts, music, and installations, that sought to recreate a sense of daily life in Tepito, a working-class neighborhood in the heart of Mexico City" (Debroise 2006a, 209). The next year the group painted a series of murals in a Tepito tenement, which reportedly gained them enthu-siastic support from the neighborhood associations. Nonetheless, there is a distant, almost academic quality to the murals' heroic, social realist represen-tations of the working class. Pedro Meyer's photograph of one such mural em-phasizes this distance: a real working-class woman is hanging laundry in front of the mural's images of several nude, muscular men in heroic poses and one pieta-like woman, her head covered by a shawl, carrying a child (figure 30).

An exception to this more distant relationship to the working class is found in the artwork of the late Rini Templeton, much of which was produced in collaboration with various grupos and political organizations in Mexico City. Templeton filled her work with images of working-class men and women active in all aspects of their lives—at work, at play, in celebration, in love, at school, in meetings, on the picket line—"donde hay vida y lucha," where

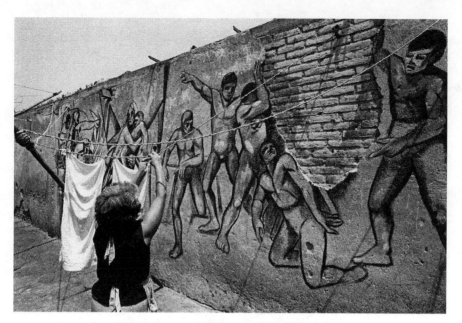

30 Tepito Arte Acá, untitled mural, c. 1979. Photograph by Pedro Meyer.

there is life and struggle, as the last series of her silkscreen prints was entitled. One print from that series depicts a woman with large hands and muscular arms (Martínez 1987, 73). Her right hand clasps what may be a subway pole or picket sign—bold vertical lines that anchor the image. She looks directly, confidently at the viewer. Templeton's simple but powerful black-and-white images—meant to be easily photocopied for mass distribution—managed to convey her subjects' full humanity. Ironically, Rini Templeton was neither Mexican nor of the working class. She was a U.S.-born feminist artist who rejected the class privilege into which she was born and who contributed to the COCEI and Chicano movement as well as to the grupos in Mexico City. Embraced by the Mexican art world as one its own, Templeton's work has been characterized by the esteemed art critic and historian Raquel Tibol (1998) as the culmination of Mexican graphic art in the 1980s.

The centrality of the working class and of working-class women in Templeton's graphics is explained in part because her work documented the rise of the new women-centered popular movements of the 1980s. Beginning in the early 1980s, the government's imposition of a neoliberal structural adjustment program to resolve Mexico's debt crisis, followed by the devastating earthquake of 1985 in Mexico City, contributed to a shift in the focus of social

movement activity. Poor urban neighborhood struggles over housing, land, public services, the cost of living, and democratic participation in local and national governance came to dominate the social agenda. One of the more significant aspects of this change was the emergence of working-class women as the critical base and leadership of many of the new movements, often in collaboration with former activists of the student movement of 1968, including a new generation of feminists.[19]

Social movements of the late 1960s and 1970s and the democratic openings they created also gave rise to a generation of photojournalists who changed the visual representations of Mexico's social class dynamics through the extensive publication of their photos in new, independent newspapers and magazines. In a detailed analysis of the work of photographers such as Elsa Medina, Marco Antonio Cruz, and Francisco Mata, John Mraz (2009, 217) argues that "the imagery of daily life produced by the New Photojournalists is neither folkloric nor officialist, neither sentimental nor sensationalist." Mraz illustrates his analysis with a photograph by Medina, "in which hands reach out from all sides to grab onto a subway pole" (216). The photograph's composition is strikingly similar to the silkscreen by Templeton described above, but in Medina's photograph the central female figure, wrapped in a rebozo, is in a crush of people and does not look at the viewer. In Mraz's analysis, the New Photojournalists aim "to discover and represent Mexico's reality in photographs that insistently document the class differences that define the country" (217).

There is, however, an important if perhaps subtle distinction between documenting class differences and representing an artist's or a movement's class identity. Zapotec and Chicano movement art tends to represent the movement *itself* as working class. The very name of the Zapotecs' main political organization — Worker-Peasant-Student Coalition of the Isthmus — emphasizes the importance of class identity for this indigenous movement, a characteristic evident in the photographs by Lourdes Grobet, Rafael Doniz, Graciela Iturbide, Luis Montes de Oca, and others that played such an important role in projecting the movement's identity to the rest of the world. Images of working-class men and women also figure prominently in the graphics of Fernando Olivera and Delfino Marcial Cerqueda discussed above. Rini Templeton spent several months creating graphics for the COCEI in the early 1980s, working closely with the artist Sabino López in semiclandestine conditions during the height of the government's repression of the movement (López 2006). Her bold, economical, black-and-white images, often produced on

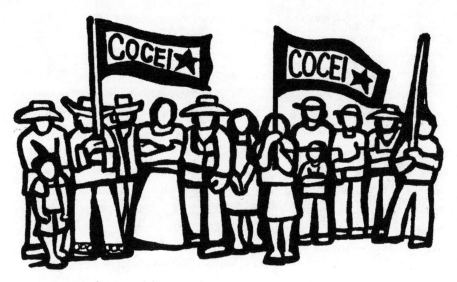

31 Rini Templeton, *Untitled*, c. 1980. Ink on paper.

scratchboard, capture the movements' ethnic, working-class, and campesino identities with deceptively simple renderings of sturdy bodies wearing broad-brimmed straw hats, baseball caps, T-shirts, flowing skirts, huipiles, simple shifts, and huarache sandals. Class, ethnic, and community pride are made evident in one of Templeton's empathetic graphics in which a dozen men, women, and children stand firmly, some with arms crossed in defiance, others holding COCEI banners aloft (figure 31).[20] This same image was reproduced, on a mural scale, on the wall of the Alvarez Bravo Photography Center in Oaxaca for an exhibition about the COCEI in 2006.

Identification as working class is even stronger and more consistent in Chicano movement art. The sometimes quiet, sometimes exuberant pride and dignity of Chicano working-class communities is present throughout Carmen Lomas Garza's many portraits of quotidian family and community activities.[21] "In many respects, the sequence of Lomas Garza's paintings resembles the pages of a family album or a young woman's diary," writes Mesa-Bains (1991b, 136). The urban Chicano working-class youths who sit on the stoop in Healy's *Ghosts of the Barrios* (figure 21) are not abstract symbols of social class but convey the familiarity of brothers, cousins, and friends. The smiling, stocky working-class men standing shoulder-to-shoulder on a back porch in the Los Angeles photographer Adam Avila's portrait from 1975 are literally *Cuatro Hermanos* (Four brothers), as the photo's title indicates (Griswold del Cas-

32 Ester Hernández, *Renee, La Troquera,*
1989. Pastel on paper.

tillo et al. 1991, 259). Avila's photographs share with Mexico's New Photojour-
nalists an appreciation for the quotidian dignity of working-class life, but they
project a more intimate identification with the subjects.

I was reminded of these photographs when I read Davalos's (2001, 133) de-
scription of a photo exhibition entitled *Celebrate Pilsen!,* Pilsen being a largely
working-class, Mexican neighborhood in Chicago. Davalos describes a sensi-
bility to the social class dimensions of an ethnic community's identity that is
also apparent in much of the work by California Chicano artists: "Capturing
their homes, families, and neighborhood, the exhibition translated struggle,
poverty, and urban decay into a Mexican community's traditions and memo-
ries. The move to authenticate the everyday cultural practices of Mexicanos
and Mexicanas is a revisionist interpretation of the dominant stereotypes and
racial hierarchies in the United States. Instead of representations of down-
trodden, passive victims or the opposite stereotype of lazy welfare cheats, the
exhibition interpreted the photographs as representations of authentic Mexi-
can country."

Leave it to the fearless Ester Hernández to disturb our comfortably hetero-sexual gaze at "authentically" Chicano working-class families and couples. In a pastel from 1985, Hernández gave us *Renee, La Troquera*, a sexually allur-ing female truck driver (figure 32). Seated inside the cab of her truck, Renee faces the viewer through the passenger widow. Loose tendrils of hair brush her high cheek bones, big sunglasses hide her eyes, and her sleeveless shirt reveals strong arms as her tongue licks the index finger of her leather gloved hand. Proud working-class identity, like cultural nationalism, helped to forge strong unity within the Chicano movement. But working-class authenticity, like ethnic and national authenticity, has been represented as unalterably heterosexual in progressive Mexican social movements at least since the early twentieth-century broadsheets of Posada and the political cartoonists of the working-class press discussed at the beginning of this chapter. Hernández's truck driver and the Guadalupe-tattooed woman of her *La Ofrenda* refuse to let sexual longing stand in the way of belonging. They refuse to be excluded from their class, their community, their movement. They seem determined, like Anzaldúa (1987, 22), "to stand and claim [their] space."

"Styles are *significations*," wrote André Malraux, "they impose a *meaning* on visual experience" (quoted in Glazer 1994, 415). In his memoirs, Edmund White (2006, 162–63) recalls a close friend who defied modernist expectations about the relationship between an artist's style and identity: "She thought of herself as a bold abstractionist and she slashed and dabbed at her canvas with a palette knife or big wide house-painting brushes. The worst thing in those days was to be 'weak' or 'delicate' or 'unresolved.' We all subscribed to the belief that only men, only heterosexual men, were cut out to be painters. Only they had the visionary violence, the power to translate directly feeling into gesture, the nerve to stick by bold, split-second decisions." It was the early 1960s and the New York–centered abstract expressionist movement of macho painters like Willem De Kooning and Jackson Pollock still cast a giant shadow over the art world. After World War II, the New York School helped to assure that the United States' new economic and political hegemony would be shored up culturally by dethroning Paris as the center of modernist Western art (Cockcroft 1985, 129). But by the 1960s, abstract expressionism— interlaced as it was with meanings of modernism, nationalism, individualism, and gender—was already being challenged by postmodernist currents such as pop, conceptual, and feminist art and by regional developments like California Cool and the emerging Chicano art movement.

In 1960s Mexico City many young artists had begun to chafe at a different modernist aesthetic: the state-sponsored Mexican School of art—a didactic, social realism associated with muralists like Diego Rivera and graphic artists like those in the Taller de Gráfica Popular (TGP). Grupo Mira (1988, 18), a collective of artists active in the student and grupos movement, recalled that "the themes, as well as the formal and technical solutions used by the TGP had become recipes. That is one of the reasons why—in the graphic arts—the new artists began to experiment with other expressions." As the hegemony of the social realist Mexican School, closely associated with the nationalist state, was collapsing, "a proposal to create a national 'school' of abstract painting" emerged: "geometrism" was promoted as "a type of institutional symbol of modernization" that also "evoked nationalist referents like the geometric patterns found at archeological sites" (Medina 2006b, 128). The artist Felipe Ehrenberg, a key figure in Mexican conceptual art and in the grupos movement, captured the irony: "There we were, in a Westernized Mexico, obeying Eurocentric paradigms even as we searched for an identity; a tragicomic search to be sure, as it concerned middle class thinkers . . . creolized *Mestizos* who glorified a Pre-Columbian past while they turned up their noses at its descendents: house servants, gardeners, bodyguards and watchmen that care for their barred streets" (Ehrenberg 2007a, 205).

In Los Angeles in the 1960s the sculptor and muralist Gilbert "Magú" Lujan (1997) recalls that he was as critical of those artists in the Chicano movement who "felt that aesthetics had ended with Diego Rivera" as he was with those, like the painter Carlos Almaraz, who, he claims, "wanted to be Jackson Pollock." "I didn't want to be Diego Rivera," says Lujan. "I wanted to be a Chicano artist. Not Mexican. I knew the difference. And so I was trying to do a home-grown product. Something out of the experience of East L.A., because that's what we were. We were not Mexicans; we were not New Yorkers." Guillermo Gómez-Peña (1996, 189), a Mexican-born artist who has worked in California and collaborated with Chicano artists for many years, observed, "Hegemonic centers like New York, Paris, and Mexico City have manufactured sacred cannons of universality and excellence that we are expected to follow in order to break out of regionalism or ethnicity. But these dogmas are crumbling."

The projection of a social movement's identity and agenda through art clearly involves formal and other aesthetic considerations as well as subject matter. Mexican and Chicano movement artists from the 1960s could draw upon a variety of influential art movements, including the Mexican School's

social realism, North American abstract expressionism, and newer international, postmodernist trends.[1] The stylistic and formal choices made by the artists were loaded politically. As the statements by White, Ehrenberg, Lujan, and Gómez-Peña suggest, association with one or another art movement could take on gendered, racialized, and/or nationalist meanings. This chapter examines the political significance of activist artists' stylistic choices and emphasizes that the full meaning of those choices only becomes clear when we consider the local, national, and international contexts.

THE MEXICAN SCHOOL'S LONG ADIOS

Consolidation of Mexico's postrevolutionary regime from the 1920s through the 1950s involved an ambitious state-funded public arts program. A distinctively Mexican modernism appeared in murals, paintings, and prints in what has been described as "one of the most visually exciting and politically dynamic periods in the history of the graphic arts" (Williams 2006, 1). The works of the TGP engraver Leopoldo Méndez and Diego Rivera are classic examples of the social realist, *indigenista* art that came to signify modern, postrevolutionary Mexico and shape the nation's racial discourse. In Méndez's linocut of 1938 *Tengo Sed* (I am thirsty), an Indian with strong, prominent profile and thick, coarse hair kneels naked and alone in a stark, desolate landscape (Ittmann 2006, 18). His hands are clenched, arms thrown wide, seemingly more in awe than anger at his harsh surroundings. In Rivera's *Sueño* (Sleep), a lithograph made in 1932, a huddled group of Indians sleep (Ittmann 2006, 13). Drawn with soft, voluptuous curves and shadings, the men have pulled hats over their faces, the young women—mothers or sisters—envelope the children, and a dog snuggles close for warmth and comfort.

By the 1940s a semiofficial Mexican School of art had consolidated its hold over the nation's art institutions, including the national academies of art, San Carlos and La Esmeralda, where most of the student movement artists of 1968 studied and produced the movement's artwork. However, many young artists of the '60s had come to regard the so-called Mexican School as yet one more sign of Mexico's "frozen revolution," a label popularized in Leftist circles by Raymundo Gleyser's 1971 film of that name. In a famously controversial essay published originally in the late 1950s, the painter José Luis Cuevas ([1958] 2001, 205–6) described the plight of "Juan," an apocryphal artist, born of the working class, who was both trapped and protected by postrevolutionary Mexico's "cortina de nopal" (cactus curtain):

Juan was taught at La Esmeralda to draw the figures in a simplified manner, with large hands and feet, with curves, undulating, in planes with special foreshortening, so that certain intellectuals may call them "strong." . . . Everything is solved with such formulas: the man with the brightly colored scarf or the Indian woman with flowers at the market, or the oil rig worker or one of those proletarian maternities that have been reproduced for over thirty years. . . . Juan's friend . . . warns him that he mustn't show the works of capitalist bourgeois tendency that he has been doing lately under the influence of nefarious foreign magazines. . . . Juan, with the protection of official and semi-official institutions begins to progress, because he has some talent, in spite of the fact that he has not been allowed to do with his art as he originally intended. . . . By supporting decisively, blindly, and without even being asked all that is picturesquely Mexican, he will repeat the usual clichés to keep Nationalism in operation. . . . He is riding on velvet rails in the "only possible way" to paint. And so Juan has found shelter behind what we call a "cactus curtain."

Cuevas's sharp but humorous critique reflected the sentiments of a growing number of prominent young Mexican artists in the late '50s and '60s whose highly public break with the Mexican School became known as the Ruptura (Rupture). Apart from their stance against the creative and political limitations of Mexico's cultural establishment, there was little commonality among the wide variety of styles, themes, and media explored by the Ruptura generation of artists. Cuevas, for example worked in a figurative expressionist style, Lilia Carrillo's paintings were in the abstract expressionist mode, while Manuel Felguérez created sculptures and paintings in a language of geometric abstraction.[2] By the 1970s the Mexican School had been eclipsed "by the so-called Ruptura Generation's very personal integration, assimilation, and interpretation of new international currents such as neofiguration, informalism, expressionism, geometrism, fantastical art, abstract expressionism, Pop Art . . . , Op Art, scientism, and post-painting abstraction" (Favela Fierro 2000, 16).

Initially, such artistic experimentation carried risks of marginalization, censorship, and ridicule. Bright and Bakewell (1995, 32) described an attitude within the Mexican art world that was pervasive at mid-twentieth century: "If Mexican artists are not visibly nationalistic, they are not honoring their country and themselves and may risk being labeled 'anti-Mexican' or 'foreign' by public or private consumers." Some powerful figures in the Mexican art world

viewed the new international art trends with suspicion. Raquel Tibol (1992), for example, an influential art historian, critic, and associate of Diego Rivera and Frida Kahlo, saw the hand of U.S. cultural imperialism at work in promoting depoliticized art currents. The argument is that during the Cold War, the United States carried out a "hegemonic cultural program" in several Latin American countries through various cultural exchange programs organized by the U.S. State Department and other agencies. "Abstract expressionism was the chosen artistic tendency, in part because of the impact of this visual expression produced by an admirable generation of artists, and because its philosophy emphasized individualism and propitiated an art that was distant from the politicizing content of Mexican muralism" (Favela Fierro 2000, 15).

During the Cold War, abstract expressionism "spoke to a specifically anti-Communist ideology, the ideology of freedom, of free enterprise" (Saunders 1999, 254). The United States Information Agency, the CIA, and New York's Museum of Modern Art all promoted international exhibitions highlighting U.S. abstract expressionism, "the perfect contrast to 'the regimented, traditional, and narrow' nature of 'socialist realism'" (Cockcroft 1985, 129).

Ironically, the North American artistic influences that proved to be far more attractive to Mexico's rebellious, postrevolutionary generation were those deemed "subversive" by U.S. governments and conservatives of the era. José Luis Cuevas (2001), for example, says he experienced the "sexual revolution" in New York, where he was influenced by the intellectual circles around Grove Press, famous in the 1950s and '60s for publishing the provocative work of authors such as Lawrence Ferlinghetti, LeRoi Jones, and Jean Genet. It was in New York, in an "almost hallucinatory state" after getting lost on the subway and soaked in a rain storm, that Cuevas first read Kafka's *Metamorphosis* and was inspired to paint the monsters—more humorously pathetic than frightening—in his *Alucinación* of 1956 (Goldman 1981, 112). Sex and psychological torment conveyed through figurative expressionism have remained constants in Cuevas's work.

Another source of subversive North American influence was Margaret Randall, the Marxist, feminist writer who, together with the Mexican poet Sergio Mondragón, cofounded and edited an influential poetry journal in Mexico City that circulated in revolutionary networks throughout the Americas. From 1962–69, *El corno emplumado* (The plumed horn) "not only forged links between Latin American and U.S. culture and poetry, it also provided space for innovative visual imagery, with design inspired by Pop aesthetics and Cuban poster design" (Debroise 2006a, 168). Felipe Ehrenberg was deeply in-

fluenced artistically and politically by his collaboration with the journal and his friendship with Randall (Medina 2006c, 158). Ehrenberg's pop-influenced artwork was used on the cover of the magazine's twenty-fourth issue.

Arnulfo Aquino was an art student in the San Carlos Academy in 1968 when the student movement took hold. As he remembers it, the art students were well aware of the influence of the new international trends and of the Ruptura artists: "We wanted to change and innovate; we wanted to know pop, minimalism, abstraction, etc.," but "the professors at San Carlos were still very much within the tradition of the Mexican School, and Siqueiros was still very influential" (Aquino 2001). There were discussions and heated debates among the students about what style to follow, and when students organized the first show of abstract art at San Carlos in 1965, Aquino (2001) recalls, "the debates led to divisions." To protest one exhibition that they regarded as too traditional and academic, students covered the show with toilet paper. But until the student movement of 1968, the "rupture" at San Carlos between students and authorities was mainly "artistic." The real political rupture came that summer, when the army broke down the door of the San Idelfonso preparatory school as part of the government's crackdown on mounting student protests. Students at the nearby San Carlos Academy were among the first to go on strike in protest of the repression, according to Aquino.

In a somewhat "paradoxical" move, as Aquino put it, when the art students who longed to experiment with new artistic styles began to produce hundreds of posters, flyers, and banners for the movement, many of them returned to the visual language of Mexican social realism that had long characterized the graphic art of the famous Taller de Gráfica Popular. Adolfo Mexiac, one of the great TGP masters, was an instructor at San Carlos in 1968, and his image of a man whose mouth is held shut by a chain was appropriated for one of the student movement's most widely reproduced posters (figure 1). At that moment, Aquino (2001) recalls, "use of the TGP language and media seemed the most natural, most accessible." It seems likely that the recognizably Mexican visual language of the TGP was also appealing to student protesters who felt compelled to respond to the government's propaganda that the movement was infiltrated by foreign subversives. In another irony, the distinctively Mexican graphic style—which would have been read as "Communist" subversion in the United States, where Leftist artists in the 1930s and '40s had been influenced by Rivera and Siqueiros—clearly identified the movement as homegrown. Aquino emphasized that the primary concerns of the artists, in the context of the movement, were more practical than aesthetic, regardless of

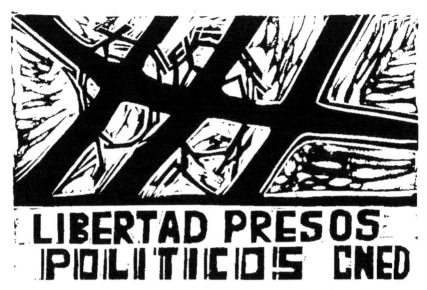

33 Anonymous Central Nacional Democrática de Estudiantes artist, *Untitled*, 1968. Silkscreen.
Reprinted from Grupo Mira (1988).

how important aesthetic experimentation was to their work before or after the
movement.

Dominique Liquois (1985a, 10) notes that the urgent political demands of
the movement led young art students like Aquino to reexamine and attempt
to update theories from the 1930s about art and activism and the importance
of didactic graphic art. Even though social realist imagery dominates much
of the graphic art from the movement of 1968, we also find elements drawn
from pop art (such as a poster for a "festival popular" that features a repeated,
Warhol-like portrait of a youth with a '60s unisex hairstyle), contemporary de-
sign (one poster is composed of a grid of nine symbols of repression designed
in the contemporary style of the signage for Mexico's then shiny new metro),
and abstract art (such as the poster shown in figure 33 demanding freedom for
political prisoners) (Grupo Mira 1988, 95, 72, 36, respectively). Geometrism,
op art, and Cuban and Czech poster art styles also appear in various move-
ment posters of 1968. Stylistically, then, the graphics of the student movement
reflect sometimes conflicting concerns of the particular moment: to commu-
nicate, educate, and mobilize with clear, didactic images and text while ex-
perimenting creatively with abstract and conceptual elements; to break with
the old Mexican School and incorporate new, youth-identified international

influences yet evoke a clear national identity and avoid being labeled dupes of U.S. cultural imperialism. The student movement artists were remarkably successful in creating a powerful collection of graphic images that largely accomplished this challenging and sometimes contradictory set of goals.

Ironically, if the urgency of the student movement momentarily breathed new life into Mexico's moribund social realism, the violent repression of the movement only furthered the generation of '68's search for creative new visual languages consistent with their antiauthoritarian impulses. Then married, the artists Felipe Ehrenberg and Martha Hellion, for example, fled the repression in Mexico City and landed in London in 1969. As Ehrenberg (2007b, 161–62) recalls,

> In 1968, before the opening of the Olympic Games, I got dragged — together with a lot of other people — into the center of the hurricane that was the student movement. . . . Everything suggested that I was on the doorstep of the capital's measly art market. Instead, I fell into the social whirlwind that lasted until the 2nd of October. The atmosphere was so repressive by the end of the year that Martha and I saw no other alternative than to say goodbye to our families. I was 23 and a half when we got on a plane to England together with our two children.

There, under the influence of European art movements such as Fluxus, with which they collaborated, the couple's work turned toward the conceptual, combining bookmaking, action art, performance, found objects, and elements of popular culture. Ehrenberg largely abandoned painting at the time. As he explained in 1976, "I quit painting when I saw that it only made us marvel, without changing anything, when I felt film was winning me over, when I realized that to survive, the tactile and the trigger are needed. Not the brush" (Ehrenberg 2007a, 15). For Ehrenberg (2007c, 168), "the new art-actions were expressions of emotional, moral and ethical concern, with community and domestic, as well as social and political, ramifications. . . . There emerged more and more artistic works that moved away from the traditional orthodoxies." During his self-imposed exile in England, according to the art historian Cuauhtémoc Medina (2006c, 156), Ehrenberg's work "achieved a curious synthesis of many other practices suggesting a metonymic relationship between urban space and the space of the artists' book. This overlap of the street with the surfaces of writing would become one of the constant subjects of Mexican urban interventions in the 1970s."

While still in England, Ehrenberg began to influence the democratic

34 Felipe Ehrenberg, *Arriba y adelante*, 1970. Two hundred–piece mail art.

changes under way in the aesthetics and institutions of the art scene back home in Mexico City. He contributed in 1970 to the third of a series of exhibitions—*Salónes Independientes*, discussed more in chapter 5—organized by artists concerned with pushing aesthetic boundaries and breaking the Mexican state's control over the arts. Six of the founding members of the Salón Independiente had painted a mural at the National Autonomous University of Mexico (UNAM) in support of the student movement in 1968, and some of them used their first exhibition, mostly of paintings, to challenge government censorship (García de Germenos 2006, 50). Their third salón, held in 1970, was more radically experimental in that it was organized around collaborative, site-specific installations. Ehrenberg's contribution (figure 34), titled *Arriba y adelante* after Luis Echeverría's presidential campaign slogan, has been described by Pilar García de Germenos (2006, 53):

> Inspired by Pop Art, and drawing on the aesthetics of comics, Felipe Ehrenberg resorted to mail-art to "transport" his work, as a medium separate from galleries and the art market. From London, Ehrenberg mailed two hundred postcards to Mexico with nothing on them but a meaning-

less black blot and a postage stamp. In an invitation to collective participation, the piece only became visible when assembled by a team, like a puzzle on the wall, following a key on the reverse of the cards. Using advertising references and typefaces reminiscent of the graphics originally developed for the 1968 Olympics, Ehrenberg's work showed a nude woman, seen in a three-quarter view and in a seductive pose, holding a soccer ball in one hand, in allusion to the 1970 World Cup, which was held in Mexico, while the other held one breast, turning her into a contemporary Madonna.

Ehrenberg eventually returned to Mexico to become a major influence in Grupo Proceso Pentágono, which along with Grupo Suma, "emphasized aesthetics, trying to avoid at all cost mere pamphleteering" (Vázquez Mantecón 2006a, 198). Ehrenberg (1985, no page) recalls: "From the first meetings of the Frente [de Grupos de Trabajadores de la Cultura] . . . there was a confrontation between two opposing forms of conceiving artistic practice, both situated on the left. On one side were those who insisted on resuming and developing proposals made by militant artists from past generations, valiant at one time but questionable in the new reality. On the other side were those who insisted on developing techniques and work habits different from processes determined by the pictorial tradition."

Debates about style and aesthetics were clearly driven by political as well as artistic concerns. The new generation's antiauthoritarian and democratic impulses informed art projects that encouraged the collaboration of the public as well as of fellow artists and attempted to erase the line between fine art and popular culture. "Changes in artistic language went hand in hand with changes in the everyday language of the country's youth," observed Gerardo Estrada, coordinator of the UNAM's Cultural Extension program. He also noted that "in the visual arts, the revolution that had torn down the 'cactus curtain' found an exceptional ally in Helen Escobedo" (Debroise 2006a, 11).

Like Ehrenberg, Escobedo was influenced by new art trends in England, where she studied sculpture at the Royal College of Art in London. For the second *Salón Independiente* in 1969, Escobedo created what has been described as "one of the freshest and most innovative works to appear in Mexico in the 1960s." *White Corridor* was an installation produced specifically for the show. García de Germenos's (2006, 52) description of the piece emphasizes its participatory quality: "Using industrial supplies, she built a sort of penetrable roofed aisle that invited audience participation. Conceived of as an ephemeral creation, it produced feelings of depth and rhythm as one walked along its length

or crossed through it, the experience modulated by play of protrusions and voids." Escobedo, as director of the UNAM's University Museum of Sciences and Art (MUCA), would go on to play a key role in consolidating the grupos movement when she was instrumental in the decision to have four of the grupos represent Mexico at the Youth Biennial of 1977 in Paris (Liquois 1985a, 27).

In another example of creative doors opened by exile, Arnulfo Aquino, Rebeca Hidalgo, and Melecio Galván left Mexico in 1971 after the student movement, which was then struggling to reemerge following the massacre of October 2, 1968, and was then hit with a second wave of repression. They headed for California, where they worked with Chicano movement artists creating silkscreen posters in San Francisco and painting murals in Fresno and Livingston (Aquino 2007 and 2010, 31–33). When they returned to Mexico City in 1973, they "painted a mural in a public school with political themes and clear influences from Chicano pop trends" (Vázquez Mantecón 2006a, 199). Aquino also promoted an exhibition of Chicano posters in Mexico City (Maciel 1991, 116). As described in more detail below, while some Chicano movement artists produced work in the tradition of social realism, others incorporated pop culture with an ironic humor not typically found in the more solemn tradition of the Mexican School. Influenced by the Chicano artists they met during their short-term exile in Aztlán, Aquino, Hidalgo, and Galván helped to move some Mexican political art of the grupos era away from the solemn and toward what Tomás Ybarra-Frausto (1996, 171–72) calls the "ephemeral," "unrestrained," and "flamboyant" qualities associated with Chicano art's "*rasquachismo.*"

Those qualities are especially evident in the work of Peyote y la Compañía, which brought together photographers, visual artists, and writers under the leadership of Adolfo Patiño. Influenced by Marcel Duchamp's theory of the readymade — an inspiration also cited by Chicano artists like Rupert García (1996) — and a working-class urban barrio upbringing not unlike that of Los Angeles–based Chicanos — Patiño combed Mexico City's famous La Lagunilla flea market for "old postcards, prints, tickets, books, notebooks, toys, comics, stickers, photographs, product wrappers, and figurines" (Debroise 2006b, 206). David Maciel sees the influence of Chicano art in the work of Patiño and other artists associated with the neo-Mexicanist trend that emerged in the 1980s. In their presentation of "urban images mixed with expressions of love, religion, and eroticism," argues Maciel (1991, 117), "the neomexicanists find in the popular element a nostalgic approach and an opportunity to solve problems of form and circumstance."

Peyote y la Compañía's installation of 1979, *Artespectáculo: Tragodia Segunda*, combined drawings, collages, photographs, mannequins (including the one shown in figure 5), *milagros*, iconography from the Mexican flag, the Virgin of Guadalupe, and Day of the Dead, Pepsi bottles, cornflakes boxes, TV sets, and more. "Both of the groups led by Adolfo Patiño, Fotógrafos Independientes and Peyote y la Compañía, questioned notions of the traditional and the popular in a context where Mexican culture was increasingly permeated by U.S. consumerism and imagery" (Vázquez Mantecón 2006a, 198). The *Artespectáculo* installation was described by Olivier Debroise (2006b, 206): "Here, in brief, was all the paraphernalia that within a few years would become recurring imagery of neo-Mexicanism. In fact, . . . it was the most complete forerunner to the post-nationalist resurrections of popular icons and visual culture . . . ; it elevated a kind of urban kitsch that until then had never been considered the primary source for making art."

The installation incorporated many elements of this generation's aesthetic and political break with the Mexican School's social realism and its symbolic power as signifier of *mexicanidad*. The revolutionary era murals and TGP graphics aimed to illuminate without nuance, inspire awe or outrage, evoke a sense of national unity and pride, and prepare the masses to be mobilized (by the state or the "revolution"). *Artespectáculo*, on the other hand, offered no clear, linear narrative, no unambiguous critique or call to action. Public engagement with the piece seemed to rest on a shared familiarity with the messiness of daily life, the aesthetic pleasures of kitsch, an ironic view of power and authority, and a sense of humor in the face of near constant tragedy. Pleasure and humor, the work seems to suggest, are as essential to meaningful social change as is righteous indignation.

Ironic humor and elements of popular culture were also central to the work of feminist artists within the grupos movement, like Carla Rippey, Mónica Mayer, and Maris Bustamante, some of whom were inspired by experiences with feminist collectives in the United States. Before moving to Mexico and becoming involved with Patiño and Peyote y la Compañía, Rippey had lived in a feminist commune and worked with the women's movement in Boston in 1971–72: "We invaded a Harvard building to agitate for a women's center and were eventually able to buy a house for this purpose." Rippey claims that Peyote y la Compañía "had no formal interest in politics. As its name implies, it was primarily ludic," that is, playful. She describes one of their first projects as "basically a play on the various invasions of Mexico, and how the invaders always get absorbed by the Mexican culture" (Rippey 2003).

Mayer, who cofounded with Bustamante the Mexican feminist art collective Polvo de Gallina Negra, was especially influenced by North American feminist artists, such as Judy Chicago, with whom she studied in the 1970s at the famous Women's Building in Los Angeles (Mayer 2001a).[3] According to Mayer (2001b, 74, 76, 87), feminist artists in Mexico at the time were studying and discussing the artwork and writings of feminists like Judy Chicago, Arlene Raven, and Adrian Piper, as well as Ursula Meyer's early anthology on conceptual art. Yet Mayer and Bustamante also emphasized the homegrown and popular nature of their feminism: the collective's name comes from one of the folk medicinal products sold in traditional markets throughout Mexico as protection against "mal de ojo" (the evil eye). Approaching even the most serious subjects with humor, Polvo de Gallina Negra staged a street performance and intervention against sexual violence by distributing a "recipe for giving the evil eye to rapists" (Bustamante 1998).

Bustamante was also a founding member of the collective No Grupo, which combined super 8 videos, performance, costume, design, and sculptural elements into humorous but politically pointed "montajes de momentos plásticos" (montages of visual moments). A poster announcing one such "montage" drew upon Mexico's popular wrestling culture—a common element in No Grupo's visual repertoire—and promised a match of the "savage vanguard," including Bustamante's wrestling world alter ego, the "smasher of academics" (figure 35). No Grupo, in the estimation of historian Vázquez Mantecón (2006a, 198), "served as a critical and ironic conscience questioning outdated artistic practices and proposing alternatives for renewal." Bustamante (2001b) claims: "The real rupture with the Mexican School, which evolved from European muralism, came with the grupos of the 1970s, in our attempt to draw upon popular culture, which is the most syncretistic." "The structures of the Mexican School are European," she says, and while acknowledging the influence of European and North American conceptual and feminist art on the grupos, Bustamante (2001b) prefers to describe her work in terms of "non-objectual" art with "alogical" narratives, "because they are not European and not American; they truly reflect the particular reality of Latin America."

Not all of the grupos shared the enthusiasm of artists like Ehrenberg, Patiño, and Bustamante for aesthetic experimentation, irony, and irreverence. Germinal, for example, "called for a more pragmatic methodology for producing politically committed art" (Vázquez Mantecón 2006a, 198). Germinal, whose members were all art students at La Esmeralda, painted cloth

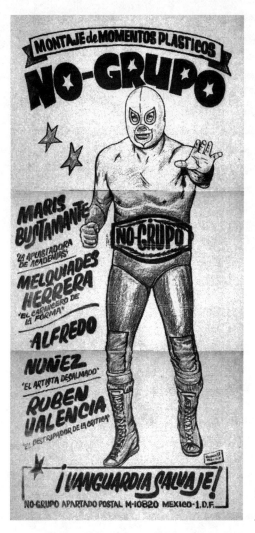

35 No Grupo, *Untitled*, c. 1980. Offset
triptych poster.

banners—such as the one about PEMEX discussed in chapter 2—and pen-
nants to be carried in protest marches and rallies. Their work incorporated
predictable iconography from the social realist tradition, such as raised fists
and caricature portraits of corrupt officials (Debroise 2006a, 223). Another
grupo, Tepito Arte Acá, sought to integrate their work into the daily life of Te-
pito, a working-class neighborhood in the heart of Mexico City. As discussed
in chapter 3, they produced murals on tenement walls with heroic represen-
tations of workers that echoed formal and thematic elements of Siqueiros's
work (figure 30).

While this new generation of activist artists had clearly blown a gaping hole in the "cactus curtain," making room for aesthetic experimentation that reflected the democratic and post-nationalist zeitgeist of the '60s and '70s, stylistic dogmatism occasionally reared its ugly head. Carla Rippey (2003), for example, recalled: "By the time I got to Mexico, 1973, the influence of the muralists was greatly lessened by the generation of the Ruptura, which was antimuralist and you might say, pro-imperialist. They wanted Mexico to be part of an international art scene. So when I started working from photos I did so in circumstances which really frowned upon this sort of 'copying'— one had to work like Cuevas or Vicente Rojo or Aceves Navarro (who had a tremendous influence at that time because he had a lot of students)." Paloma Díaz, one of the original members of Grupo Suma, also recalled pressures to conform to a particular style of aesthetic. A figurative painter who says she's not all that comfortable with conceptual art and other media, Díaz (2007) remembers that she used to draw in secret while in Grupo Suma because drawing was looked down upon. "I should have been collecting garbage," she laughed, referring to the then favored practice of incorporating found objects and elements of daily street life into one's art.

In summary, then, activist artists in Mexico City struggled to reconcile Leftist political convictions, nationalist pride, and creative impulses with ambivalence about the art world's stylistic repertoire. The so-called Mexican School of social realism was familiar, accessible, and lent itself readily to politically themed art, but many young artists found it stodgy and constipated; it was the visual language of the authoritarian state-party regime and closely associated with a romanticized and deracinated *indigenismo*. By comparison many of the contemporary art movements such as pop, op, minimalism, conceptual art— even the already waning abstractionism—felt fresh and liberating to many young Mexican artists. At the same time, some of the art produced in these styles could seem esoteric, inaccessible, or too easily commodified by foreign art markets, and the artists who produced them were vulnerable to nationalist charges of slavishness to London, Paris, or New York.[4]

"FROM THE 'NON-WESTERN' MARGINS OF THE NATION"

For many of the Mexico City–based activist artists, the metropolitan capitals of the Western art world—London, New York, and Mexico City itself— remained the major points of reference for their creative tensions and stylistic polemics. The dynamics were considerably different in the context of the

36 Francisco Toledo, *Dos muertes*, 1994. Gouache on paper.

Zapotec and Chicano movements, where much of the artwork produced was distinguished by thoroughly syncretistic, often sui generis, styles. Francisco Toledo's work, for example, was described by Debroise (2006c, 258) as "a new *mestizaje* of Western and non-Western materials and references, sometimes using indigenous objects and techniques, sometimes resorting to elements taken from native traditions in Africa and Australia. . . . A new hybrid art . . . challenging the urban and Western influences that had dominated Mexican contemporary art in the 1950s and 1960s." In Toledo's gouache on paper *Dos muertes* (Two deaths), skeletons engage in sex, one penetrating the other from behind (figure 36). The bawdy scene of sexual escapades among the dead is consistent with the playful Juchitán-based Zapotecs' attitude toward sexuality discussed in chapter 3. The painting's reds, browns, and ochres, combined with the mosaic-like grid of the background, bring to mind Mexico's artisanal clay and tile work. Yet despite these popular culture elements, there is a contemporary sophistication about the piece. Debroise (2006c, 253) reads the work that Toledo produced after returning to his Zapotec family's hometown of Juchitán, Oaxaca, in the 1960s "as a 'purification' of Mexican artistic culture from the 'non-Western' margins of the nation itself." A similar case can

be made for a great deal of the work created by working-class Chicano artists who produced on the margins of California's largely white, elite art world, but first let's look more closely at the Oaxacan art scene.

Delfino Marcial Cerqueda (2006), a painter from Juchitán who was active in the Zapotec movement in the 1970s and 1980s, recalls that for Oaxacan artists of his generation the major influences were Rufino Tamayo (1899–1991), Rodolfo Nieto (1936–85), and Francisco Toledo (1940–present), all native Oaxacans. In Oaxaca an artistic space for creative departures from the reigning Mexican School was made possible in part by the success of these three artists. They incorporated international influences absorbed during extensive periods of time spent in Europe and the United States into commercially successful, distinctive visual vocabularies marked by their Oaxacan roots.

Although Tamayo, who spent considerable time in New York, was initially criticized for his departure from the social themes and formal approaches of the Mexican School, by the 1950s he had attained "sacred cow" status in the Mexican art world. Many artists of the Ruptura generation held him in high regard, despite his having become part of the establishment, because he "never adhered to dogmatic statements" and was regarded as an artist "of a universal cultural trend and an openness of vision that went beyond regionalism" (Calvo and Arteaga 2001, 46–47). Tamayo's artwork is a hybrid of European influences, such as cubism, and elements of Mexican culture as varied as pre-Columbian ceramics, Oaxacan folk art, and the bright colors of daily life, including, according to the artist, the blue "used to whiten clothes" (Tamayo quoted in Metropolitan Museum of Art 1990, 670). Tamayo helped open doors for Toledo, promoting his work and defending him against critics such as the powerful writer Octavio Paz who attacked the young Toledo as a "savage"—allegedly for reasons more personal than artistic. The art critic Raquel Tibol once dismissed Toledo's work, in so many words, as "exotic hypersexualized surrealism" (Debroise 2006c, 252).

Rodolfo Nieto was another Oaxacan-born artist of the Ruptura generation. As a very young art student in Mexico City, he apprenticed with Diego Rivera. Nieto received much acclaim in Paris in the 1960s but was met with a cool response from the established Mexican art world upon his return in 1970. He rejected nationalism, and his expressionist, surrealist-influenced paintings incorporated colors and iconography from Oaxacan folk art and animals inspired by Tarzan comic books—a dramatic departure from both the Mexican School's social realism and abstractionism (Calvo and Arteaga 2001, 180–84).[5]

The work of Tamayo, Toledo, and Nieto—and some would add Rodolfo

Morales, though he did not achieve the same level of international acclaim and was not referenced by the Oaxacan artists I interviewed—has often been described as contributing to a "Oaxacan School" of art. Carlos Monsiváis took issue with the idea of a Oaxacan School, arguing that "regions don't create style" and "traditions" don't determine genius or talent. But he did recognize "the links between a communitarian richness (the myths and the realities of Oaxaca) and creative development," and he believed that "tradition, when well understood and assimilated, feeds renovation" (Monsiváis 1993, 1). Monsiváis regarded Tamayo, Nieto, Toledo, and Morales as artists distinguished by their ability to integrate international art with the "primordial legacy" of Oaxaca. He also recognized certain common features among Oaxacan painters: "They share the density of indigenous art and the (imaginative, chromatic) vigor of popular art; they have grown up in the face of Monte Albán and the colorfulness of their towns and festivals" (Monsiváis 1993, 1).

According to Robert Valerio (1997, 120), contemporary Oaxacan art is characterized by common media (painting with oils, water colors, and gouache), iconography (such as local architecture, flora, and fauna), colors (intense and high contrast), themes (mythology, oral story telling, the countryside, fiestas, and customs), and style (figuration, "magic realism," naïveté, primitivism, and "fantastic fundamentalism"). Alberto Blanco (1998, 23–24) notes additional features that contributed to a recognizably Oaxacan art: "an idea of Oaxaca constructed from the outside and frequently nourished in exile"; "a rich colonial past distinguished by the architectonic presence of its great convents and churches"; and the fact that almost all of the contemporary artists know one another very well and share workshops, presses, audiences, and galleries. Finally, Blanco argues that the work of Oaxaca's contemporary artists rotates around four poles: imagination and reality, ancient world and modernity.

All of these qualities and influences can be seen in the work of artists who became active supporters in one or more of the many action fronts associated with the broad Zapotec-identified social movement from the early 1970s on. The late Jesús Urbieta, for example, was described by Macario Matus, one of his mentors, as having painted, "dreams with his eyes open; the scenes feel primitive and the art explodes inside a magical fantasy of the first days of the creation. Is it the full consecration of spring or a grand symphony for the creation of the new world?" (Vargas 1997, 21). In Urbieta's engraving, *Bañistas de Tehuantepec* (figure 37), two naked figures relax along the bank of a river teeming with fantasy creatures. Geometric motifs evoke the region's pre-Hispanic

37 Jesús Urbieta, *Bañistas de Tehuantepec*, 1994. Engraving. Reprinted from *Generación* 11, no. 25 (1999).

cultures, the subtle, elegant pallet suggests the influence of Toledo, but one also senses the presence of Picasso and Miró.

At different points in his career, Sabino López's work has revealed influences as different as surrealist figuration and geometric abstraction. Many of his titles emphasize his Zapotec, isthmus roots as a major source of inspiration: *Camino a Guiengola* (referring to a stone hill that served as a fortress for the ancient Zapotecs), *Cosijopoi* (name of the last Zapotec emperor), *San Mateo del Mar* (one of López's favorite places on the Pacific coast near Juchitán), *El estero* (the brackish marshlands between Juchitán and the coast), and *Monte Albán* and *Mitla* (two important pre-Hispanic cities in Oaxaca). Yet all of these pieces feel very contemporary: they are largely abstract, with geometric patterns (sometimes created by weaving together handmade paper) sparsely populated by an occasional figurative allusion to flora and fauna. See, for example, his piece titled *Bixee* (figure 38), a Zapotec word that López (2006) defines as "the sounds recorded by a house from the life that goes on within its walls." Strange creatures, simultaneously serpentine and mushroom-

38 Sabino López, *Bixee*, c. 1994. Ink on woven paper.

like, are drawn in ink on woven paper tinted red with traditional cochineal dye. López (2006) described the influences on his work: "I ground myself in many pre-Hispanic elements but adding contemporary elements, as there has to be an evolution. There is something of cultural resistance in the content of my work. For me it is very important to value Mesoamerican artistic symbols and traditions, without ignoring all of the other schools such as expressionism, surrealism, etc."

Activist artists like Urbieta, López, and others also produced more typically "political" artwork—murals, banners, and posters—in support of the movement during its height in the late 1970s and 1980s, and some politically active artists, such as Fernando Olivera, worked in a style closely identified with the social realist graphics of the Mexican School. However, most of the work produced by movement-affiliated artists in Oaxaca was not overtly political. Rather, the distinctively Oaxacan style of these artists took on political meaning because it evoked deep ancestral memory and popular culture through a sophisticated contemporary visual discourse and became a powerful symbolic expression of renovated Zapotec ethnic identity.

Tamayo, Nieto, Morales, and Toledo all helped to create the recognizable Oaxacan aesthetic, but Toledo's influence was also profoundly political. As de-

scribed more fully in chapter 5, Toledo was instrumental both intellectually and institutionally in creating the conditions in which political activism could be expressed through art and in which art could serve political ends without being reduced to political slogans. Toledo's political involvement and his influence on young artists associated with the nascent Zapotec movement are related to the repression of the student movement of 1968 in Mexico City. A group of student leaders were looking for a safe haven after the massacre of October 2 when they learned that Toledo had cancelled an art exhibition in Oaxaca to protest the repression and had donated his artwork to be auctioned off to support the defense of political prisoners. The activists contacted Toledo, who offered them refuge in his home in Oaxaca (Debroise 2006c, 253; Abelleyra 2001, 57).

The events of 1968 also affected a generation of Oaxacan art students, several of whom came under the stylistic and political influence of Toledo. The Zapotec painter Delfino Marcial Cerqueda was a student at the San Carlos Art Academy in Mexico City in 1968, but when the student strike was called he and his buddies "went to Acapulco to wait things out on the beach." Cerqueda, as he signs his artwork, admits that at the time he "didn't want any problems" and "wasn't interested in politics." With his studies at San Carlos interrupted by the student movement, he soon returned to Oaxaca to study at the Escuela de Bellas Artes at the Universidad Autónoma Benito Juárez de Oaxaca (UABJO). But he was unable to escape the politics of the times. As he describes the university scene, "The Marxist influence was very strong and there was a guerilla cell operating within the Escuela de Bella Artes." Cerqueda became increasingly politicized and a few years later, in response to a call by Macario Matus, then director of the Casa de la Cultura in Juchitán, began to create artwork in support of the Coalición Obrera-Campesina-Estudiantil del Istmo (COCEI) and the larger Zapotec movement. A small group of artists, including Cerqueda, Sabino López, Oscar Martínez, Jesús Gallego, and Jesús Urbieta, began to work together, using the workshops at the Casa de la Cultura but, according to Cerequeda, "not as an organized group with a clear project like the grupos" in Mexico City. As Cerqueda described it, the style of these Tehuantepec Isthmus natives was also quite different from that of the student movement artists in Mexico City: "Young Istmeño visual artists began to work together, supporting the COCEI but not painting raised fists in the style of social realism but rather each working in his own way. There wasn't much awareness or discussion about various schools or tendencies of art. Here the big influences were Tamayo, Nieto, and Toledo. We had relatively little direct contact and communication with Toledo, but his work was a huge in-

fluence and he supported our efforts by donating materials and money" (Marcial Cerqueda 2006). Sabino López (2006) agrees that their generation did not give too much importance to the various schools of art: "Here it's more each person seeking his own way. But it has to be recognized that the maestro [Toledo] carries a lot of weight."

Roberto Donís, an artist associated with the Ruptura generation, was another significant influence on Oaxacan artists who came of age artistically and politically in the 1970s. Although not a native of Oaxaca, Donís moved there in 1970, where he became director of the Taller de Grabado (Printmaking Workshop) at the UABJO at a moment of tremendous student activism and repression. In 1974 he founded the influential Taller de Grabado Rufino Tamayo in the city of Oaxaca, which he directed until 1984 (Toledo 1992). Donís studied painting and sculpture at La Esmeralda in Mexico City, and his early work showed the influence of the Mexican School. But travels in the United States and Europe introduced him to the work of artists like Adolph Gottlieb, Mark Rothko, Arshile Gorky, Robert Motherwell, and Franz Kline, and by the early 1960s he had largely abandoned the figurative for abstract painting (Calvo 2001, 32). Donís was close to Toledo; in fact, according to his younger brother, the photographer Rafael Doniz (they spell their last name differently), Roberto was one of the first to recognize the talent of the young and unknown Toledo in the early 1960s and helped get Toledo's work into the prestigious Antonio Souza Gallery in Mexico City's Zona Rosa (Doniz 2006). But Donís seems to have lacked Toledo's skills (or perhaps commitment) for helping young, politically active artists learn how to balance the often contradictory demands of politics, art, and commercial success.

Under Donís's leadership, the Taller de Grabado Rufino Tamayo gained a reputation for being highly selective in its acceptance of students and of maintaining high standards of professionalism. Indeed, some exceptionally talented artists were involved in the Taller de Grabado Rufino Tamayo, including Máximo Xavier, Filemón Santiago, Eddie Martínez, Emiliano López, Luis Zárate, and Nicéforo Urbieta, some of whom became politically active (Toledo 1992; Urbieta 2001). But Donís expressed ambivalence—even contradictory feelings—about the "political effervescence" of the early '70s, to the extent that it undermined the students' professional discipline, and about the Taller de Grabado Rufino Tamayo's emphasis on professional and commercial success. In one interview Donís boasted that he admitted only the most talented artists and helped them learn how to make a living selling their artwork, and then in the same interview he complained that none of the young

artists were willing to do the work to keep the Taller de Grabado Rufino Tamayo going because they were more interested in becoming rich and famous (Toledo 1992).

Nicéforo Urbieta, a former student who had once been identified by Donís as a possible future director of the Taller de Grabado Rufino Tamayo (Toledo 1992), is now quite critical of Donís's approach, which he says gave too much emphasis to a commercially viable but aesthetically and politically questionable folkloric style and content. Urbieta (2001) believes that in glorifying Toledo, Donís helped to produce a group of artists now "sarcastically called Toleditos" (little Toledos). Sabino López (2006) agrees that there has been a downside to Toledo's influence: "Many artists who try to emulate Toledo fall into folklorism and artisanal work, without seeking his aesthetic [quality]." These observations seem valid, based on much of the artwork on sale in Oaxaca's many galleries and street markets. Nevertheless, López found a way to integrate his artistic creativity and career with political involvement through Toledo's Casa de la Cultura in Juchitán. Nicéforo Urbieta's politics — and dissatisfaction with the Taller de Grabado Rufino Tamayo's emphasis on preparing students for the art market — led him in a very different direction. Urbieta "felt ever more frustrated at not being able to promote more experimental, more social art. The Taller was much more professional, more individual, more closed." Urbieta became increasingly active politically, first painting a mural and banners in support of an activist who had been disappeared. He was arrested in 1975 for alleged involvement with a guerilla movement, tortured, and spent six years as a political prisoner. Upon his release from prison, Urbieta returned to Oaxaca with his politics, his Zapotec identity, and his painting profoundly changed by the experience (Urbieta 2001). His subsequent paintings were sensual, dreamlike, and expressionistic, incorporating many symbolic references to indigenous culture and history.

In the case of the Zapotec movement, then, a few artists deployed the predictable social realist styles of the Mexican School to produce the posters, banners, and murals needed by the political wing of the movement, and others, in trying to emulate styles pioneered by Tamayo, Nieto, and especially Toledo, fell into an equally predictable folkloric primitivism. However, a significant group of talented, activist artists working from "the non Western margins of the nation" created sophisticated paintings whose political power radiates from a vibrant, sui generis visual language that builds upon Zapotec culture and the syncretistic aesthetics forged by their Oaxacan-born but universal artistic predecessors.

Working on the ethnic, social class, and artistic margins of another nation, Chicano movement artists also created a unique, syncretistic body of art, one that Tomás Ybarra-Frausto (1996, 180) has called a "visual narration of cultural negotiation." Artists affirmed Chicano culture "as a creative hybrid reality synthesizing elements from Mexican culture and the social dynamics of life in the USA" (Ybarra-Frausto 1996, 173). Chicano art from the movement's beginning drew upon both traditional Mexican and contemporary international styles. Many Chicano muralists were influenced by the work of Rivera, Siqueiros, and Orozco, whereas expressionism is clearly evident in paintings such as Salvador Roberto Torres's iconic *Viva La Raza*, described in chapter 2, while pop influences such as cinema and punk mark the performances and murals of the collective Asco. Amalia Mesa-Bains has worked extensively with installations and Patricia Rodríguez with assemblage boxes (media associated with postmodernist trends), but they infuse them with content and meaning grounded in traditional Mexican and Chicano popular genre such as altars and *retablos*.

California Chicano artists in the 1960s and 1970s were more directly and immediately exposed than their Mexican counterparts to the dizzying array of international art movements of the period. While New York abstract expressionist painters like Jackson Pollock remained influential, from the mid-1950s to the mid-1960s, California, and especially Los Angeles, emerged as a major center of modern art. The beat aesthetic of California's "Cool School" challenged the New York School's dominance with geometric abstract work of artists like Karl Benjamin, the found-object assemblages of Ed Kienholz, Ed Rucha's words, and Peter Volka's large-scale ceramic sculptures. L.A.'s Ferus Gallery gave Andy Warhol his first gallery show in 1962, exhibiting all thirty-two of his now famous Campbell's soup cans. Walter Hopps, who founded the Ferus Gallery, recalled that he witnessed the new artwork first being ignored, then attacked as communist, and then as obscene (Neville 2007).[6]

By the late 1960s, postmodernist trends in feminist and conceptual art were jockeying with modernism for influence in the California art world. Judy Chicago and Miriam Schapiro, for example, cofounded a feminist art program at the California Institute for the Arts in 1971 and a year later organized *Womanhouse*, a collaboration of installations and performances by several feminist artists in Los Angeles. Works like Chicago's controversial *Red Flag*, depicting a woman removing a bloody tampon, were part of the larger art scene in which Chicano artists were beginning to find their way. Mesa-Bains (1991b,

133) notes, for example, the Chicana muralist Judy Baca's "artistic association with Suzanne Lacy and Judy Chicago." "During the 1960s," notes Deniz Tekiner (2006, 42), "the growth and invigoration of alternate styles of art and art criticism were concurrent with intensified counterculture activities in society at large."

Thanks to the GI Bill—which allowed artists like Gilbert Lujan to attend college—successful struggles for affirmative action, and California's huge postwar investment in education, Chicano art students in California were attending a diverse range of art schools in the '60s and '70s, including the Otis College of Art and Design, UCLA, CalArts, Long Beach State, UC Berkeley, San Francisco State, the San Francisco Art Institute, and the California College of Arts and Crafts. The "cultural negotiation" required to survive and indeed thrive in the transition from working-class, Mexican American barrio to white, middle-class art institutions could be daunting. Integrating the various stylistic influences into meaningful expressions of the Chicano experience was a challenge in the context of university art programs where racism persisted in spite of their supposedly progressive approach to the arts. The Chicana painter Carmen Lomas Garza, renowned for her scenes of quotidian community life, recalled her experience in a university art department: "The anger, the pride, and self-healing had come out as Chicano art—an art that was criticized by the faculty and white students as being too political, not universal, not hard edge, not pop art, not abstract, not avant-garde, too figurative, too colorful, too folksy, too primitive, blah, blah, blah" (Bright and Bakewell 1995, 1). When Chicano artists did occasionally find openings for professional success, the hypercommercial California art market was fickle: "Impertinent and out-of-bounds ethnic visions are embraced as energetic new vistas to be rapidly processed and incorporated into peripheral spaces within the arts circuit, then promptly discarded in the yearly cycle of new models" (Ybarra-Frausto 1996, 180).

Another dilemma faced by some Chicano artists who wanted to ground their work in Mexican traditions was that the U.S.-centric and Eurocentric focus of the academy meant that they had relatively little exposure to the Mexican School of art. Sonya Fe, who studied at the Otis Art Institute in Los Angeles, Los Angeles City College, and the Art Center College of Design in Pasadena, recalls that she only discovered the great Mexican muralists when she first traveled to Mexico in the 1970s: "To my astonishment, I had not learned anything about the [Mexican] artists in my formal education. My style changed dramatically after my visit to Mexico" (quoted in Keller 2002,

218). But such experiences on the other side of the border were often less than ideal. Many Chicano artists were better informed about a wide variety of international art movements than were some of their Mexico City counterparts, whose education was often limited to national art academies still under the sway of the Mexican School. Despite their knowledge and sophistication, however, Chicano artists were sometimes dismissed by their Mexican counter parts as uncultured *pochos*—Americanized, country-cousin bumpkins.

In a process of cultural negotiation fraught with tensions and contradictions, Chicano artists struggled to find their own creative voice, often doing so by integrating a great variety of artistic styles. The experience of the Mujeres Muralistas cofounder Patricia Rodríguez (2010) illustrates the layered complexities of such efforts. Rodríguez studied at the San Francisco Art Institute, where she remembers one professor who pushed the students in the direction of minimalism. Rodríguez resisted—"I didn't want to be a minimalist"—and produced something figurative: "The professor came up to me and said, 'You think you're cute, huh? You think you're Diego Rivera?' And I said, well, sir, 'I don't know who Diego Rivera is.' And he said, 'You don't know who Diego Rivera is? You're Mexican.' . . . I was nineteen or twenty, I mean what did I know? I was coming from the barrio." At the same time that Rodríguez was derided by a professor for being Mexican and not knowing Rivera, the models offered at the art institute, she recalls, "were Lichtenstein, Braque. We weren't studying Siqueiros. We were studying everybody else, all the French painters." Once Chicano artists became aware of the Mexican muralists, Rodríguez continued, "all the murals started to look like Rivera, like Siqueiros."

When Rodríguez, Irene Pérez, Graciela Carrillo, and Consuelo Méndez found an opportunity to paint a large mural of their own, "We decided that it had to be totally different. . . . And so we had a lot of influences. We were Chicanas. We ate a hamburger and a taco. We were multicultural. So our mural had to be special." The Mujeres Muralistas' first mural was painted in 1972 on Balmy Alley in the heart of San Francisco's Mission District (figure 39). Rodríguez (2011) explained that it was painted with donated exterior house paint, which largely determined the mural's pastel color pallet; they could only afford to buy one tube of good quality paint, so they chose a tube of red used to paint the fish that swim among the dreamy, watery images of lush, tropical vegetation. Absent any human figures and obvious references to Mexican, Latin American, or indigenous culture, the women's work was strikingly different from many of the more overtly political Chicano murals of the era.

"Figuration and abstraction, political art and self-referential art, art of pro-

39 Mujeres Muralistas, *Balmy Alley Mural*, 1972. Mural.

cess, performance and video all have adherents and advocates" among Chicano artists, notes Ybarra-Frausto (1996, 177). The late Carlos Almaraz (1987), for example, cited Monet, Klee, and the fauvists, as well as the Mexican muralists, Indian serapes, and Tijuana's black velvet canvases as influences on his neo-expressionist canvases. When an interviewer told Almaraz (1987), "I always assumed that your sense of color came from the school of Mexico," the painter explained:

> Well, I think people do believe that, but actually it's not true. The sense of color initially came from Mexico, but it's . . . re-recognized in paintings. In other words, I probably reacted as a child to a serape before I ever saw a painting. But then when I saw the fauvists and I saw their paint, I said, "Oh, this reminds me of something familiar." . . . The influences are many. The fauvists are one, in the purity of color they have. . . . I try to keep up with the brilliancy of the color and actually work with that brilliancy in the way an Indian might make a beautiful blanket out of brilliant-colored yarn. It's the combination of colors that give him a sense of tonality, not so much that he's mixing his own colors. And this is what I was trying to do in the early color paintings that I was working with.

Fellow artist Gilbert Lujan (1997) only half-jokingly asserted that Almaraz "wanted to be Jackson Pollock" after his years in New York. But listen to Almaraz (1987) talking about Tijuana's famous black velvet paintings: "For all their tackiness, there's something captivating about them, in seeing the luscious velvety black against the brilliant tones of color and in highlights. That's something which I have rendered in my pastels, those that are done on black paper specifically. There the influence, I can say, it has more to do with south of the border than it does with New York City."

Almaraz (1987) said that when he began painting murals and banners to support the United Farm Workers Union (the Chicano movement's most important labor front), he drew upon the technique of Siqueiros ("incorporating body movement in the motion of the mural") and the iconography of Rivera ("obvious symbols for capitalism and socialism"). But he "had to learn to interpolate, to take ideas from Rivera and put them into the context of California in 1972, and not Mexico in 1924." There's an undeniable influence of Southern California culture in Almaraz's work, especially the expressionist canvases dominated by freeways and car crashes, such as his *Sunset Crash* of 1982 (figure 40). The body of work resulting from Almaraz's "cultural negotiation" was a stunning synthesis of seemingly very strange bedfellows.

The collective Asco incorporated a very different set of stylistic influences into its work, including the social sensibilities of early twentieth-century German artists, the Dadaists' sense of the absurd, cinematic visuality, soap operas, urban Pachucho attitude, and Hollywood glamour. The Asco member Gronk (1997) especially "felt an affinity to the Dadaists or the German expressionists, who were also social critics of their particular moment in time and observers of what was taking place within the culture . . . depicting the rise of the Nazis." Otto Dix comes to mind when looking at Gronk's Josephine Bonaparte series (see figure 25, discussed in chapter 3). Many of his influences may be European, but Gronk (1997) insists, "I can only do what I'm about, and I'm an urban Chicano." When Gronk and Willie Herrón painted their *Black and White Mural* for the Estrada Courts neighborhood in East L.A., they were thinking of Gillo Pontecorvo's classic film *Battle of Algiers* and about newsreel footage of police tear-gassing protesters at the Chicano Moratorium in 1970 against the Vietnam War in Los Angeles. Gronk was also reading Sartre and Camus at the time and thinking about the "imagery of the grotesque." In another example of cultural negotiation and syncretism, those influences were brought to bear on the very local experience of East L.A. in the *Black and White Mural* with its collage of portraits of police and protesters, screaming

40 Carlos Almaraz, *Sunset Crash*, 1982. Oil on canvas.

faces and bleeding bodies (figure 41). Gronk (1997) says the artists were aiming for "a cinematic documentary kind of thing—almost like a time capsule for that neighborhood. Like, this is what was experienced here at a particular moment in time."

U.S. and particularly California popular culture influences are especially evident in Asco's "walking murals" and "No-Movie" film stills. As described by the curator Tere Romo (1999, 15), Asco's *Walking Mural* from December 24, 1972, was "a parody on the very definition of murals and wall art." The performance and art action was "the group's attempt to resurrect the traditional Christmas parade down Whittier Boulevard which had been cancelled" after the police riot that erupted in response to the Chicano Moratorium:

> Gronk, in green chiffon with a star painted on his face and draped with red Christmas lights, was a walking Christmas Tree. Herrón wore a three-dimensional masonite crown with three agitated faces creating a mural. [Patssi] Valdez was the Virgen de Guadalupe dressed in a black glittering

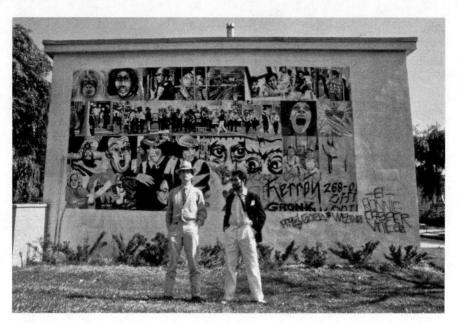

41 Harry Gamboa Jr. *Willie Herrón III and Gronk with Black and White Mural*, 1979. Photograph.

gown, with a black and silver *mandorla* (aura) and an aluminum *calavera* (skull) on the back of her head. As the artists paraded down one of the busiest streets in East L.A. they were confronted by many of the people they encountered. Valdez was accused of being sacrilegious and disrespectful of the Virgen. (Romo 1999, 13)

Asco's Harry Gamboa documented the *Walking Mural* with photographs and super 8 film, which led the group to a new art concept they called the "No-Movie." Fake stills were created of scenes from imagined movies with titles such as *Take-One, Asshole Mural,* and *A la Mode* (figure 42), in which Patssi Valdez is sitting on a piece of pie "like a scoop of ice cream" (Gronk 1997). Gronk, Herrón, and Gamboa were all featured in the No-Movie stills, but Valdez, with her "out of East L.A.," "thrift store kind of glamour" (Gronk 1997), "her extraordinary ability to transform herself and her acute photogenic presence" (Romo 1999, 15–17), was the undeniable star. Hollywood films as well as Mexican soap operas and *fotonovelas* were obvious influences, but Asco's images were "manufactured and controlled by Chicanos," thus offering "a very different portrayal of Chicanos that contradicted the prevailing images" (Romo 1999, 15). Sánchez-Tranquilino and Tagg (1991, 105) write that

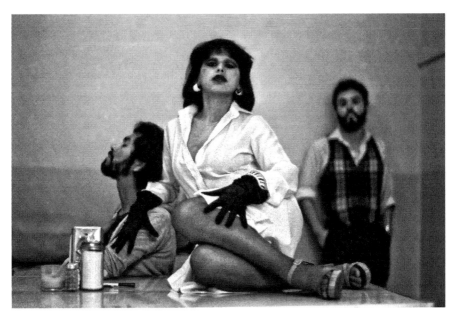

42 Harry Gamboa Jr. / Asco, *A la Mode*, 1976. Left to right: Gronk, Patssi Valdez, and Harry
Gamboa Jr. Photograph from the *No-Movie* series.

Asco "seemed at odds . . . not only with the agencies of dominant Anglo cul-
ture, but also with those Chicano artists and historians whose sense of cultural
identity sprang from the fountainhead of nationalist cultural metaphors . . .
rather than from the exhilaration of cultural cross-dressing."

Chicano artists engaged in passionate polemics about what kind of art best
served the movement. Carlos Almaraz (1987) recalled "heated debates on
the role of art" in art classes at Otis, where he and Judithe Hernández both
studied. "How does art relate to workers? How does it relate to the poor? And
is it really a democratic idea to have a museum and to have high art?" Este-
ban Villa described lively debates in 1968 about form and style in meetings of
the Mexican American Liberation Art Front (MALAF or Mala-Efe as it was
commonly known): "Discussions were heated, especially the polemics on the
form and content of revolutionary art and the relevance of murals and graphic
art" (quoted in Ybarra-Frausto 1996, 166).

Gilbert "Magu" Lujan (1997), a cofounder of the Los Angeles–based art
group Los Four and one-time art editor of the Chicano publication *Con Safos*,
described the often contentious debates among the artists about Marxist ver-
sus "indígena/cultural nationalist" versus abstract expressionist aesthetics. Ju-

dithe Hernández (1998), also active in Los Four, talked about the role that Carlos Almaraz played in "making connections" between the radically "different styles [of] approaching the same subject" that characterized Los Four and Asco. Hernández described the work of Los Four as more traditionally figurative, whereas Asco artists "were kind of the vanguard of the punk sort of perspective." As Gronk (1997) remembers it, the Asco collective found Los Four "old-fashioned" and "stodgy," with a somewhat dogmatic view of "Chicano art is this." Barbara Carrasco (1999) remembers being somewhat disconcerted by the "nontraditional, antimural" approach of Asco, and both Gronk (1997) and Almaraz (1987) recalled that Asco faced considerable ridicule from some Chicano artists and art organizations because their aesthetics could not be neatly reconciled within the more Marxist and nationalist conceptions of what political art, and Chicano political art in particular, should be.

In what may at first appear as a contradictory move, a number of prominent feminist Chicana artists — Ester Hernández, Yolanda López, Judith Baca, Juana Alicia, and the Mujeres Muralistas collective, for example — have sometimes worked in figurative styles more akin to the Mexican School aesthetics favored by some of the macho nationalists. This phenomenon may be explained in part by the desire of Chicana feminists to legitimate their voice within the movement by communicating in a visual language that was irrefutably Mexican or Chicano or Chicana. Recall from chapter 3 that Chicana feminist artists were often ridiculed for being "too white" or not authentically Chicana or Mexican. Yolanda López reports being encouraged by some critics to use "traditional," figurative iconography in her work because "abstract images do not satisfy the mandate of cultural nationalism" (Davalos 2001, 72). Barbara Carrasco (1999), who experienced firsthand the power of nationalist censorship within the movement, has expressed admiration for other Chicana artists who were willing to risk a "break" with the mural tradition.

Among California Chicana artists, there are many examples of feminist content expressed in more traditional Mexican forms. Yreina D. Cervántez describes using indigenista iconography to express a woman's perspective, and Margarita "Mita" Cuarón incorporates sensual images of the Virgin of Guadalupe to "heighten [the virgin's] connections to the community and her condition as woman, with a woman's life cycle and a woman's social and communal domain" (Keller 2002, 124–25, 138–39). California-educated Sonya Fe appropriates Posada's calaveras in a provocative painting that depicts the untenable position of a woman trying to choose between two male lovers (Keller 2002, 219). Rosa M.'s work has been described as "within the tradition of interna-

tionally respected Mexican artists such as Posada and Rivera. However, her work is imbued with feminist perspectives" (Keller 2002, 105).

Perhaps incorporating elements of the formal language of the Mexican School appeared to these artists as a way to anticipate and undermine censorious attacks, in a manner parallel to the Mexican students' ambivalent deployment of similar formal elements because of their familiarity, accessibility, and association with "Mexicanness." Ochoa (2003, 37) observes, for example, that in choosing to create mural and altar installations, the Mujeres Muralistas collective selected genres "that can be located within Chicana and Chicano cultural tradition." Gaspar de Alba (1998, 132–33) describes a "Chicana aesthetic" in the early years of the Chicano movement that was constituted by images of "motherhood, regeneration, and female ancestry" along "with iconography from Catholic ritual and pre-Columbian mythology and stressing the political vantage point of the working class." Clearly, some Chicana artists chose to break with these political and aesthetic norms, but in doing so they risked, unlike their Mexican feminist counterparts, being cast out of the very ethnic community that seemed to offer protection against a racist, white-dominated society.

For many Chicano artists, it was precisely such cultural, political, and aesthetic tensions that spurred creativity. Salvador Roberto Torres has said, "The distinctive influences of Anglo-American and Indo-Hispano bilingual/bicultural experiences, along with the concept of *La Raza* as humanity, become my sources of spiritual and creative nourishment" (Keller 2002, 274). Ybarra-Frausto (1996, 169) identifies "visual biculturalism" and the vernacular aesthetics of popular culture as common qualities unifying the stylistically varied body of work produced by Chicano artists: "In opposition to the hierarchical dominant culture, which implicitly made a distinction between 'fine art' and 'folk art,' attempts were made to eradicate boundaries and integrate categories. . . . Handcrafted and store-bought items from the popular culture of Mexico and the mass culture of the USA mix freely and exuberantly in a milieu of inventive appropriation and recontextualization. The barrio environment itself is shaped in ways that express the community's sense of itself, the aesthetic display projecting a sort of visual biculturalism."

Rasquachismo is another distinguishing feature of the artwork inspired by the hybrid culture and social movements of twentieth-century Chicanos. In his brilliant interrogation of the phenomenon, Ybarra-Frausto (1991, 156) describes rasquachismo as "an underdog perspective—a view of *los de abajo* . . . a stance rooted in resourcefulness and adaptability, yet ever mindful of aes-

thetics." It is associated with the practice of using "available resources" — often vernacular expressions of popular culture — to create works characterized by "syncretism, juxtaposition and integration" (Ybarra-Frausto 1996, 171). Its sensibility is "not elevated and serious, but playful and elemental" (Ybarra-Frausto 1991, 155). Gaspar de Alba (1998, 12) sees in rasquachismo the "subversive power of popular pleasure," an exuberant "oppositional form" in the context of minimalism and modern art.

Chicano rasquachismo shares an aesthetic kinship with the urban, working-class kitsch of Mexico City's Peyote y la Compañía and its founder Adolfo Patiño discussed above. However, Amalia Mesa-Bains (1991a) draws an important distinction between kitsch and rasquachismo: "Kitsch as a material expression is recuperated by artists who stand outside the lived reality of its genesis. Conversely, rasquachismo for Chicano artists is instrumental from within a shared barrio sensibility. One can say that kitsch is appropriated while rasquachismo is acclaimed or affirmed. Rasquachismo is consequently an integral world view that serves as a basis for cultural identity and a socio-political movement." As examples of this Chicano sensibility, Mesa-Bains cites Asco's "urban street pageantry" and David Avalos's "hubcap assemblage" that fuses "the amulets of Catholicism with urban car art into a new icon, the 'Milagro Hubcap.'" Whereas, according to Carla Rippey (2003), Peyote y la Compañía's kitsch-infused work was motivated more by playfulness than politics, the aesthetic and attitude of rasquachismo were passionate, though often humorous, expressions of the Chicano movement's pride in its bicultural ethnic and working-class identity.

In all three locations — Mexico City, Oaxaca, and California — the stylistic choices of movement-associated arts were as politically significant as the subject matter of their work. Debates over the appropriateness of one or another school of art sometimes reflected political, gendered, or class divisions within the movements. At other times, the deployment of one or another style represented democratic challenges to the authoritarianism of the state or the elitism of cultural institutions. And for many Zapotec and Chicano artists, the sophisticated, syncretistic aesthetics of their work was an assertion of pride in and control over the production of their own ethnic identity, a refusal to be either acculturated into the dominant society or pigeonholed into essentialist stereotypes of a primitive other. In many ways, then, decisions about style were claims to autonomous space and power.

As Gronk (1997) remembers it, when he and fellow Asco artist Harry Gamboa visited the L.A. County Museum of Art (LACMA) in 1972 and asked about exhibiting Chicano art at the museum, a director remarked, "Well, Chicanos they don't make art. They're usually in gangs." Gronk continues: "So — in gang fashion — we went to the L.A. County Museum — Harry, Willie [Herrón], and myself — and we spray-canned our names on all the entrances and exits to the L.A. County Museum, claiming the entire museum as ours and all the contents within, sort of like an artist signing his name to an art object. And Patssi [Valdez] showed up the next day to take photographs in front of it as sort of her signature to our signature. And so that was the project *Pie in Deface.*" Gamboa calls their action "the first conceptual work of Chicano art to be exhibited at LACMA," and his photograph of the event accompanies his essay about Asco (1991, 125). Some twenty years later, LACMA would present Gronk's work in a retrospective exhibition. In a sly reference to the earlier act of rebellion, Gronk included a site-specific piece called *Pie in Deface,* "a defacement of a clay facial mask that's slapped onto a wall that I paint. It's sort of defacing on the inside of the museum, and I doubt very much if they understood or got it — or want to get it or understand it" (Gronk 1997).

In 1968, inspired by the Mexican student movement's decentralized strike committees and fed up with the state-controlled art institutions' hollow nationalism, a group of

Mexico City artists founded the Salón Independiente (Debroise and Medina 2006, 26–28). In addition to mounting stylistically and thematically daring exhibitions, the salón organized a public debate about the function and relevance of the state-run Museum of Modern Art (MAM), leading some already established artists to withdraw their work from the museum (García de Germenos 2006, 52).[1] Less than fifteen years later, MAM would showcase No Grupo's *¡Caliente! ¡Caliente!* performance in which Maris Bustamante wore her now famous penis-nose mask (figure 18).

In the years between these acts of outsider defiance and gestures of partial mainstream acceptance, artists affiliated with Chicano and Mexican social movements worked to create counterhegemonic, autonomous spaces and new democratic practices that challenged the state, market, art-world elite, and sometimes even their allies on the left. They organized activist-artist collectives, created alternative publications, built new institutions, and fought their way into the hallowed halls of established institutions from which their kind had long been excluded. In doing so, many tried to avoid reproducing the forms of power exercised in "the establishment" as well as inside the movements themselves by those with class, race, and/or gender privilege. Instead, some artists promoted alternative notions of power and social change rooted in community, democratic participation, egalitarian relations, antimaterialistic values, and, as explored in chapter 6, ways of knowing that transcend Western concepts of rationality and objectivity. Certainly through the creation of new visual discourses of citizenship, as described in chapter 2, but also through the enactment of new practices and the building of new institutions, social movement affiliated artists played a significant role in broader efforts to forge a distinct cultural politics of citizenship that Dagnino (1998, 52) described as "a *project of a new sociability* . . . , a more egalitarian format for social relations at all levels."

COLLECTIVES OF CULTURAL WORKERS

For Mexican artists in the intolerant and repressive context of the late '60s and early '70s, survival itself was a strong motivation to create autonomous artists' collectives (Debroise and Medina 2006, 28). As described earlier, violent state repression forced activist artists like Arnulfo Aquino and Felipe Ehrenberg into exile. State-run museums and galleries were closed to politically and aesthetically radical artists, and only a very small number of private galleries supported their artistic efforts. One that did was the Mexico City gallery run

by the Pecanins sisters — Montserrat, María Teresa, and Ana María — who had left their native Barcelona to escape the fascism of Franco-era Spain (Emerich 2000). The first *Salón Independiente* was organized out of the Pecanins Gallery in 1968 and opened its first exhibition less than two weeks after the massacre of student protesters on October 2 (García de Germenos 2006, 50). Even after the so-called political opening in the 1970s under presidents Luis Echeverría and José López Portillo, censorship and harassment of "subversive" artists continued. Referring to that period, when he first returned to Mexico from self-imposed exile in England, Ehrenberg (2007b, 162) writes, "I still remember the bitter taste of censorship during these years. Jorge Birbiesca censored my exhibition [*Chicles, chocolates y cacahuates* at the Palace of Fine Arts] and destroyed 75% of the catalogues in the office of his boss, Jorge Hernández Campos: it contained newspaper articles — pages on which the name of Luis Echeverría appeared. They also forbade me from appearing nude in my performance at the Sala Manuel M. Ponce." Similarly, Maris Bustamante (2001a) recalls that her performances in 1981 of *El Porno Show* at a small, private theater in the sophisticated Coyoacán neighborhood of Mexico City were suspended under pressure from the local government. Creating their own autonomous collectives and alternative spaces, then, was one way of reducing the risks of government interference.

Yet the artists were motivated by more than survival. The democratic spirit of 1968 informed the collectivist, participatory nature of the new structures, which were viewed in some ways as prototypes for a future society that would be more egalitarian and less individualistic and authoritarian. The Salón Independiente, for example, drafted a set of "internal regulations" that gave "supreme authority" to a general assembly made up of all of the participating artists, who determined the allocation of their collective exhibition space by means of a lottery. The group prohibited its members from participating in "exhibitions that promoted nationalism in art, or that were based on competitions" (García de Germenos 2006, 51). When the grupos movement reached its peak in the late 1970s, there were at least a dozen activist-artists collectives operating in Mexico City (Liquois 1985a). In 1978 several of the more politically oriented grupos formed the Frente de Grupos Trabajadores de la Cultura (Front of Cultural Workers Groups) "as a self-managed association promoting connections between the various social movements of the era" (Vázquez Mantecón 2006, 198). The members referred to themselves as cultural workers to distinguish themselves from elitist conceptions of the precious, privileged artist and refused to attribute credit for their work to any individual member

of the collective. As the photographer Lourdes Grobet (2006), a core member of Grupo Proceso Pentágono, recalls, insisting on anonymous authorship was a basic principle of the grupos: "We rejected leadership" ("rechazabamos protagonismo").

Some grupos movement artists also rejected participation in any state-sponsored events or institutions, especially at a time when the Mexican state was pursuing policies of co-optation and repression of Leftist activists. Others believed that in the process of building new, independent spaces, it was also important to force open the doors of elite institutions and exercise their influence from within. They tried to walk a fine line by exercising their right to participate in official exhibitions but doing so on their own terms. In 1979, for example, when the government's National Fine Arts Institute (INBA) included a room for "experimentation" in its annual *Salón Nacional de Artes Plásticas*, where several of the grupos were invited to exhibit: "Proceso Pentágono decided to 'participate outside of the competition,' rejecting the notion that some higher authority could judge and categorize the quality of vastly different works. . . . Grupo Suma protested against the judges who had in fact awarded them first prize: at the end of the show they intervened in their own installation, covering it with graffiti ('Down with the INBA,' 'Crappy jury') that vividly expressed their disagreement" (Vázquez Mantecón 2006, 198–99).

Artists also promoted a more democratic and egalitarian culture of citizenship through editing, publishing, and distributing alternative magazines, journals, and books. *El Corno Plumado* (The Plumed Horn) was published from 1962 until 1969 (when government repression forced coeditor Margaret Randall to flee the country). In 1968 *El Corno Plumado* used its extensive international network to defend the student movement against the government's disinformation campaign and called for a "total revolution of mind/body/senses and of the social order" (Medina 2006c, 155). Also in 1968 a group of cartoonists—Rogelio Naranjo, Helio Flores, Rius, and Emilio Abdala—began publishing *La Garrapata*, a magazine of political satire that fiercely but humorously skewered the Mexican government, as discussed in chapter 2. An essential component of its message seemed to be that humor and irreverence were powerful tools of resistance at moments of terrible violence and injustice. Felipe Ehrenberg founded the Beau Geste Press as an alternative publishing outlet and network because, as he explained in a letter to a fellow artist in 1972, "the answer to the uniformity of taste, to the monopolic control of culture by the artmongers (publishers, galleryowners, museum curators, critics, the whole proverbial slew of mystifiers—sic—sick) the answer I repeat, is

to set up as many possible sources, each existing within the organic limits of their own capacities and yes, even of their immediate communities capacities" (Medina 2006c, 158).

Clearly there was an effort to weave together many different threads of a new cultural politics through these various collectives, publications, and actions, and the effort was not without contradictions. The anti-leadership, ultra democratic, participatory spirit of some of the artists — all of whom identified with a broadly defined Left opposition — was at odds with Marxist-Leninist sectors of the Left who saw "democratic centralism" with strong leadership and disciplined cadre as the most effective organizational form in the context of state violence and class struggle. Carla Rippey (2003), who participated in both the less explicitly political Peyote y la Compañía and the very politically oriented Frente de Grupos Trabajadores de la Cultura, says she ultimately "dropped out of the political scene because [she] was making posters without having any say about the slogans."

There was also tension between some artists who were committed to creating autonomous spaces for uncensored artistic and political expression and others on the left who disparaged art that did not directly serve the revolutionary vanguard. In the neo-Marxist framework of the 1970s, art created outside the context of a political organization or movement was considered too easily commodified by the capitalist market, absorbed by mass culture, or co-opted by the "culture industry." The founding manifesto of the Frente de Grupos Trabajadores de la Cultura reflected this perspective. As summarized by Shifra Goldman (1994b, 135):

> The Front's manifesto, signed February 1978, declared the necessity of transforming the production relations of the capitalist system and its ideological-cultural meaning, and the necessity of countering exploitation by national and international capital. To carry out this program, the signers called for 1) artistic and cultural production articulating proletarian and democratic struggles; 2) an alternative position to the apparatuses of production and reproduction of the artistic and cultural ideology of the dominant class; 3) theoretical and practical research and discussion that would result in aesthetic-ideological effects; 4) regaining control of the production, distribution, and circulation of their own work.

The Frente's practice exhibited many of the tendencies of what the feminist artist Magali Lara, a member of the grupo Março, described as the "heroic," macho Left (see chapter 3). It stressed the "combative" nature of the gru-

pos' purpose and sometimes engaged in more sectarian activities, such as denouncing "anti-Marxist French influences" on the left (Liquois 1985a, 32–33). One observer of the Frente's formation and rapid demise noted, "as time went on, the association's weekly meetings became more of an arena for making political declarations than for designing creative projects" (Vázquez Mantecón 2006a, 198). No Grupo never joined the Frente because of differences over approaches to politics and art. In a pamphlet describing its perspective in 1979, No Grupo emphasized its use of humor and irony (in contrast to the "serious" tone of many of the grupos) and rejected what it considered the Frente's "opportunism" of jumping from one hot conflict of the moment to the next. No Grupo also rejected what it called "the forced and fraudulent collectivism that frees one of responsibility through comfortable anonymity" (Liquois 1985a, 37). The seemingly egalitarian practice of anonymity sometimes served mainly to hide everyone except the de facto leader—always male—who received most of the credit for the group's work (Lara 1984, 34).[2]

Feminist artists were especially critical of the self-serving authoritarianism and lack of attention to process that characterized some of the grupos and Left political organizations. They had come to embrace feminist commitments to democratic process—believing that ends ultimately reflect rather than justify means. They emphasized egalitarian relations, the "personal is political" principle, and a faith in more subjective understandings of the social world. Feminist critiques were part of a broader reassessment throughout Latin America—indeed, the world—of the Marxist and nationalist Left's conceptions of democracy and leadership, spurred by the increasingly evident shortcomings of socialist states, nationalist regimes, and revolutionary organizations, as well as by the emergence of diverse new social movements.[3]

As the Frente and grupos movement waned in the 1980s, women artists from the movement began to create their own practices and structures. In Magali Lara's (2001) view, "The grupos disappeared precisely because the patriarchs did not want to see their children grow up. So the women had to get out of the structure of the grupos and work together in order to develop the issues [of concern to them]." Rippey (2003) concurs that the hierarchical practices that came to dominate some of the grupos—despite their theoretical emphasis on democracy, egalitarianism, and collectivity—contributed to their demise, because "hierarchical make up always leads to eventual resistance of authority and dissolution." The history of movements and states characterized by centralized, authoritarian leadership would seem to justify Rippey's observation, although the process of dissolution is sometimes quite prolonged

(as in the case of Mexico's Partido de la Revolución Institucional [PRI], the Soviet Union, and Cuba's postrevolutionary regime). Her conclusions are also consistent with my own experience in a cadre party that was eventually dissolved by militants who were no longer willing to abide the abusive, arbitrary authority of the general secretary—in this case a woman.

Alternative spaces created by women included informal discussion groups, the organization of formal feminist art collectives, collaborative art projects by two or more feminist artists, group shows of women artists, and the creation of new galleries and cultural spaces. Magali Lara (2001) described the contrast between these gatherings of women and the work they had done within the grupos: "Among the women, it was so different: the opening was total and very strong. We could talk about anything and say anything. There was no teacher and disciple. We were equals—distinct, different, but equal. We set out to create a feminine culture, which has to do with the emotional part of life and with how social identity is formed, and to talk about sexual identity, which in Mexico is to talk about power."

Maris Bustamante and Mónica Mayer pioneered the formation of feminist artist collectives when they organized Polvo de Gallina Negra in 1983. Other feminist art groups, such as Bio-arte, Coyolxauhqui Articulada, and Tlacuilas y Retrateras followed (Mayer 2001b; Tlacuilas y Retrateras 1984). Feminist artists also organized many group shows over the years. Mayer organized the first exhibition of work called "feminist art" in Mexico in 1977 (Barbosa 2001). Mayer subsequently organized several all-women shows in the 1980s, although by the end of that decade she had come to question the merits of this strategy, as the government and established museums began to sponsor all-women shows with little thematic or aesthetic coherence: "we'll have to ask ourselves if continuing to organize group shows of women, simply on the basis of our biology, doesn't serve, at this moment, to continue segregating women's participation in the arts" (Mayer 2001b, 3).

Feminists also created alternative galleries, cultural spaces, and forums. Although these efforts were clearly limited by a lack of financial resources and mainstream institutional support, several have survived. Mayer and her husband, Victor Lerma, for example, established the Pinto Mi Raya Gallery in 1989 "as a space to show artistic projects that didn't have a place in museums and commercial galleries" (Mayer 2001b, i); it has evolved since into an elaborate, on-line "applied conceptual art project."[4] For more than twenty years, until their retirement in 2005, the feminist actor and playwright Jesusa Rodríguez and her companion, the singer and songwriter Liliana Felipe, ran

El Hábito and Teatro de la Capilla, a cabaret and theater that were the site of many artistic efforts by feminists and other activist artists over the years, from Maris Bustamante's *El Porno Show* in 1981 to forums organized in the early 2000s to condemn the murder of hundreds of women in Ciudad Juárez.[5] Another group of women artists, Coordinadora Internacional de Mujeres en el Arte (ComuArte), organized the first Encuentro Nacional de Mujeres en las Artes Visuales (National Encounter of Women in the Visual Arts) in 2000 (Mayer 2001b, 126), and ComuArte continues to organize regular international gatherings of women artists.[6]

Most of the artist-led organizations and publications associated with the student and grupos movements disappeared by the late 1980s. Their demise is attributed to many factors, including government repression and cooptation, lack of resources, burn out, internal divisions, authoritarianism, changing political strategies on the left, and the lure of professional acclaim in a more pluralistic art market—in part the result of the artists' own success in changing Mexico's art world. Though many projects were relatively short-lived, this generation of activist artists set a powerful example of creating autonomous, alternative spaces for socially and politically committed artists that is still being followed. In addition to the feminist art networks, two other examples illustrate the variety of activist art practices that continue to flourish in Mexico City today. For more than twenty years, an annual queer art exhibition at the National Autonomous University of Mexico's (UNAM) El Chopo Museum has been a featured component of the Semana Cultural Lésbica-Gay (Lesbian-Gay Cultural Week). The painter Nahum Zenil, a frequent collaborator with other activist artists from the grupos and feminist movements, played a key role in establishing this forum (Coordinación de Difusión Cultural 2002). Since 1988 the Escuela de Cultura Popular "Mártires del '68" (Martyrs of '68 School of Popular Culture) has trained social movement activists and political militants to paint murals, silkscreen posters, and make stencils. Alberto Híjar, leader of the grupo Taller de Arte e Ideología (TAI), was one of the escuela's founders (Noyola Iglesias 2006).

BARRIO INSTITUTIONS AND BEYOND

Chicano movement artists in California also contributed to the international generation of 1968's radically democratic and egalitarian agenda with the creation of alternative institutions. In the 1960s and '70s, writes Jacinto Quirarte (1991, 166), "The artists in college and university art departments were . . . no

more interested in Chicano art and artists than were their colleagues in commercial galleries and public museums. These so-called art professionals still did not take Chicano artists seriously." As a result, Chicano artists began to create their own organizations and venues.[7] A variety of activist-artists collectives were founded, including Asco (Spanish for "nausea"), Congreso de Artistas Chicanos en Aztlán (CACA, Spanish for "poop"), Los Four, Mexican American Liberation Art Front (MALAF), Las Mujeres Muralistas, the Royal Chicano Air Force (originally Rebel Chicano Air Force, RCAF), and Toltecas en Aztlán. The very names of the collectives reflect the variety of political postures that coexisted within the movement. Chicano artists also were involved in creating a network of alternative publications, including *La Chispa, La Vida Nueva, Sin Fronteras, El Pocho Che, La Voz del Pueblo,* and *La Raza.*[8] In addition, they established cultural centers, galleries, and arts advocacy organizations, such as the Mechicano Art Center, Self Help Graphics, El Centro Cultural de la Raza, and the Social and Public Art Resource Center (SPARC) in Southern California, the Mission Cultural Center for Latino Arts, Galería de la Raza, and the Mexican Museum in San Francisco, and Centro de Artistas and Galería Posada in Sacramento.

Chicano artists experienced contradictions similar to those of their Mexico City counterparts. There were serious differences of opinion, for example, over whether exhibiting in or collaborating with mainstream arts institutions were signs of progress or of selling out. That particular debate was the focus of a sharp, polemical exchange in 1980–81 between the artists Malaquías Montoya and Lezlie Salkowitz-Montoya (1980)—who warned against what they viewed as the inevitable dangers of co-optation by ruling class institutions—and the art historian Shifra Goldman (1980–81)—who argued that further advance of the movement required "functioning within the mainstream . . . always bearing in mind the difficulties and dangers of doing so."[9] As in similar polemics in Mexico City, at stake was a question much greater than whether to exhibit one's artwork inside a commercial or elite institution. Through such debates the artists were contributing to larger strategic reassessments on the left about whether a more just and democratic society could be better advanced by building completely autonomous organizations from the ground up or by reforming existing structures from the inside. Goldman's position was one shared by a growing number of Leftists in the United States and Latin America who sought to define a more nuanced position that avoided the either-or dichotomies of the old revolution versus reform debate.

There were also differences of a more subjective nature about the appropri-

ate attitude one should take toward political struggle, similar to those revealed by No Grupo's previously cited criticism of the Frente de Grupos de Traba-jadores de la Cultura in Mexico. Asco, with an ironic, irreverent sensibility similar to that of No Grupo, was not always taken seriously by more explicitly political, Marxist-influenced collectives like Los Four. Asco in turn mocked their critics' seriousness by "crashing" a Los Four exhibition in 1974. As Harry Gamboa (1991, 125) tells it, "Gronk and [Patssi] Valdez tried to outdo each other by wearing platform shoes that reached heights over one foot. Gronk was felled by an irate cholo who did not appreciate the turquoise and black platforms he wore in defiance of gravity." More than antics, Gronk and Val-dez's intervention can be read as a performance that challenged the narrowly materialist, structuralist view of politics and social change advocated by many movement activists, Marxists and nationalists alike. Dogmatic politics and patriarchal views about gender and sexuality left some movement activists unable to appreciate the subtly subversive nature of Asco's intervention that called so many things into question, including representations of Chicano identity and definitions of political art.

There were also parallels between the experiences of Mexico City feminists and Chicana artists. As discussed in chapter 3, when cultural nationalism was added to "heroic" Left dynamics within movement organizations, the creative and political space for Chicana feminists was especially restricted. Most of the Chicano art collectives were exclusively male or, as in the case of Asco and Los Four, included only one woman (Patssi Valdez and Judithe Hernandez, respectively). Moreover, Chicanas' important roles in cultural centers were often overshadowed by more visible male leadership. Davalos (2001, 87), for example, notes the critical role of María Pinedo in moving La Galería de la Raza "toward economic autonomy" in 1980, a chapter of that organization's history that is "often obscured by a discourse that romanticizes the activities of the Galería's first decade and of men." As a result of such marginalization, as with their counterparts in Mexico City, Chicanas mounted dozens of Chicana art exhbitions, and some created their own organizations, such as Mujeres Muralistas. Through a practice informed by feminist understandings of col-lectivity, cooperation, and community and a rejection of narrow nationalism, Mujeres Muralistas offered a very different way to be a woman, an artist, and a movement activist (Ochoa 2003).

While there were many similarities between the Mexico City and Chicano movement experiences, California's different sociopolitical context made for some notably distinct dynamics and outcomes. In both locales, for example,

survival was one very important motivation for creating autonomous spaces. In California, however, the focus was on surviving pervasive racism and alienation rather than massive state violence. Although Chicano movement activists faced state repression, as in the brutal police attack on the antiwar Chicano Moratorium in 1970 in Los Angeles, state violence never reached the levels experienced in Mexico in those years. Malaquías Montoya and Lezlie Salkowitz-Montoya (1980) expressed the sentiment of many movement artists when they wrote about Chicano art as an "art of liberation" in a struggle to resist the historic "suppression of a culture": "The American-born Mexican in this imperialist country has been denied a language (by the school system), an identity (by the portrayals of stereotypes), and has been made to feel ashamed and inferior (by psychological impositions)." Mexico City artists created their own spaces in order to maximize their freedom of political and creative expression, but they did so with a sense of national belonging and entitlement as relatively privileged members of their nation's mixed-race majority. In the racist context north of the border, Chicano artists used such spaces to remind themselves and their own ethnic minority community of their self-worth, as well as to demand their civil rights.

Many of the Chicano art collectives, as did the Mexico City grupos, eventually disbanded, especially after the intensity of the movement's early mass mobilizations, and visibility decreased in the 1980s. However, a case can be made that Chicano artists were relatively more successful than their Mexico City counterparts in building sustainable, community-based organizations. Four striking examples illustrate this point. San Francisco's Galería de la Raza, founded by local Chicano and Latino movement artists, celebrated its fortieth anniversary in 2010 with a stunning retrospective exhibition of artwork, photos, videos, and artifacts documenting the wide range of artists, media, issues, and politics brought together over the years within the walls of this neighborhood gallery. Galería de la Raza not only continues to exhibit innovative work by Latino and Latin American artists, it has also become a dynamic forum for a young generation of visual, performance, and spoken-word artists. Its poetry slams attract an overflow crowd of hip-hop generation youth, assuring that the galería is far more than an exercise in nostalgia.

The Mission Cultural Center for Latino Arts (MCCLA), founded in 1977, today boasts an extensive staff, offers weekly classes in arts and crafts, dance, music, and printmaking, runs a youth program, and regularly hosts a variety of community cultural events. Its gallery, made more professional and relevant than ever under Patricia Rodríguez's curatorial leadership from 2001–9,

remains an important venue for politically engaged artists. Key to MCCLA's sustainability is a creative strategy to assure funding for San Francisco's neighborhood cultural centers, engineered in large part by the community arts advocate María X. Martínez. As she explains,

> In the early '90s I conducted an analysis comparing city funds budgeted to maintain the city-owned War Memorial facility (which houses the opera, symphony and ballet) with the city-owned community cultural centers. The results showed a wide variance ($4.11 per attendee at the War Memorial versus, for example, $0.41 per attendee at the Center for African American Arts and Culture). Proving the wide cultural inequity of city funding enabled the community to lobby for language in the City Charter which would hold political leaders accountable for assuring the stability, maintenance, and expansion of the community cultural centers. As a result, $2.1 million dollars were funneled to the community cultural centers over the course of the next few years. (Martinez 2010)

In Southern California, SPARC, cofounded in 1976 by the Chicana painter Judith Baca, describes itself as "an art center that produces, preserves and conducts educational programs and community based public art works."[10] Based in Venice, it is arguably one of California's most important public art institutions. A final example is Self Help Graphics in Los Angeles. As the Chicano studies professor Chon Noriega describes it, "For nearly forty years, Self Help Graphics has been one of the major community-based arts centers serving Los Angeles. . . . Self Help has reinvented itself as a self-sustaining organization, and it has shown the continued vitality and relevance of its mission by reaching new generations of artists and community members through innovative programs and cutting edge artistic production" (Self Help Graphics 2008).

All four of these organizations face ongoing struggles to secure adequate funding, run a professional operation, navigate dicey community politics, and remain politically and creatively relevant. Yet they have managed to thrive for several decades, whereas it is difficult to identify social movement–birthed arts organizations in Mexico City of comparable longevity, continuity, and grassroots engagement. Several factors help to explain this difference. First, the Chicano movement was a mass-based, multifaceted movement sustained over a period of two decades (roughly 1965–85), whereas the student movement of 1968 was short-lived (though its effects were long term), and the constituency of the grupos movement was less diverse and less mass based (despite efforts to serve various popular movements). The more prolonged mobiliza-

tion and larger mass base of the Chicano movement allowed artists to consolidate institutions over time. Second, because the Chicano movement was thoroughly rooted in working-class, ethnic communities (rather than in communities of students and relatively privileged, middle-class professionals), the institutions founded by movement artists had a potentially deep and broad base of community support. Finally, the enormous wealth and relatively progressive politics in California gave rise to a wider variety of public and private funding sources to support Chicano arts organizations. Galería de la Raza, for example, is funded by the California Arts Council, the Hass Foundation, and the Hewlett Foundation, among other public and private sources. Funders of the MCCLA include the San Francisco Arts Commission and the Tides Foundation, founded in 1976, according to its web page, to support "individuals and institutions committed to positive social change." Galería de la Raza and the MCCLA are both supported by the San Francisco Foundation, whose web page says it was founded in 1948 "by a small group of forward-looking civic leaders." Today the San Francisco Foundation is run by Dr. Sandra Hernández, a long-time advocate for public health and Latino communities; it supports a wide variety of arts, community development, and social justice programs.

TOLEDO'S SINGULAR LEGACY

The dynamics and outcomes of creating alternative spaces in Oaxaca were quite different from the Mexico City and California cases due to the dominating presence of one political organization, the Coalición Obrera-Campesina-Estudiantil del Istmo (COCEI), and one larger-than-life artist, Francisco Toledo. Many opportunities for autonomous, democratic institution building were afforded by the COCEI's status as the first Left opposition party to govern an important municipality (Juchitán) and by Toledo's fame, wealth, and generosity. The COCEI's rise to municipal political power in Juchitán was an unquestionably impressive accomplishment, which provided many opportunities for supporting alternative community institutions. However, there were also liabilities for a movement so closely associated with one political organization and one artist and patron.

Activist artists could support the Mexico City– and California-based movements in a wide variety of ways without having to identify as political militants of any one organization. In Oaxaca, given the COCEI's unparalleled leadership of the movement, artists who balked at the COCEI's specific political agenda had fewer opportunities to support the movement's broader socio-

cultural agenda. Cultural activities aimed at reinforcing indigenous identity, pride, and mobilization—such as Zapotec-language radio programming, festivals, street theater, poetry workshops, and art exhibitions—were an important part of the COCEI's program, and they attracted the participation of artists and intellectuals. At the same time, the COCEI placed significant strategic emphasis on developing itself as a viable Left opposition party—through a combination of local electoral politics and confrontational mobilizations—and as the helm of a "liberated," quasi-socialist, indigenous-identified, participatory democratic government.[11] Such efforts, especially in the context of violent state repression, required cadre-like commitment. Even some of the most socially conscious Zapotec artists were not comfortable with the kind of political militancy sometimes demanded by the organization.

Nicéforo Urbieta, for example, as described previously, spent six years as a political prisoner following his arrest in 1975 as an alleged guerrilla. When he returned to Oaxaca after his release, the COCEI movement was at its height. Wanting to return to political activism with newfound insights, Urbieta (2001) recalled, "I approached the COCEI and they said that I first had to think about political militancy. I said no because I had been there and learned that political militancy comes from rational thought, when I was seeking another form of intelligence based on our culture, another way of understanding life." Urbieta says he donated paintings for COCEI fundraising raffles but became disillusioned when more money was spent on political campaigns than on activities to strengthen Zapotec culture at the grassroots level. Howard Campbell (2008), who has published two excellent books on the Zapotec movement, suggests that Urbieta's difficulties with the COCEI likely stem as well from the isthmus Zapotec's historic conflicts with competing forces, including other Zapotecs, centered in the Valley of Oaxaca: "One of the main reasons people like Nicéforo Urbieta didn't prosper in the COCEI is because they weren't Isthmus Zapotecs or from Juchitán or married to a Juchiteco or Juchiteca."

Francisco Toledo created spaces in which artists could work on behalf of the movement without becoming COCEI militants. Toledo himself, one of the movement's most important supporters, was apparently never an official COCEI member. His status as a world-renowned artist, and the fortune he made from selling his paintings, gave Toledo a measure of autonomy vis-à-vis both the COCEI and institutions of the Mexican state. He was central to the founding of the Casa de la Cultura in Juchitán in 1972, subsidizing its operations with his own money and using his national and international networks to defend it against repeated attacks by the PRI. The Casa de la Cultura, di-

rected over the years by talented local intellectuals such as Macario Matus and Víctor de la Cruz, has been described as "the center of an Isthmus Zapotec cultural revival" and a COCEI "stronghold" (Campbell 1994). It became a venue for Zapotec language and pottery classes, poetry, painting, and photography workshops, concerts, art exhibitions, and film festivals. It published the journal *Guchachi' Reza* for several years and maintains a library. For Campbell (2008), "the most beautiful thing about the COCEI-related Zapotec art movement was seeing young kids learning and aspiring to be artists at the Casa de la Cultura in Juchitán, not the success of a few in Oaxaca art galleries."

The painters Delfino Marcial Cerqueda (2006) and Sabino López (2006) described working with a group of movement-identified artists in the Casa de la Cultura's studio that had been fully equipped and supplied by Toledo. The artists, they explained, were not necessarily COCEI militants and were not as organized as the Mexico City grupos, but they made banners and posters for COECI marches, taught community painting classes, and organized group exhibitions of their art to support the movement. Macario Matus (2006), who directed the Casa de la Cultura from 1979–89, says he encouraged the artists not to abandon painting and "creating" even when they were making political posters for the COCEI. "I insisted that they not repeat the errors of the [Russian, Cuban, and Nicaraguan] revolutions, that it's better to follow the example of Marc Chagall," the Russian artist who participated in the Bolshevik Revolution but resisted the efforts made to turn him into a Soviet art bureaucrat.

Toledo's wealth and stature also allowed him to promote the establishment of institutions on a scale far grander than those founded by activist artists in Mexico City and California. Often working with other artists like Luis Zárate, José Villalobos, and Sergio Hernández, Toledo was a central force in restoring several historic buildings in or near the Oaxacan capital and establishing the institutions that they now house, including the Contemporary Art Museum of Oaxaca, the Graphic Arts Institute of Oaxaca (IAGO), the Álvarez Bravo Photographic Center, El Pochote Film Club, the Santo Domingo Cultural Center, the Ethnobotanical Garden, the Jorge Luis Borges Library, the San Agustín Paper Workshop, and the San Agustín Etla Center for the Arts.[12] Illustrating Campbell's observations about the rivalry between isthmus and Oaxaca Valley Zapotecs, Nicéforo Urbieta (2001) suggested that Toledo's institution building was part of an effort to restore the valley as the center of Zapotec culture.

In addition to their important role in documenting, preserving, and pro-

moting culture, history, and the arts, these institutions often support grass-roots community and social movement demands. The IAGO, for example, served as something of a "safe zone" when the state government repressed the Oaxacan teachers' movement in 2006. Toledo and Zárate are also key players in Patronato Pro Defensa y Conservación del Patrimonio Cultural y Natural del Estado de Oaxaca (PROOAX), a politically active environmental and con-servation organization that led successful efforts to prevent McDonald's from opening a restaurant on Oaxaca's central plaza. PROOAX was also active in defense of the Asamblea Popular de los Pueblos de Oaxaca (APPO), the mass social movement that grew out of the teachers' strike of 2006. Individually, Toledo consistently defends social justice causes. When Nicéforo Urbieta was kidnapped by the army in 1997 because of his community organizing efforts in his hometown of Zegache, Toledo was one of the first to demand his release (Malvido 1997).

Toledo's unparalleled artistic and political leadership comes with its own liabilities. As described in chapter 4, several of the movement artists I inter-viewed expressed concerns about the "Toledito" phenomenon of younger art-ists, describing their efforts to copy the maestro's formula for commercial suc-cess that produces aesthetically inferior clichés for the tourist market. This is evident in galleries and in artists' plazas throughout Oaxaca. Some of the insti-tutions he founded have experienced leadership problems. Over the course of the past decade many directors have come and gone at the IAGO and the Álvarez Bravo Photographic Center—the two institutions in which Toledo is directly involved on an almost daily basis. The high turnover rate is reflected in the sometimes uneven quality and efficiency of the services provided by these important centers.

It is a testament to the efforts of Toledo and other politically engaged artists and intellectuals like Luis Zárate, Macario Matus, Víctor de la Cruz, Sabino López, Delfino Marcial Cerqueda, and Nicéforo Urbieta that the cul-tural renaissance unleashed by the Zapotec movement in the 1970s remains vibrant despite the significant weakening of the political movement centered around the COCEI. Expressions of the cultural movement's vitality today take many forms throughout Oaxaca, including collectives of indigenous women weavers, Zapotec language and music workshops for children, grassroots orga-nizing efforts that combine political mobilization with the revival of cultural practices such as harvesting cochineal and sculpting with clay, and a dynamic visual arts scene. De la Cruz (2001), a former director of Juchitán's Casa de la Cultura and now affiliated with a social anthropology research center in

Oaxaca, explained that the political and cultural movements were parallel and often coincided but that they each had their own dynamic and one did not depend on the other. "The cultural movement had already begun with 1968," before the founding of the COCEI. Today, although the political movement has "lost much of its prestige," says de la Cruz, the cultural movement remains strong.

Toledo (2006) agrees, explaining that while "artists contributed a lot to the political movement in terms of money and artwork," unlike the *políticos*, "artists are not so limited by and dependent on the state, political institutions, and the political movement." The COCEI, he argues, "lost much of its spontaneous quality" when it went through a difficult period of change in becoming part of the national center-left opposition Party of the Democratic Revolution (PRD), the party that initially emerged out of the mass movement that supported Cuauhtémoc Cardenas's insurgent presidential campaign in 1988. However, "when the movement changed, the artists were able to continue to create their own spaces to work." Despite his and the movement's many accomplishments, however, Toledo expressed a sense of regret that they hadn't been able to take full advantage of the moment offered at the height of the COCEI movement to put forth a more organized program to assure survival of the Zapotec language and culture and to slow the constant out-migration that robs communities of vital human resources.[13]

The relatively impressive successes of the Zapotec cultural movement and artists' disillusionments about the COCEI's turn toward more traditional party politics brings us to another important legacy of Mexican and Chicano social movement artists: efforts to reconceptualize the very meaning of power. As explored in chapter 6, some activist artists, while recognizing the importance of building alternative institutions, have emphasized the power of knowing and changing the world more deeply through an integration of the bodily senses, spirit, and mind.

An issue of the Mexico City–based poetry journal *El Corno Plumado* called for a "total revolution of mind/body/senses and of the social order" in 1968 (Medina 2006c, 155). In the Beatles' hit of 1968, "Revolution," John Lennon warned, "You say you'll change the constitution / Well, you know / We all want to change your head / You tell me it's the institution / Well, you know / You'd better free your mind instead." And in 1969 *El Plan Espiritual de Aztlán*, a foundational manifesto of the Chicano movement, declared that "Our cultural values of life, family, and home will serve as a powerful weapon to defeat the gringo dollar value system and encourage the process of love and brotherhood."[1] Such sentiments reflected what Wallerstein (1989) identified as a generation's disenchantment with the rationalist pursuit of institutional political power and economic development that had characterized communist, nationalist, liberal, and conservative political movements alike. As one informed observer of the era in Mexico noted:

During the 1960s and 1970s, Mexico had an especially intense share of the widespread cultural malady that had spread all over the Western hemisphere. A series of underground currents—sexual dissent, psychotropic curiosity, spiritual experimentation, skeptical positions regarding modernity, in brief, anything contesting those repressive and production-oriented limitations that made up bourgeois identity—came together in a

variety of ritual and artistic adventures, defined by a break with conventional values as defined by society's "normative" centers. This was not a shift toward some concrete goal, but rather an epidemic of a variety of obsessions, desires, and instant utopias. Just as lifestyles, sexual roles, pursuits of pleasure, or notions of the absolute were all infiltrated and agitated, so did art become a space to express a particular form of heterodoxy for some practitioners. (Medina 2006a, 97)

However, Wallerstein (1989, 437) argues that while "the counterculture of the new Left was salient to most of these forces themselves, as it was to their enemies, in the final analysis it was a minor element in the picture." The important legacies of 1968, he maintains, were more political than cultural. Certainly, many of the idealistic sentiments expressed in the quotes above were quickly abandoned for more instrumentalist politics as the era's social movements confronted harsh realities, such as state repression, bureaucratic imperatives, institutionalized racism, and the seductive allure of individual or institutional power. Throughout the '70s and '80s movement activists largely concentrated on challenging or gaining state power, and sometimes both, as the key to realizing imagined utopian futures. They did so through variations on Leninist cadre parties, guerrilla armies, electoral politics, labor unions, and broad nationalist and populist fronts led by powerful charismatic men.

Nevertheless, many artists associated with social movements continued to advocate for alternative notions of power and social change based on counter-hegemonic cultural transformations and fuller ways of knowing the world through the body, spirit, and mind. Artists have often served as the movements' inner consciousness, reminding us of the powerful countercultural spirit of 1968 that was sometimes overshadowed by a focus on institutional power. Explicitly or implicitly, many movement artists have questioned the effectiveness of institutional power—whether in the form of collectives, political parties, or state institutions—absent radical cultural transformations of our worldviews.

The Mexico City–based artist Maris Bustamante (2006), for example, urges us to reject rigid disciplinary categories that discourage creative collaboration among intellectuals trained to interrogate the world from vastly different perspectives. Bustamante is rightly concerned about the implications of long-held assumptions that "science relies primarily on intellective and rational reasoning [while] the arts rely on intuition and the senses" (166). By privileging the former over the latter, scientists, policymakers, and social

activists deny their publics full access to forms of knowledge produced by artists. Bustamante captured elements of this analysis in *A corazón abierto* (With heart open), one of a series of *NaftaPerformances* at Chicago's Mexican Fine Arts Center Museum in 1994. Bustamante interacted with an enormous, five-meters-tall, foam rubber human heart. She talked to the heart about love and its contradictions and paradoxes. At one point she removed a chair and whip from inside one of the heart's little openings and began to insult the heart. The heart responded by showering the audience with little foam rubber hearts that flew from its interior like shooting stars, thus incorporating the public into what might have remained a private and personal dispute. When two white doves emerged from inside the heart, Bustamante and the heart made up and the performance ended. I read the performance as a series of challenges to reconcile one's mind with one's heart (and body), to overcome the assumed boundaries of the intellectual and emotional, the rational and subjective, the personal and the public, and to acknowledge the potential power of generosity even in the face of insults and brutality.

Wisely, Bustamante is not advocating a simple epistemological inversion that would privilege intuition and bodily senses over intellectual powers. Instead, she encourages and practices collaboration between the sciences and the arts, and she argues that "creating new ways of thinking through visuality and, above all, through transdisciplinarity, could transform the modes of interpreting, reproducing, and constructing the reality to which we have access as a species" (Bustamante 2006, 165). She describes several examples of transdisciplinary collaborations, including a project at the Multimedia Center founded in 1993 by Andrea di Castro at Mexico City's National Center for the Arts: "Di Castro designed a project whose goal was to send signals to a satellite with a predetermined itinerary, which resulted in a drawing showing a concept substantially different from anything we previously knew" (167–68). By opening our imaginations to new concepts—by "freeing our minds"— di Castro's project is more Lennonist than Leninist. In addition to more traditional Leftist goals of accumulating power and redistributing wealth, Bustamante emphasizes the importance of redistributing "the power of thought" as a means toward utopian ends that we may not yet be able to imagine. To further such efforts, she founded El Centro de Artes, Humanidades y Ciencias en Transdisciplina (CAHCTAS, the acronym for an organization roughly translated as Transdisciplinary Center for the Arts, Humanities, and Sciences).

The late Chicana theorist Gloria Anzaldúa advocated similar ideas. One of her last essays is an in-depth exploration of how progressive social change

could be better served by paying as much attention to spiritual and sensorial sources of understanding as we do to intellectual reasoning. Social movement activists would be well served by a careful reading of her work, in which she argues: "Breaking out of your mental and emotional prison and deepening the range of perception enables you to link inner reflection and vision—the mental, emotional, instinctive, imaginal, spiritual, and the subtle bodily aware-ness—with social, political action and lived experiences to generate subversive knowledges" (Anzaldúa 2002, 542). Given the nature of their creative work, activist artists are among those with great potential to generate such knowledges.

Contemporary Mexican and Chicano artists in particular often look for new ways of knowing in very old places: the sometimes deeply buried collective memory of their indigenous ancestors. Many Mexican and Chicano artists seem to share Bustamante's (2006, 166) contention that "a European version of Rationalism was imposed in the Americas with great contradictions beginning in 1492. From the beginning to the present, this provoked contestational postures informed by different, indigenous ways of thinking about conflictive reality." The work of the artists described below is, in one form or another, about increasing our powers of perception through the recovery and re-creation of social memory and historical systems of thought and knowledge within contemporary conditions. And therein lay one of their most creative and potentially transformative contributions to movements for social change.

The importance of such cultural projects has often been underestimated by social movement scholars and activists alike. Perhaps, in part, this is because the dominant structures of modern European and Anglo-American thought make it difficult to readily comprehend what Bustamante (2001b) claims is a distinct logic at work in Latin American cultures that are still deeply influenced by precolonial, indigenous structures of thought and aesthetics. This is not to suggest some genetic phenomenon in which contemporary Mexicans and Chicanos inherited a biologically distinct sense of time, space, beauty, and rationality. At work is a sociocultural phenonmenon of indigenous memory, as conceptualized by the historian Enrique Florescano (1999): in Mexico's syncretistic cultures, despite the Spaniards' determined efforts at cultural eradication, core structures and values from pre-Hispanic thought have been reproduced (and transformed) in daily life through symbols, rituals, ceremonies, fiestas, popular sayings, myths, oral histories, and the like. Consider, as one obvious example, Mexican and Chicano Catholicism: All Saints' Day and All

Souls' Day are fundamentally enactments of pre-Hispanic beliefs about death, and for some people the Virgin of Guadalupe is another manifestation of the Nahuatl-speaking people's Tonantzin, while in Oaxaca the Christ figure, el Señor del Rayo, is regarded by some as the Zapotecs' last emperor.

Much of the social science literature on social movements, like modern European and North American approaches to knowledge, emphasized the "rational," "objective," and quantifiable elements of movements: their composition, organization, resources, and *measurable* outcomes. For scholars active on the left in the 1960s and '70s, such tendencies were reinforced by a laser-like focus on winning state power for the proletariat. However, as discussed in chapter 1, starting in the late 1980s some social movement scholarship underwent a cultural turn toward analyses focused on how people attribute meaning to the world through symbolic practices and discourses. This shift is not in conflict with social movement efforts to influence change at the institutional or policy level, but it does extend our field of vision to the equally important cultural aspects of progressive social change. Our understanding of social movements and social change in general has begun to respond to a variety of developments inside and outside the academy. Feminist scholars like Donna Haraway (1988) dared us to critically interrogate claims of "objectivity," insisting that knowledge is always "situated" and "embodied." Scholars of racial and ethnic identity like Stuart Hall ([1990] 2001) emphasized the cultural politics of how identities are constituted through representation, while Michael Omi and Howard Winant (1986, 60) described the "discursive or representational means in which race is identified and signified." On the ground, new social movements of environmentalists, feminists, sexual minorities, and indigenous communities were questioning the wisdom of counsel to keep their eyes on the prize of party building, proletarian revolution, economic modernization, and state power. Instead such movements helped broader networks of social justice advocates to consider the limitations of changes in formal politics that are unaccompanied by deep cultural changes.

As noted earlier, an anthology edited by Alvarez, Dagnino, and Escobar (1998, 7) is an example of an approach to social movements that recognizes the centrality of the cultural politics of representation and signification, "because meanings are constitutive of processes that, implicitly or explicitly, seek to redefine social power." Gloria Anzaldúa's analysis is consistent with this approach. She urged those committed to social justice to recognize the subversive power of what she called *conocimiento*—understandings or bodies of knowledge that draw upon the spirit and body as well as the mind to "chal-

lenge official and conventional ways of looking at the world, ways set up by those benefiting from such constructions." She suggested, "Those carrying *conocimiento* refuse to accept spirituality as a devalued form of knowledge, and instead elevate it to the same level occupied by science and rationality. A form of spiritual inquiry, *conocimiento* is reached via creative acts—writing, art-making, dancing, healing, teaching, meditation, and spiritual activism. . . . Through creative engagements, you embed your experiences in a larger frame of reference, connecting your personal struggles with those of other beings on the planet, with the struggles of the Earth itself" (Anzaldúa 2002, 542).

Laura Pérez (2007, 3) argues that Chicana feminist artists have engaged "the spiritual alongside more familiar areas of social struggle (gender, sexuality, class, 'race')." Pérez understands this work as constituting a powerful "voice of dissent" against Euroamerican notions of enlightenment, progress, politics, spirituality, and art. References to their indigenous past are common in much Chicano art, but "what [Pérez] saw in Chicana feminist work with the Indigenous went beyond what for some in the initial Chicano movement had been a rather shallow war of symbols with Eurocentric culture to a genuinely more decolonizing struggle at the epistemological level, where being, existence, meaning, and of course knowledge are defined" (4).

For Anzaldúa the privileged site for acquiring—or recovering—this deeper form of knowledge was *nepantla*, "the place where different perspectives come into conflict and where you question the basic ideas, tenets, and identities inherited from your family, your education, and your different cultures" (548). The word "nepantla" was used by the Nahuatl-speaking indigenous population of Mexico in the sixteenth century, apparently to describe the unsettling, liminal, or "in-between two worlds and times" state of their postconquest social condition. Laura Pérez (2007) cites the videos of Frances Salomé España and the lithographs of Yreina D. Cervántez as examples that directly engage the concept of nepantla, disrupt dominant notions of time and space, attempt "to undermine racist and sexist histories of representation," and to "reinscribe alternative and healing visions of reality" (37). Pérez describes España's videos as an "experimental poetics" that "return spirit to the human tribe, allowing us to perceive spiritual presence and power." España's work, as read by Pérez, "produces a different experience of time and consciousness, interrupting linear time and arbitrarily authoritative linear narratives of cause and effect" (35). Pérez persuasively interprets Cervántez's *Nepantla* triptych as addressing "the ongoing struggle between two cultural legacies, as revealed in their different ways of seeing: that of an ostensibly universal, European scientific perspec-

tive . . . and that of American Indian worldviews," represented by objects that signify "continuous change and balance differences" (41).

The following examples are offered to illustrate how social movement associated artists have contributed to a reconceptualization of knowledge and power, and thus progressive social change, by placing our sensorial and spiritual powers on a par with our intellectual powers. I use the term "spiritual" to signal that dimension of human experience related to what cultural anthropologists refer to as the sacred realm of symbolic meanings and actions through which people interpret the often unobservable, supernatural forces that may ultimately control and shape the universe. These activist art projects also disrupt modern notions of space and time and urge us to dig more deeply for meanings of community and justice in collective memory banks that are often difficult to access in our hyperaccelerated, commodity-clogged lives. The process of imagining and executing the work described below involved the artists in interdisciplinary pursuits of knowledge drawn from their own individual and cultural subjectivity as well as from fields as varied as history, aesthetics, architecture, botany, physics, chemistry, anthropology, psychology, communications, and semiotics. Their work, I argue, engages the public in a multisensorial encounter that enhances our intellectual understanding of the material and spiritual worlds and re-illuminates the past to permit new ways of knowing the world, approaching what Anzaldúa called conocimiento.

ESTER HERNÁNDEZ'S *CANCIÓN MIXTECA*

In her ambitious installation *Canción Mixteca*, the California-born Chicana artist Ester Hernández disrupts nationalist discourses of space, time, experience, and identity. The project explores the social and ecological costs of the tomato—one of indigenous Mexico's many gifts to the world. The installation works simultaneously against the complacency and blissful ignorance of North American consumers and the narrowly drawn self-representations and romantic *indigenismo* of Chicano nationalists. The piece's title itself evokes deep emotions about separation from one's homeland. It is taken from a still much-beloved song written in the early twentieth century by the famed Mexican composer José López Alavéz while homesick for his native Oaxaca: "¡Qué lejos estoy del suelo donde he nacido! / Inmensa nostalgia invade mi pensamiento" (How far I am from the land where I was born! Immense nostalgia invades my thoughts).

When exhibited at the Santo Domingo Museum and Cultural Center in Oaxaca in 2001, the installation consisted of twenty-six sheets of rice paper onto which Hernández had hand-transferred text, pre-Hispanic figures, and photographic images of Mixtec and Zapotec migrants laboring in the tomato fields of California's San Joaquin Valley. Hernández (2008) explained that the images in the collage on the first sheet were taken from Nahuatl codices: the Nahuatl word for tomato (meaning "una cosa gordita con ombligo," a chubby thing with a belly button), a drawing of a tomato plant, and one of a man who appears to be tending the plant. Fourteen of the sheets contain text that presents succinct, clearly stated information about the history of tomato cultivation and about the human and environmental costs of modern tomato production. Issues highlighted in the text include genetic modification of the plant, use of pesticides and other chemicals, background on a small, poor, largely black town in Alabama that is a toxic dump for the wastes from pesticides, and Mixtec migrants who first traveled to Mexico's northwest state of Sinaola in the 1980s to harvest tomatoes.

With help from her sister's evangelical congregation in Selma, California, and the transnational migrant organization Frente Indígena Binacional (Binational Indigenous Front), Hernández met with Zapotec and Mixtec migrant farmworkers in Fresno County to conceptualize the project. Hernández (2008) says that in her conversations with the workers they emphasized their sense of "invisibility" but also expressed the often fulfilling collective experience of work, travel, and adventure. Eleven of the installation's sheets featured Hernández's photographs of the migrant workers, both men and women. One portrait is strikingly similar to the famous colossal Olmec heads, reminding us of this man's ancient genetic and cultural roots. Another, lit from behind by a low sun, appears Christlike. For whose sins will he die?

After transferring the images onto the rice paper, Hernández dipped them in beeswax, which produced an exquisite effect, almost like tattooed skin. For the installation in Oaxaca, the sheets were hung from wire, which allowed the natural light from the colonial site's large windows to shimmer through the translucent images. They hung above a floor map of Mexico made of tomatoes on green gravel, framed by bright orange marigolds, a flower associated with the Day of the Dead. The strategic combination of formal elements and content in Hernández's *Canción Mixteca* offered a multidimensional way of accessing and assimilating the complex social realities of class and race, migration and exploitation, commodity production and community, postmodern

globalization and premodern civilization. The artist's project significantly enhances the more objective, didactic interventions of investigative journalists, academics, and traditional documentary filmmakers and photographers.

In Fredric Jameson's ([1992] 2001) account of postmodernism as the cultural logic of transnational capitalism, he questions whether new political art is possible. Jameson describes a flat, affectless, decontextualized postmodern culture — symbolized by Andy Warhol's dazzling but superficial *Diamond Dust Shoes* in contrast to the deep emotional charge of Van Gogh's modernist *Peasant Shoes*. Jameson wonders whether meaningful political art is possible in a globalized system where place, space, time, and our own subject position can be difficult to grasp. He longs for an art that will achieve "a breakthrough to some as yet unimaginable new mode of representing" the global space of multinational capital, so that "we may again begin to grasp our positioning as individual and collective subjects and regain a capacity to act and struggle which is at present neutralized by our spatial as well as our social confusion" (557). Ester Hernández's representations of the people, places, and spaces involved in the transnational production of the tomato suggest that the art Jameson hoped for is indeed possible.

ELOY TARCISIO'S *CONFLICTO DE TIEMPO*

Eloy Tarcisio was active as a young teenager in the student movement of 1968 in Mexico City, and in the 1980s he was a member of the activist artists' grupo Atte. La Dirección (Sincerely, The Management). Throughout the decades since, he has collaborated on many alternative art projects with other progressive artists. In 1998 *Conflicto de tiempo en las horas y los días de la obra de Eloy Tarcisio* (Time conflict in the hours and days of Eloy Tarcisio's work) was mounted at the Museo José Luis Cuevas in Mexico City. The large-scale paintings and installations, which filled several rooms, were about time and memory. The works incorporated materials such as blood, mole, rose petals, and nopal cactus leaves and fruit, which, as organic matter, are ephemeral, short-lived (Tarcisio 2007). But, as representation, as memory, these powerful symbolic elements of Mexican cultures persist for millennia. The personal and social, present and past, ephemeral and enduring, organic and synthetic, material and symbolic, were integrated throughout the show.

In one piece a simple image of a preconquest pyramid was scratched graffiti-like into a blood-soaked background. In another, a figure composed of dried up nopales evoked the Virgin of Guadalupe. *Vista del Valle de México de*

1492 a 1992 (View of the Valley of Mexico from 1492–1992), a dark expressionist canvas, suggested the enduring agony of conquest. Is the valley teeming with humanity? Or oozing human remains? Or spewing toxic air pollution? In writing about one of Tarcisio's works that is painted partially in blood, *Torso, Cabeza, y Corazón* (Torso, head, and heart), the art critic Raquel Tibol (2003, 13) noted his ability to "invent signs and symbols referring to the life-death, to the death-life of human beings in their brief transit through the enigmatic valley of tears."

Perhaps the most powerful component of the exhibition—because it simultaneously engaged all the senses and mind—was a huge installation titled *El Milenio Nuevo* (The new millennium). The museum walls were hung with expressionist canvases of blood reds and browns (actually painted with mole), and each canvas contained a single word or phrase: "time," "memory," "end," and "no se olvida" (it is not forgotten). While the textual signs were incorporated into the blood- and earth-colored canvases, human figures appeared on separate panels in gray and white: naked bodies plunging through black space. On the floor, earth and corn kernels had been scattered and watered. The corn had begun to sprout and the dank, musty odor of stagnant water and earth filled the air.

Tarcisio's installation deepened my intellectual understanding of Mexican histories and cultures by stimulating a more empathetic appreciation for the powerful role of the symbolic in many Mexicans' sense of themselves as players in a sweeping historical drama. The sight and smell of organic matter we know as earth, water, corn, and blood—presented with masterful craftsmanship and aesthetic sensibility—combined with my rational knowledge of the symbolic power of those objects to allow for a fuller understanding of the enduring roots of Mexican cultures. The installation seemed to warn that the new millennium offers many false promises to which we can easily fall prey, if we fail to comprehend the past as a vital component of the present, alive in the material and spiritual realms of daily life.

As was also true of Hernández's *Canción Mixteca*, Tarcisio's ability to create such an opportunity for deeper ways of knowing is as much the result of careful research and planning as it is of his artistic creativity and talent. He has studied Mexican history and popular culture. He experiments with how the materials he uses will change over time and gives careful attention to every aspect of an exhibition or installation, including the architecture, light, atmosphere, and patterns of movement available to the public (Tarcisio 2007, MacMasters 2000).

FRANCISCO TOLEDO, LUIS ZÁRATE, AND THE
JARDIN ETNOBOTÁNICO OF OAXACA

The Ethnobotanical Garden in Oaxaca can also been understood as a project to recover historical memory and knowledge. The artists Francisco Toledo and Luis Zárate were key players in creating the garden, which opened to the public in 1998. It is located on the grounds of a former Dominican convent, which once served as a military base and was about to be turned into a convention center or a luxury hotel when a coalition of environmentalists, historic preservationists, community activists, and artists managed to secure the property. Spearheaded by the organization Patronato Pro Defensa y Conservación del Patrimonio Cultural y Natural del Estado de Oaxaca (PROOAX), the result is an extraordinary collaboration of botanists, anthropologists, archeologists, historians, and artists, funded by public and private sources.[2]

The garden's purpose is to collect, document, preserve, and educate about Oaxaca's rich (and endangered) biodiversity and the long, historical relationship between plants and human beings. Each of the plants in the garden is carefully labeled and catalogued, and well-informed docents guide visitors on a two-hour tour for a modest fee. There is no dichotomous presentation of the natural world versus the human world. Indeed every effort is made to remind the visitor that the garden itself is a human creation, exquisitely and thoughtfully landscaped—almost like an enormous earth work project.

The importance of aesthetics is emphasized in even the most practical matters: what at first appear to be elegant mosaics of natural stones turn out to be part of the system for capturing, filtering, and recycling water as it falls from the convent roof. In other examples, aesthetic design serves to jar cultural memory. In one of the convent's patios, Toledo created a fountain sculpted from an ancient wood; water tinted bloodred with the traditional, natural dye from the cochineal bug drizzles over the sculpture's mica-encrusted face. In another area of the garden stands the monumental, stark-black stone carved by Zárate in a design that evokes the architecture of the pre-Hispanic Zapotec sites at Monte Albán and Mitla in the Valley of Oaxaca.

Archeological evidence suggests that the earliest human cultivation of maize likely took place in the Valley of Oaxaca. As one strolls along paths of brightly colored gravel ground on site from local stones, a guide explains how the region's indigenous populations use flowers, leaves, seeds, bark, and roots for everything from perfume extracts, dyes, cosmetics, shampoo, glue, and jewelry to antibacterial medicines, weight-loss potions, paper, rope, rugs,

clothes, and food. Visitors are encouraged—in a controlled manner—to touch, smell, and taste the plants. I toured the garden three times, with three different docents (one English-speaking, one Spanish-speaking, and one bilingual), three different groups of visitors (two largely foreign tourists, one largely Mexican), and at different times of the year. On each occasion the experience for me was not unlike my encounter with Tarcisio's installation. The "objective facts" themselves were impressive, but immersion in the total sensorial experience of sight, smell, touch, and sounds that resulted from this collaboration between nature, scientists, scholars, artists, landscapers, and gardeners generated an awareness of the region's natural and cultural past and present that transcended the purely intellectual.

However, even an environment as sublime as this risks being reduced—at least momentarily—to a sign in the globalized, materialist world of commodities. One evening I glanced through the window that looks onto Zárate's sculpture to see gigantic, swirling, gloriously violet-colored images being projected onto the convent's towering walls. A multimedia theatrical presentation of the international fashion designer Carolina Herrera's new line was being staged in the garden.

NICÉFORO URBIETA, MARCELA VERA, AND THE CENTRO DE INVESGTIACIONES DEL PENSAMIENTO VISUAL

A final example of an art project that seems to answer Anzaldúa's call for conocimiento is a grassroots project that is far more modest in scale than the Ethnobotanical Garden but no less ambitious in its goals. It was carried out by the Oaxacan painters Nicéforo Urbieta and Marcela Vera. Urbieta is Zapotec, born and raised in the Zapotec pueblo of Zegache. As described earlier, Urbieta was imprisoned and tortured in the 1970s for alleged involvement in a guerrilla group. Vera was born in Chiapas, though her parents returned to their native Ocotlán, Oaxaca, to raise their daughter. She explained that, unlike Zegache, Ocotlán was founded by Spaniards and that the residents, like her parents, identify as mestizos (Mexico's majority, mixed-race ethnic identity); many lost the Zapotec language and traditions long ago (Vera 2001). Vera and Urbieta both studied art the Universidad Autónoma Benito Juárez de Oaxaca (UABJO) and Oaxaca's prestigious art workshop, the Taller Rufino Tamayo, discussed in chapter 4.

By the time Urbieta was released from jail in late 1980 and returned to Oaxaca, he had developed a new project: "I was in search of another form of

intelligence based on our culture, another way of understanding life." Urbieta (2001) explained:

> In jail I recovered my Zapotec identity and left with a very clear proposal to work for my culture, but with real importance for the whole world. I now saw the great limitations of Marxism — which was the freshest of what Europe had to offer. I began to study and reflect on my own culture, the Zapotec language, and with an interest in becoming an artist based on my identity as a Zapotec, but not folkloric, truly based on the thoughts, beliefs, feelings, and symbols of our culture. I had a dream of a renaissance of our culture, through its ceremonies, rituals, families. The past was still alive there, not in terms of some linear, analytical reading [of history], but in terms of the life, blood, and body of the people.

Urbieta's paintings reflect those themes. He explained the relationship between his new ideas about recovering his culture and his painting: "The process of my return to painting was the same as my return to Zapotec culture, after my long detour through Marxism. For me, Marxism was the culmination of Western rational thought, but its weakness was that it always insisted on the conscious. Returning to my Zapotec culture was, like my painting, learning how to play with the conscious and the subconscious."

Though Urbieta continues to paint, he explained that he was also interested in "creating creativity workshops with the people themselves, with their own culture, as part of the struggle for power." He understands power in terms of cultural understanding, knowledge, awareness, ability, and self-confidence, and he began to develop a strategy for community empowerment through the recovery of cultural knowledge. In his hometown of Zegache, which has undergone what he describes as a process of social and cultural decomposition as a result of changes in agriculture, the ecology, out-migration, and more, he decided to undertake an experiment to see "what was left of the deep Zapotec culture." Urbieta and Vera established the Centro de Investigaciones de Pensamiento Visual (Center for the Study of Visual Thought). Through a series of experimental events, the artists and their team attempted to evaluate how much traditional knowledge remained among people in Zegache of things like harvesting *cochinilla* and working with clay.

During one of their meetings in the community, they invited people to take a piece of clay, and people began to work with the clay and create figures while the meeting was going on. After the meeting, they put all the figures out on a table and discussed which they liked best and why. For several months

in 1996, Urbieta, Vera, and Zegache community members continued to work in this way, sculpting clay while discussing the pueblo's concerns, grievances, and desires. Vera (2001) contrasted the work she had done as an artist in the professional Taller Rufino Tamayo with her experience in Zegache, where her "art and . . . community work are so organically linked; the relationship with the community changes things." According to Urbieta, "the people of Zegache created incredible pieces, despite the fact that they no longer had any tradition of working with clay." He takes this as proof that historical, cultural knowledge persists, deeply embedded and embodied in people, and that it can be the basis for cultural and social rebirth of communities like Zegache.[3] Urbieta and Vera organized an exhibition of the Zegache community's work in Oaxaca City and brought people from the town for a big celebration, which was videotaped. Photos of the fanciful, sometimes surreal sculptures created in these workshops can be seen in the exhibition catalog (Urbieta 1998).

Urbieta and Vera's attempt to recover indigenous cultural memory and knowledge would seem to bear out observations by the native Hawaiian scholar and educator Manulani Aluli Meyer (2003, 52): "If a people develop a relationship with a place and people for countless generations, they will be in full dialogue with what that place and people have to teach. These are epistemological points that bring us to ancient clarity that highly mobile Anglo-Americans often do not possess: (1) place educates, (2) beauty develops our thinking, and (3) time is not simply linear."

These examples illustrate some of the ways in which activist artists have used diverse bodies of knowledge and skill to craft environments that stimulate the public's body, mind, and spirit to produce a deeper knowledge of the social world and of the individual's position in it. The content and aesthetics of their work have been influenced by the shared experiences of an international generation of social movement activists as well as by the particularities of their local histories, cultures, and politics. Such activities can be vital catalysts for progressive social change because they challenge hegemonic and purposefully fractured ways of understanding the world and potentially empower the public with alternative, more holistic ways of knowing and being.

Artists add instruments to the collective toolbox of social change that can compliment and enhance those offered by movement strategists, theorists, organizers, and propagandists. As artists they are attuned to important sensory and emotional data about the human experience that are often overlooked by activist policymakers and political strategists who place greater stock in readily observable, quantifiable phenomena. Deeply engaged in the

symbolic, artists are often better able to fully appreciate the cultural processes by which people attribute meaning to social reality through representation. When the contributions of artists are fully integrated into social movements, they help to shape a praxis informed by the triangulation of meanings derived from body and spirit as well as the mind (Meyer 2003).

To commemorate the fortieth anniversary of 1968's worldwide student movements, San Francisco State University's Departments of Sociology and Raza Studies, in collaboration with the Mission Cultural Center for Latino Arts, the community arts organization Tenth Muse Presents, and the Chicana Latina Foundation, staged a multimedia forum called "1968: Still Dreaming." The program included Maris Bustamante's performance of *960 Seconds*, written specifically for the event as a homage to eight deceased Mexican artists from the activist generation of '68. Bustamante's strikingly simple and elegant set consisted of a row of eight naked light bulbs suspended over a long table covered with red satin. On the table under each light was a "place setting" that included an artist's name, an object or image representing that artist, and a bag of micro-wavable popcorn. Behind and to the left of the table sat a microwave oven rigged with a microphone. Bustamante approached the first place setting, picked up the bag of popcorn, placed it in the oven and set the timer for two minutes. She then pricked her finger, squeezed out a drop of blood, and smeared the blood on the white blouse over her heart. She spoke lovingly and humorously about the artist and his work as the corn began to pop, slowly at first, then faster and faster until the oven's shrill timer signaled it was done. As the room went silent, Bustamante reached up and turned off the first light. Two assistants began to offer the audience small cups of the freshly popped corn, rather like

holy wafers during Communion. Bustamante then moved on to each of the other place settings, repeating the same action with the popcorn, the blood, and the light until, after her goodbye to the final artist, she turned off the last light and, 960 seconds after the performance began, the theater went completely dark. The audience was made to feel witness to eight fragile, frantically creative lives ended too quickly. But their legacy lived on, the performance promised, signaled by the aroma of popcorn and bonds of community that filled the theater.

As argued and documented throughout this book, Mexican and Chicano artists made lasting contributions — too often overlooked or underestimated by scholars and activists alike — to the social movements identified with the international generation of 1968. Artists created a visual discourse of expanded citizenship that allowed broad, previously disenfranchised constituencies — students, workers, immigrants, women, ethnic and sexual minorities — to imagine and enact a newly empowered agency. Those efforts contributed significantly to the democratization of state and civil society over the past forty years by expanding our democratic and egalitarian imaginary. Artists also helped to constitute new, prideful collective identities through images that subverted and destabilized hegemonic, seemingly fixed representations of class, gender, sexuality, race, and nation. Artists were often the most vocal advocates for those who were ignored or oppressed within their own social movement communities; through their images, artists invited us to inhabit our individual and collective body in new ways.

Social movement artists also disrupted the dominant aesthetics and cultural politics of the elite art world, reappropriating or inventing genres, forms, styles, and media to create syncretistic expressions of social realities for which Western modernism had no place. They often tried to put their visions into practice by creating alternative spaces informed by their commitment to building more democratic, egalitarian, mutually respectful communities. At other times they forced open the doors of established institutions long closed to working-class people of color and other visionary advocates of progressive social change. Finally, artists helped activist communities to rethink conventional ways of knowing and changing the world. They have invited us to pay more attention to our bodily and spiritual senses and warned us of the limitations of the rational and scientific. Artists have questioned the effectiveness of social change driven by a pursuit of institutional power unaccompanied by deep cultural changes, and they have worked to uncover sources of social

power that may lay dormant in collective, indigenous memories obscured by centuries of colonial acculturation.

As we have seen, these efforts were not without contradiction, including the reproduction of social divisions, hierarchies, and authoritarianism within the movements themselves. Progressive activists, including artists, face many unresolved challenges in the quest for social justice and more democratic, egalitarian communities. As the mass movements that originated in the 1960s waned in the '80s, individuals committed to progressive social change were often forced to settle for less dramatic, smaller-scale interventions whose impact was not always immediately apparent. Worldwide, the Left faced a period of malaise and paradigm crisis following the collapse of the Soviet Union and the, at best, uneven record of revolutionary national liberation movements that came to power in the '60s and '70s. The increased political and social power of the Right in the United States and the imposition of neoliberal economic policies throughout the world contributed to the malaise, deepened class inequalities, and further reduced the already scarce public resources available to progressive organizations and artists. As demands for democratization contributed to an opening of political systems in countries like Mexico, progressive forces faced new challenges of learning how to govern, at the local or national level, with few resources and in political cultures characterized by corruption, nepotism, and personalized networks of power. A mass consumerist culture seemed to reach more broadly and penetrate more deeply than ever before, overshadowing the altruistic and communitarian spirit of earlier countercultural movements. Much of the art world devolved into an art market, rapidly commodifying the latest trend or star before moving on to the next hot property. In this context, some of us allowed social justice activism to take a backseat to our pursuit of professional success, financial security, and other personal goals.

These challenges remain real and formidable, but there are also reasons to be hopeful about the prospects for new forms of social movement activism in which artists continue to play pivotal roles. In the San Francisco Bay Area, for example, multiracial youth organizations of Chicanos, Latinos, blacks, Asians, and individuals who self-identify as mixed race turn hip-hop music, spoken word, and digital media into powerful tools for expressing their concerns, anxieties, demands, and dreams in what has been called a post–civil rights era (Clay 2006). In Mexico City, governed for the past decade by the Party of the Democratic Revolution (PRD), organizing by the LGBT community helped

make same-sex marriage legal; the playwright and actor Jesusa Rodríguez and the songwriter and singer Liliana Felipe helped give visibility and legitimacy to that struggle with a very public wedding and performance on Valentine's Day in 2001.[1] Oaxaca and California are geographic poles of a transnational movement of Zapotec and Mixtec migrants in which the artistic expressions of cultural traditions are being transformed by life in a new space commonly called Oaxacalifornia.[2] A version of Oaxaca's famed annual Guelagetza festival, which features dancers representing the state's many indigenous groups, is now staged in Fresno, California. In Zapotec towns like Teotitlán del Valle and Juchitán, some migrants have returned from months or years in California with a newfound "gay" identity and inject "drag queen" performance aesthetics into traditional festivals, provoking discomfort and tensions but also new ways of thinking about gender and sexuality.

The world as it is, wracked by extreme inequalities, injustice, and violence, is frightening, but so are the risks of challenging the status quo and the uncertainties of an unknowable future. To counter such fears when we contemplate the possibilities of profound social change, perhaps we should heed the advice of one of our artists: "We should encourage the most eccentric actions and prepare individuals to handle confrontations with other truths. We should encourage conduct that uses demystifying humor as a means of survival when confronted with the feeling of chaos. All accomplices are welcomed" (Bustamante 2006, 170).

NOTES

PREFACE

1 For reproductions of 1968 Student Movement art, see Grupo Mira (1988), Aquino and Perezvega (2004), and Ayala (1998). For examples of grupos movement art, see Liquois (1985a), Debroise (2006a), García Márquez et al. (1977), and Híjar (2007). For images of Chicano movement art, see Griswold del Castillo et al. (1991), Gaspar de Alba (1998), Keller (2002), and Keller et al. (2004).

2 In 2010 the Instituto de Artes Gráficas de Oaxaca (IAGO), located in the city of Oaxaca, completed an extensive digital archive about the COCEI that includes many of the same images that I was able to locate over the past ten years, which will make future research on this movement much easier.

ONE | SIGNS OF THE TIMES

1 Cynthia Fowler (2007, 63) offers a similar analysis of the work of several contemporary American Indian artists who "explore hybridity as a vehicle for the redefinition not only of themselves as individuals, but also of their culture as a whole."

2 On the legend of Aztlán and artwork derived from it, see Fields and Zamudio-Taylor (2001). See especially Mesa-Bains (2001) and Zamudio-Taylor (2001) about the relationship of Aztlán to the Chicano movement and associated art.

3 On the student movement of 1968, see Poniatowska ([1971] 1992); Zermeño ([1978] 1998); Álvarez Garín (1998); Frazier and Cohen (2003); and Carey (2005). On the artwork of the student movement of 1968, see Grupo Mira (1988); Ayala (1998); Aquino and Perezvega (2004); and Vázquez Mantecón (2006b). On the grupos movement, see El Rollo et al. (1980);

Liquois (1985a); Goldman (1994); Sánchez (2003); Vázquez Mantecón (2006a); and Hijar (2007).

4 In my interview with Lourdes Grobet (2006), an artist active in the grupos movement who also did work in support of the COCEI, she recalled an interview with the late Mexican Communist Party (PCM) leader Valentín Campa. Campa told her the story of the PCM's electoral victory in 1980 in a town in the state of Guerrero (a year before the COCEI's election), which would make it the first electoral victory of the Left opposition in Mexico.

5 For additional analysis of the COCEI and Zapotec movement, see Aubague (1985); Bañuelos et al. (1988); Campbell et al. (1993); and Barriga Mateos (2006).

6 On the Chicano movement, see Mariscal (2005); Muñoz (2007); Martínez (1991); Martínez (2008); and Rosales (1996). On Chicano movement art, see the essays in Griswold del Castillo et al. (1991); Gaspar de Alba (1998); Davalos (2001); Keller (2002); Pérez (2007); Montoya and Salkowitz-Montoya (1980); Ybarra-Frausto (1996). For monographs about individual Chicano movement artists, see the A Ver: Revisioning Art History series published by the UCLA Chicano Studies Research Center Press.

7 On Ehrenberg's experiences with the student movement of 1968, his exile in England, and his contributions to the grupos movement, see Debroise (2006a) and Ehrenberg (2007b and 2007c).

8 Patricia Rodríguez confirmed her relationship with Galván in personal conversations with the author.

9 I provided a fuller exposition of this analysis in McCaughan (1993).

10 For a summary of the isthmus's local political economy of the era, see Rubin (1997, especially 110–13).

11 For an astute analysis of liberalism see Wallerstein (1992).

TWO | SIGNS OF CITIZENSHIP

1 Templeton's design for the banner was found in Sabino López's personal collection.

2 García's poster was viewed at the Fine Arts Museums of San Francisco webpage, http:// famsf.org.

3 How distinct local and national political and cultural contexts give rise to distinct discursive strategies within otherwise similar democratization movements is described in an insightful study of political cartoons in Taiwan and Hong Kong; see Lo, Bettinger, and Fan (2006).

4 Photographs of a few of the rare examples of student movement art that included Juárez and Zapata can be seen in Aquino and Perezvega (2004, 88).

5 The artist is not identified but the style of the image suggests it was likely created by an engraver affiliated with the Taller de Gráfica Popular, such as Leopoldo Méndez or Alberto Beltrán.

6 See Campbell's (2003) excellent study of Mexican muralism in the 1990s and McCaughan (2002) for an analysis of more recent social movement art in Mexico City. Iconography associated with nationalist and revolutionary heroes is also featured

prominently in political street art in Oaxaca since 2006 when a mass movement was sparked by the government's repression of the teachers union; see, e.g., Nevaer (2009).

7 García's poster was viewed at the Fine Arts Museums of San Francisco webpage, http://famsf.org.

8 García's poster was viewed at the Fine Arts Museums of San Francisco webpage, http://famsf.org.

9 For more information on Montoya, see Romo (2011).

10 Some of Héctor García's photographs of government repression of the student movement of 1968 are reproduced in Morales Carrillo et al. (2004). Mraz (2009, 187–88) notes, "it is ironic that [García] went to work shortly after the massacre for the man who is today considered to have orchestrated it, President Luis Echeverría (1970–76). García maintains that, having become convinced of Echeverría's sincerity and capacity, he accepted his offer to be the presidential photographer because he was given independence and the right to his negatives."

11 García's posters were viewed at the Fine Arts Museums of San Francisco webpage, http://famsf.org.

12 A few years later Rius based an issue of his popular Los Agachados comic book on the research Peter Baird and I did about the North American colony in Mexico (Baird and McCaughan 1974).

13 Montoya's graphic was viewed at www.malaquiasmontoya.com.

14 García's posters were viewed at the Fine Arts Museums of San Francisco webpage, http://famsf.org.

15 García's poster was viewed at the Fine Arts Museums of San Francisco webpage, http://famsf.org.

16 Artists involved in creating the mural efímero included José Luis Cuevas, Roberto Donís, Francisco Icaza, Jorge Manuell, Benito Messeguer, Adolfo Mexiac, Mario Orozco Rivera, Ricardo Rocha, Manuel Felgúerez, Fanny Rabel, and Guillermo Meza (Vázquez Mantecón 2006, 38).

17 García's posters were viewed at the Fine Arts Museums of San Francisco webpage, http://famsf.org.

18 Montoya's graphics were viewed at www.malaquiasmontoya.com.

19 According to several sources, Corrales's photograph was a staged recreation of an earlier event. Corrales's obituary on May 8, 2006, in the Telegraph, for example, reports: "Corrales's best-known picture, Caballeria (Cavalry, 1960), was political in nature, showing as it does a band of horsemen symbolically riding on to a plantation owned by an American fruit company. . . . Corrales's subjects were re-creating for the camera an event that had actually taken place earlier, since in this case the uprising had happened months before" (see http://www.telegraph.co.uk/news/obituaries/1517727/Raul-Corrales.html). However, it seems more likely that Corrales photographed a reenactment of an action taken by nineteenth-century Mambí revolutionaries during Cuba's struggle for independence. In any case Corrales's photograph became iconic and a symbol of the continuity between the Cuban Revolution of 1959 and the nation's war of independence against Spain in the previous century.

1 These posters can be seen in Aquino and Perezvega (2004): 154, 161, 71, 63, and 79, respectively.

2 See Aquino and Perezvega (2004, 68, 74, 78, 83, 111, 114, 131, 143, 155, and 225).

3 These studies vary widely in their methodologies, time frames, and particular subject matter, though most are interested in cultural aspects of the construction of political and social power in Mexico. Franco (1989) offers a sweeping historical view of how Mexico's master national narrative was both highly gendered and absent of real women. Natividad Gutiérrez (1999) argues that state formation in Mexico relied on pervasive nationalist myths that downplayed separate ethnic identities. Marjorie Becker (1995) describes how the Cárdenas administration in the 1930s had to come to terms with the campesinos' culture, particularly its Catholicism. Michael Nelson Miller (1998) focuses on the 1940s, when the Avila Camacho administration helped shape *mexicanidad* through funding radio, film, art, and architecture. Jeanne L. Gillespie (1998, 19) explores how the *china poblana*—the image of a "dark-haired, dark-eyed young Mexican woman dancing the jarabe tapatío (Mexican Hat Dance) and wearing a white embroidered blouse, a full green skirt adorned with ribbons, and a red rebozo (shawl)"—became a national archetype for Mexican women and an icon for economic interests. Finally, and significantly, some scholars have begun to highlight how national identity and power were always constructed in the context of counterhegemonic efforts by grassroots communities and movements; see Mary Kay Vaughan (1997) and Jeffrey Rubin (1997).

4 Janet Wolff (1990, 56–57) draws upon analyses by Shari Benstock and Griselda Pollock to make a case for the idea that the central themes of modernist writing and art "were bound to marginalize women, whose experience was not encapsulated therein."

5 Siqueiros's painting is reproduced in Edward J. Sullivan (1996).

6 According to Robert Buffington (2003, 195), "working-class homophobia was about much more than just identifying, defining, and naming (with a number) a despised category of nonsubjects; it was also about social domination or, in this case, about the contestation of bourgeois social domination. That purpose gave Mexican working-class homophobia its distinctive contours—contours that are just beginning to adjust to the expansion of middle-class notions of gay identity through mass media, transcultural contacts, and gay rights movements."

7 For example, the famed artist José Clemente Orozco's cartoon lampooning male homosexuals as swishy dandies dressed in tight pants and groping one another's buttocks appeared in an edition of *El Machete* in 1924.

8 *La Regla Rota* was edited by Adolfo Patiño, the leader of Peyote y la Compañía, and Rogelio Villareal of Grupo de Fotógrafos Independientes. The name of the magazine, according to Rippey (2003), "came from a performance of Adolfo Patiño . . . in which he broke a lot of old school rulers while he repeated, 'hay que romper las reglas' ('you have to break the rules')."

9 The only substantial coverage of women artists in these journals that I have found is in *Fem* 9, no. 33 (1984) and *Debate Feminista*, año 12, vol. 23 (2001).

10 The editors of *Debate Feminista* incorrectly attributed this statement to Magali Lara, but in a personal communication Lara informed me that the statement was made by Mónica Mayer. One might consider the important work of Rita Eder and Eli Bartra as exceptions to Mayer's statement, but Eder's body of scholarship is not primarily focused on women artists and Bartra has focused on women and folk art.

11 For additional analysis of Bustamante, Mayer, Polvo de Gallina, and this performance in particular, see Blanco Cano (2006 and 2010).

12 Tomás Almaguer (2008) suggested that it was actually a local Chicana politician, not male movement leaders, who blocked production of Baca's mural. However it happened, one effect, intended or not, was to reinforce the notion that Chicano movement identity was a largely masculine construction.

13 The assemblage artist Ed Kienholz recreated Barney's Beanery as an installation, including the prominently displayed "Fagots — Stay Out" sign. The original sign as well as Kienholz's installation can be seen in Morgan Neville's film *The Cool School: How LA Learned to Love Modern Art* (2007).

14 Lesser-known Oaxacan photographers who sympathized with the movement include Madrigal Simancas (whose work focuses on the female body), Javier Sánchez Pereira, and Guillermo Petrikowsky. Madrigal Simancas emphasizes that for this generation of photographers — "the generation of 1968" — their formation as photographers was inseparable from the formation of their social and political consciousness (Castellanos 1997, 156).

15 See work by Cerqueda in *Generación* 9, no. 25 (October–November 1999): 18, and in illustrations for *Fábula de Gubixa, Mudubina y Xtagabe'ñe*, http://www.gbw.com.mx/__pap/fabula/fabula.htm.

16 On the muxe as a third gender construction, see Stephen (2002).

17 Henestrosa (1906–2008), a Zapotec intellectual from Juchitán, was an important promoter of Zapotec language and culture from the 1920s on. Miguel Covarrubias (1904–57), a Mexico City–born painter and ethnologist, was, like Henestrosa, an influential figure in Mexico's early twentieth-century *indigenista* movement, and the Tehuana was featured prominently in some of his work.

18 Debroise (2006c, 253) claims that, together with Víctor de la Cruz, Ramírez Castañeda edited the journal *Guchachi' Reza*. Angélica Abelleyra (2001, 57) writes that the poet helped Toledo establish Casa de la Cultura in 1972.

19 See, e.g., essays in Foweraker and Craig (1990) and Rodríguez (1998).

20 Several of Templeton's COCEI-related graphics can be seen in Martinez (1987, 86–88).

21 Lomas Garza's work can be viewed at http://www.carmenlomasgarza.com/.

FOUR | THE SIGNIFICANCE OF STYLE

1 On the political significance of abstraction and realism, see Balfe (1985); on the politics of abstract expressionism, see Cockcroft (1985).

2 On the so-called Ruptura artists, see Calvo and Arteaga (2001) and Manrique (2000).

3 For a description of the Women's Building and Judy Chicago's role in establish-
 ing feminist art schools and spaces, see Lippard ([1974] 1995) and Schapiro ([1972]
 2001).

4 Howard Becker (1982) has noted the art world's ability to assimilate "maverick" art.
 Issa María Benítez Dueñas (2007, 23) argues that many conceptual art projects, espe-
 cially in the highly evolved art-as-commodity markets in Europe and the United
 States that were ever "eager of novelty," often "ended up completely integrated into
 the complex and hegemonic artistic system."

5 For examples of Nieto's work, see http://www.rodolfonieto.com/.

6 In addition to Neville's film, for more on the L.A. art scene of the late 1950s and early
 1960s, see Nelson (2008) and Armstrong (2008).

FIVE | CREATIVE SPACES

1 Francisco Icaza, Vicente Rojo, Lilia Carrillo, Manuel Felguérez, and Felipe Orland
 were among the artists who withdrew their work from the MAM (García de Germe-
 nos 2006, 52).

2 Contrasting analyses of the legacy of the Frente and grupos movement more gen-
 erally can be found in Híjar (1985), who offers more of a Marxist-Leninist critique
 of individualism and the lack of revolutionary vanguard; in Ehrenberg (1985), who
 characterized the movement as a revolutionary model for living life in which artis-
 tic creation and social commitment were fully integrated; and in an interview with
 Helen Escobedo by Liquois (1985b), in which she emphasizes that the particular
 conjuncture that gave rise to the grupos had passed, in part due to the very success
 of the movement.

3 On the Left's reassessment of democracy, leadership, vanguard organizations, the
 state, and so forth, see McCaughan (1997). On feminism's influence on the Latin
 American Left, see Chinchilla (1991).

4 For more information, see http://www.pintomiraya.com/.

5 On Rodríguez and Felipe's center and work, see Costantino (2000), Franco (1994),
 and McCaughan (2002).

6 For more information, see http://www.comuarte.org/.

7 A list of Chicano "grupos, centros and teatros" is included as an appendix in Gris-
 wold del Castillo et al. (1991, 223–32).

8 On Chicano and Chicana artists' collectives and other arts organizations, see Davalos
 (2001), Gaspar de Alba (1998), Ochoa (2003), and Quirarte (1991). The role of Chi-
 cano publications is discussed in Mariscal (2005).

9 Goldman and Ybarra-Frausto (1991, 91) noted one of the contradictory outcomes as-
 sociated with the relative decline of activism and the privatization and commercial-
 ization of Chicano art in the 1980s: a "great surge of women artists" and "the possi-
 bilities for exhibiting smaller, more intimate work" as "the Chicano gallery structure
 expanded throughout the Southwest, and community and feminist galleries became
 aware of Chicana artists."

10 For more information, see http://www.sparcmurals.org.

11 On COCEI political strategies, see Aubague (1985), Bañuelos et al. (1988), Campbell (1994), Campbell et al. (1993), and Rubin (1997).

12 For more information about these institutions, see Patronato Pro Defensa y Conservación del Patrimonio Cultural y Natural del Estado de Oaxaca (2000).

13 See Stephen (2007) for an excellent description and analysis of the complex migration dynamics among Oaxaca's indigenous communities.

SIX | CREATIVE POWER

1 The full text of the Plan Espiritual de Aztlán can be found at http://studentorgs .utexas.edu/mecha/archive/plan.html.

2 For a detailed description of how the garden came into being, including the various institutions and personalities involved, see Holo (2004), especially chapter 3, "The New Philanthropy: Private/Public Partners."

3 Zegache is also the site of a major historical restoration of its church, funded and directed by the late, famed Oaxacan artist Rodolfo Morales.

POSTSCRIPT

1 The text of their vows and photos of the wedding by Lourdes Almeida were published as a cover story in the cultural magazine *Exis* (March 2001). In the photospread, Rodríguez and Felipe staged a sendup of traditional wedding ceremonies (complete with over-the-top romantic bridal gowns), made a statement about the arbitrariness of heterosexual marriages, insisted on the importance of love and commitment, and poked fun at norms of femininity, all while sharing their love for one another and their hope for the future.

2 On the transnational indigenous Oaxacan communities in Mexico, California, and Oregon, see Stephen (2007) and Rivera Salgado (1999a and 1999b).

Abelleyra, Angélica. 2001. *Se busca una alma: Retrato biográfico de Francisco Toledo*. Mexico: Plaza Janés.

Acuña, Rodolfo. 2000. *Occupied America: A History of Chicanos*. 4th ed. New York: Longman.

Almaguer, Tomás. 1991. "Chicano Men: A Cartography of Homosexual Identity and Behavior." *differences: A Journal of Feminist Cultural Studies* 3, no. 2: 75–100.

———. 2008. Personal communication with author, San Francisco, April 16.

Almaraz, Carlos. 1987. Interview with Margarita Nieto, February 6, 13, and 20, 1986; July 31, 1986; and January 29, 1987. *Smithsonian Archives of American Art*. http://www.aaa.si.edu/collections/oralhistories/transcripts/almara86.htm.

Alvarez, Sonia E., Evelina Dagnino, and Arturo Escobar, eds. 1998. *Cultures of Politics, Politics of Cultures: Re-Visioning Latin American Social Movements*. Boulder: Westview.

Álvarez Garín, Raúl. 1998. *La estela de Tlatelolco*. Mexico City: Editorial Grijalbo.

Anzaldúa, Gloria E. 1987. *Borderlands/La Frontera: The New Mestiza*. San Francisco: Aunt Lute Books.

———. 2002. "now let us shift . . . the path of conocimiento . . . inner work, public actions." In *this bridge we call home: radical visions for transformation*, ed. Gloria E. Anzaldúa and A. Keating, 540–78. New York and London: Routledge.

Aquino, Arnulfo. 2001. Interview with author, March 27, Mexico City.

———. 2007. Interview with author, August 7, Oaxaca.

———. 2010. *Melecio Galván. La ternura, la violencia*. Mexico City: Instituto Nacional de Bellas Artes.

Aquino, Arnulfo, and Jorge Perezvega. 2004. *Imágenes y símbolos*

del 68: Fotografía y gráfica del movimiento estudiantil. Mexico City: Universidad Autónoma de Mexico.

Arias, Carlos, Maris Bustamante, Mónica Castillo, Lourdes Grobet, Magali Lara, Mónica Mayer, and Lorena Wolffer. 2001. "¿Arte feminista?" *Debate Feminista* 12, no. 23: 277–310.

Armstrong, Elizabeth, ed. 2008. *Birth of the Cool: California Art, Design, and Culture at Midcentury.* New York: Prestel Publishing.

Atkins, Robert. 1990. *Art Speak. A Guide to Contemporary Ideas, Movements, and Buzzwords.* New York: Abberville Press Publishers.

Aubague, Laurent. 1985. *Discurso político, utopía y memoria popular en Juchitán, Oaxaca.* Oaxaca: Instituto de Investigaciones Sociales, Universidad Autónoma Benito Juárez de Oaxaca.

Ayala, Leopoldo. 1998. *Lienzo Tlatelolco.* Mexico City: Organización Editorial Nuevo Siglo.

Baird, Peter, and Ed McCaughan. 1974. "Golden Ghetto: The American Colony in Mexico." NACLA*'s Latin America and Empire Report* (January).

———. 1979. *Beyond the Border: Mexico and the U.S. Today.* New York and Oakland: North American Congress on Latin America.

Balfe, Judith Higgins. 1985. "Art Style as Political Actor: Social Realism and Its Alternatives." *Sociologia Internationalis* 23, no. 1: 3–26.

Bañuelos, Marta. 1993. "Testimonies of COCEI Women." In *Zapotec Struggles: Histories, Politics, and Representations from Juchitán, Oaxaca,* ed. Howard Campbell et al., 177–82. Washington, D.C.: Smithsonian Institution Press.

Bañuelos, Marta, et al., eds. 1988. *Juchitán: Lucha y poesía.* Mexico: Editorial Extemporáneos.

Barbosa, Araceli. 2001. "Influenciado por el feminismo de la nueva ola: El discurso de género en las artes visuales, una nueva expresión de la cultura femenina." *Triple Jornada,* March 5, 2.

Barriga Mateos, Adrian Edson. 2006. "Participación política de la COCEI en el municipio de Juchitán de Zaragoza, 1974–2004." Tesis de Licenciado (bachelor's thesis), Universidad José Vasconcelos de Oaxaca.

Barrita, Demetrio. 2006. Interview with author, February 6, Oaxaca.

Barron, Stephanie, Sheri Berstein, and Ilene Susan Fort, eds. 2000. *Made in California: Art, Image, and Identity, 1900–2000.* Los Angeles: Los Angeles County Museum of Art; Berkeley: University of California Press.

Becker, Howard. 1982. *Art Worlds.* Berkeley: University of California Press.

Becker, Marjorie. 1995. *Setting the Virgin on Fire: Lázaro Cárdenas, Michoacán Peasants, and the Redemption of the Mexican Revolution.* Berkeley: University of California Press.

Benavides, Max. 2007. *Gronk.* Los Angeles: UCLA Chicano Studies Research Center Press.

Benítez Dueñas, Issa María. 2007. "Reconstructing Emptiness and Recovering Space: The Conceptual Ehrenberg." In *Felipe Ehrenberg: Manchuria, visión periférica,* ed. Fernando Llanos, 23–26. Mexico, D.F.: Editorial Diamantina S.A. de C.V.

Berdecio, Roberto, and Stanley Applebaum, eds. 1972. *Posada's Popular Mexican Prints: 273 Cuts by José Guadalupe Posada*. New York: Dover Publications, Inc.

Bhabha, Homi. 1990. *Nation and Narration*. London and New York: Routledge.

Blanco, Alberto. 1998. "Introducción: Imágenes y colores de Oaxaca." In *Imágenes y colores de Oaxaca*, 23–24. Oaxaca: Fundación Ingeniero Alejo Peralta y Díaz Ceballos. Exhibition catalog.

Blanco Cano, Rosana. 2006. "Dissident Mexican Women: Textual and Performative National Disidentifications Since 1970." PhD dissertation, Tulane University.

———. 2010. *Cuerpos disidentes del México imaginado. Cultura, género, etnia y nación más allá del proyecto posrevolucionario*. Madrid and Mexico City: Iberoamericana, Vervuert, and Bonilla Artigas Editores.

Bright, Brenda Jo, and Liza Bakewell, eds. 1995. *Looking High and Low: Art and Cultural Identity*. Tucson: University of Arizona Press.

Buffington, Robert. 2003. "Homophobia and the Mexican Working Class, 1900–1910." In *The Famous 41*, ed. R. M. Irwin, E. J. McCaughan, and M. R. Nasser, 193–225. New York: Palgrave Macmillan.

Bustamante, Maris. 1998. Interview with author, December 22, Mexico City.

———. 2000a. "Non-objectual Arts in Mexico, 1963–83." In *Corpus Delecti: Performance Art of the Americas*, ed. Coco Fusco, 236–37. London: Routledge.

———. 2000b. Interview with author, May 10, New Orleans.

———. 2001a. Interview with author, April 1, Mexico City.

———. 2001b. Interview with author, April 6, Mexico City.

———. 2006. "New Transdisciplinary Visualities as an Alternative to Redistribute the Power of Thought." *Social Justice* 33, no. 2: 165–70.

Calvo, Enrique Franco. 2001. "Roberto Donís." In *Rupturas: A liberación da imaxe; A arte en México despois de 1950*, ed. Enrique Calvo and Agustín Arteaga, 132. Pontevedra, Spain: Museo de Pontevedra.

Calvo, Enrique Franco, and Agustín Arteaga, eds. 2001. *Rupturas: A liberación da imaxe; A arte en México despois de 1950*. Pontevedra, Spain: Museo de Pontevedra.

Campbell, Bruce. 2003. *Mexican Murals in Times of Crisis*. Tucson: University of Arizona Press.

Campbell, Howard. 1990. "Juchitán: The Politics of Cultural Revivalism in an Isthmus Zapotec Community." *Latin American Anthropology Review* 2, no. 2 (Winter): 47–55.

———. 1993. "Class Struggle, Ethnopolitics, and Cultural Revivalism in Juchitán." In *Zapotec Struggles*, ed. H. Campbell et al., 213–32. Washington, D.C.: Smithsonian Institution Press.

———. 1994. *Zapotec Renaissance: Ethnic Politics and Cultural Revivalism in Southern Mexico*. Albuquerque: University of New Mexico Press.

———. 2008. Personal e-mail correspondence with author, August 21.

Campbell, Howard, Leigh Binford, Miguel Bartolomé, and Alicia Barnabas, eds. 1993. *Zapotec Struggles: Histories, Politics, and Representations from Juchitán, Oaxaca*. Washington, D.C.: Smithsonian Institution Press.

Carey, Elaine. 2005. *Plaza of Sacrifices: Gender, Power, and Terror in 1968 Mexico*. Albuquerque: University of New Mexico Press.

Carrasco, Barbara. 1999. Interview with Jeffrey Rangel, April 13. *Smithsonian Archives of American Art*. http://www.aaa.si.edu/collections/oralhistories/transcripts/carras99.htm.

Carrillo, Hector. 1999. "Cultural Change, Hybridity, and Male Homosexuality in Mexico." *Culture, Health, and Sexuality* 3: 223–38.

———. 2002. *The Night Is Young: Sexuality in Mexico in the Time of AIDS*. Chicago: University of Chicago Press.

———. 2008. Personal communication with author, San Francisco, April 16.

Castellanos, Alejandro. 1997. "Ojo de Luz: La fotografía en Oaxaca." In *Historia del Arte de Oaxaca: Arte Contemporáneo*, vol. 3, 156. Oaxaca: Gobierno del Estado de Oaxaca, Instituto Oaxaqueño de las Culturas.

Castillo, Ana. 1995. *Massacre of the Dreamers: Essays on Xicanisma*. New York: Plume/Penguin.

Caulfield, Jon. 1992. "A Framework for a Sociology of Visual Images." *Visual Sociology* 7, no. 2: 60–71.

Chinchilla, Norma Stoltz. 1991. "Marxism, Feminism, and the Struggle for Democracy in Latin America." *Gender and Society* 5, no. 3: 291–310.

Cimet, Esther. 1979. "Nuevas opciones plásticas." *Plural* 8, no. 91: 32–34.

Clay, Andreana. 2006. "'All I Need Is One Mic': Mobilizing Youth for Social Change in the Post-Civil Rights Era." *Social Justice* 33, no. 2: 105–21.

Cockcroft, Eva. 1985. "Abstract Expressionism, Weapon of the Cold War." In *Pollock and After: The Critical Debate*, ed. Francis Frascina, 147–54. New York: Harper and Row.

Cockcroft, Eva, John Pitman Weber, and James Cockcroft. (1977) 1998. *Toward a People's Art: The Contemporary Mural Movement*. Albuquerque: University of New Mexico Press.

Coordinación de Difusión Cultural. 2002. *Una exposición, varias exposiciones, un tiempo de inauguraciones: 15 años de la Semana Cultural Lésbica-Gay*. Mexico: Coordinación de Difusión Cultural, Universidad Nacional Autónoma de México.

Cortines, Gabriela, and Francesco Siqueiros, curators. 1990. *Aquí y allá*. Los Angeles: Los Angeles Municipal Art Gallery. Exhibition catalog.

Costantino, Roselyn. 2000. "Visibility as Strategy: Jesusa Rodríguez's Body in Play." In *Corpus Delecti: Performance Art of the Americas*, ed. Coco Fusco, 57–71. London: Routledge.

Cuevas, José Luis. (1958) 2001. "La cortina de nopal / The Cactus Curtain." In *Rupturas: A liberación da imaxe; A arte en México despois de 1950*, ed. Enrique Calvo and Agustín Arteaga, 205–6. Pontevedra, Spain: Museo de Pontevedra.

———. 2001. Interview with author, March 22, Mexico City.

Cullen, Deborah, ed. 2008. *Arte ≠ Vida: Actions by Artists of the Americas 1960–2000*. New York: Museo del Barrio.

Cushing, Lincoln, ed. 2007. *Visions of Peace and Justice*. Berkeley, CA: Inkworks Press.

Dagnino, Evelina. 1998. "Culture, Citizenship, and Democracy: Changing Discourses and Practices of the Latin American Left." In *Cultures of Politics, Politics of Cultures: Re-Visioning Latin American Social Movements*, ed. Sonia E. Alvarez, Evelina Dagnino, and Arturo Escobar, 33–63. Boulder, CO: Westview.

Davalos, Karen Mary. 2001. *Exhibiting Mestizaje: Mexican (American) Museums in the Diaspora*. Albuquerque: University of New Mexico Press.

———. 2008. *Yolanda M. López*. Los Angeles: UCLA Chicano Studies Research Center Press.

de la Barrera, Gerardo. 2001. Interview with author, April 23, Oaxaca.

———. 2009. Interview with author, July 17, Oaxaca.

de la Cruz, Víctor. 1988. "Incógnita de la Resistencia: La cultura Za y el porqué de la iguana." In *Juchitán: Lucha y Poesía*, ed. Marta Bañuelos et al., 89. Mexico: Editorial Extemporaneos.

———. 2001. Interview with author, April 27, Oaxaca.

de la Mora Martí, Laura. 1999. "El otro lado de las artes visuals en Oaxaca." *Generación* 11, no. 25: 50–51.

Debroise, Olivier, ed. 2006a. *La era de la discrepancia / The Age of Discrepancies: Arte y cultura visual en México / Art and Visual Culture in Mexico 1968–1997*. Mexico, D.F.: Universidad Autónoma Nacional de México.

———. 2006b. "El dandy kitsch / A Kitsch Dandy." In *La era de la discrepancia / The Age of Discrepancies: Arte y cultura visual en México/Art and Visual Culture in Mexico 1968–1997*, ed. Olivier Debroise, 200–207. Mexico, D.F.: Universidad Autónoma Nacional de México.

———. 2006c. "Toledo insurgente / Insurgent Toledo." In *La era de la discrepancia / The Age of Discrepancies: Arte y cultura visual en México / Art and Visual Culture in Mexico 1968–1997*, ed. Olivier Debroise, 244–55. Mexico, D.F.: Universidad Autónoma Nacional de México.

Debroise, Olivier, and Cuauhtémoc Medina. 2006. "Genaología de una exposición / Genealogy of an Exhibition." In *La era de la discrepancia / The Age of Discrepancies: Arte y cultura visual en México/Art and Visual Culture in Mexico 1968–1997*, ed. Olivier Debroise, 18–31. Mexico: Universidad Autónoma Nacional de México.

del Conde, Teresa. 1994. *Historia mínima del arte mexicano en el siglo xx*. Mexico: Museo de Arte Moderno.

Díaz, Paloma. 2007. Personal communication with author, August 1, Mexico City.

Domínguez, Francisco, ed., and Jorge Reynoso, curator. 2000. *Estar y no estar. Helen Escobedo. 15 instalaciones*. Mexico: Universidad Nacional Autónoma de México.

Doniz, Rafael. 2006. Interview with author, February 27, Mexico City.

Eder, Rita. 1984. "Las mujeres artistas en México." *Fem* 9, no. 33: 7–11.

———. 1985. "Los Grupos." Unpublished text written for the exhibition *De los grupos los individuos: Artistas plásticos de los grupos metropolitanos*. Mexico City: Museo de Arte Carrillo Gil.

———. 2001. Interview with author, March 26, Mexico City.

Ehrenberg, Felipe. 1985. "En busca de un modelo para la vida." Unpublished text written for the exhibition *De los grupos los individuos: Artistas plásticos de los grupos metropolitanos*. Mexico City: Museo de Arte Carrillo Gil.

———. 2007a. *Felipe Ehrenberg: Manchuria, visión periférica*, ed. Fernando Llanos. Mexico, D.F.: Editorial Diamantina S. A. de C. V.

———. 2007b. "1960 and a Bit More . . ." In *Felipe Ehrenberg: Manchuria, visión perifé-rica*, ed. Fernando Llanos, 156–62. Mexico, D.F.: Editorial Diamantina S. A. de C. V.

———. 2007c. "Life in England, a Separate Story." In *Felipe Ehrenberg: Manchuria, visión periférica*, ed. Fernando Llanos, 168–75. Mexico, D.F.: Editorial Diamantina S. A. de C. V.

El Rollo, et al. 1980. "Grupos: Autodefiniciones." *Artes Visuales* 23: 8–32.

Emerich, Luis Carlos. 2000. *Pecanins*, Mexico: D. G. E. Ediciones / Turner Libros.

Fanon, Frantz. (1963) 1968. *The Wretched of the Earth*. New York: Grove Press.

Favela Fierro, María Teresa. 2000. "Los 70: La llamada ruptura y la gráfica interna-cional." In *Los 70: La llamada ruptura y gráfica internacional*, 16. Mexico: Museo Dolores Olmedo Patiño and Universidad Autónoma Metropolitana.

Fields, Virginia M., and Victor Zamudio-Taylor, eds. 2001. *The Road to Aztlan: Art from a Mythic Homeland*. Los Angeles: Los Angeles County Museum of Art.

Florescano, Enrique. 1999. *Memoria indígena*. Mexico: Taurus.

———. 2001. "La formación de la nación y el conflicto de identidades." Paper delivered at the Southeast Council of Latin American Studies Annual Conference, Veracruz, Mexico, March 2.

Flores Cortés, Demián. 1999. "Regreso a la tierra: 13 grabadores juchitecos." *Generación* 11, no. 25: 36–38.

———. 2001. *Monte Albán*. Mexico: Casa Lam. Exhibition catalog.

Fondo Cultural Carmen, A. C. 2000. *Oaxaca: Bajo su intensa inspiración*. Mexico: Fondo Cultural Carmen, A. C. Exhibition catalog.

Foweraker, Joe, and Ann L. Craig, eds. 1990. *Popular Movements and Political Change in Mexico*. Boulder, CO: Lynne Rienner.

Fowler, Cynthia. 2007. "Hybridity as a Strategy for Self-Determination in Contempo-rary American Indian Art." *Social Justice* 34, no. 1: 63–79.

Franco, Jean. 1989. *Plotting Women: Gender and Representation in Mexico*. New York: Columbia University Press.

———. 1994. "A Touch of Evil: Jesusa Rodríguez's Subversive Church." In *Negotiating Performance: Gender, Sexuality, and Theatricality in Latin America*, ed. D. Taylor and J. Villegas, 159–75. Durham: Duke University Press.

Frazier, Lessie Jo, and Deborah Cohen. 2003. "Defining the Space of Mexico '68: Heroic Masculinity in the Prison and 'Women' in the Streets." *Hispanic American Historical Review* 83, no. 4: 617–60.

Fréot, Christine. 1992. "Le Regard Qui Pense." *Les Sorciers de la Forme: Sept Peintres Contemporarins D'Oaxaca Mexique*, 25–26. Exhibition catalog.

Fuller, Diana Burgess, and Daniella Salvioni, eds. 2002. *Art / Women / California, 1950–2000*. Berkeley: University of California Press.

Galería Arvil. 1996. *Francisco Toledo: Obra creada en diversas técnicas entre 1970–1995*. Mexico: Arvil, S.A. Exhibition catalog.

Gálvez, Fernando. 2004. Interview with author, July 27, Oaxaca.

Gamboa, Harry, Jr. 1991. "In the City of Angels, Chameleons, and Phantoms: Asco, A Case Study of Chicano Art in Urban Tones (or Asco Was a Four-Member Word)." In

Chicano Art: Resistance and Affirmation, 1965–1985, ed. Richard Griswold del Castillo et al., 121–30. Los Angeles: Wright Art Gallery, University of California, Los Angeles.

García, Rupert. 1996. Interview with Paul J. Karlstrom, September and November 1995 and June 1996. *Smithsonian Archives of American Art*. http://artarchives.si.edu/oralhist/garcia96.htm.

García, Velia. 2008. Personal communication with author, San Francisco, April 16.

García de Germenos, Pilar. 2006. "Salón Independiente: una relectura / The Salón Independiente: A New Reading." In *La era de la discrepancia / The Age of Discrepancies: Arte y cultura visual en México / Art and Visual Culture in Mexico 1968–1997*, ed., Olivier Debroise, 40–57. Mexico, D.F.: Universidad Autónoma Nacional de México.

García de Krinsky, Emma Cecilia. 1994. "Una década emergente." In *Una década emergente, una década después: Homenaje a Arnold Belkin*. Mexico, D.F.: Museo Universitario El Chopo.

García Márquez, Gabriel, et al. 1977. *Grupo Proceso Pentágono / Grupo Suma / Grupo Tetraedro / Taller de Arte e Ideología X Bienal de París*. Mexico: Instituto Nacional de Bellas Artes.

Garner, Roberta, ed. 2001. *Social Theory: Continuity and Confrontation*. Peterborough, Ontario: Broadview Press.

Gaspar de Alba, Alicia. 1998. *Chicano Art: Inside / Outside the Master's House. Cultural Politics and the CARA Exhibition*. Austin: University of Texas Press.

Geldzahler, Henry. 1994. *Galería Quetzali*. Oaxaca: Galería Quetzali. Exhibition catalog.

Gillespie, Jeanne L. 1998. "Gender, Ethnicity, and Piety: The Case of the China Poblana." In *Imagination Beyond Nation: Latin American Popular Culture*, ed. E. Paulino Bueno and T. Caesar, 19–37. Pittsburgh: University of Pittsburgh Press.

Glazer, Lee Stephens. 1994. "Signifying Identity: Art and Race in Romare Bearden's Projections." *Art Bulletin* 76, no. 3: 411–26.

Goldman, Shifra M. 1980–1981. "Response: Another Opinion on the State of Chicano Art." *Metamórfosis* 3–4, nos. 1–2: 3.

———. 1981. *Contemporary Mexican Painting in a Time of Change*. Austin: University of Texas Press.

———. 1994a. *Dimensions of the Americas: Art and Social Change in Latin America and the United States*. Chicago: University of Chicago Press.

———. 1994b. "Elite Artists and Popular Audiences: The Mexican Front of Cultural Workers." In Shifra Goldman, *Dimensions of the Americas: Art and Social Change in Latin America and the United States*, 123–39. Chicago: University of Chicago Press.

Goldman, Shifra M., and Tomás Ybarra-Frausto. 1991. "The Political and Social Contexts of Chicano Art." In *Chicano Art: Resistance and Affirmation, 1965–1985*, ed. Richard Griswold del Castillo et al., 83–96. Los Angeles: Wright Art Gallery, University of California, Los Angeles.

Gómez-Peña, Guillermo. 1996. "The Multicultural Paradigm: An Open Letter to the National Arts Community." In *Beyond the Fantastic: Contemporary Art Criticism from Latin America*, ed. Gerardo Mosquera, 183–93. Cambridge: MIT Press.

Gómez-Peña, Guillermo, and Felipe Ehrenberg. 2007. "How Does One Reach Man-

churia?" In *Felipe Ehrenberg: Manchuria, visión periférica*, ed. Fernando Llanos, 198–206. Mexico, D.F.: Editorial Diamantina S.A. de C.V.

Gonzalez, Jennifer. 2002. "Landing in California." In *Art / Women / California, 1950–2000*, ed. Diana Burgess Fuller and Daniella Salvioni, 219–40. Berkeley: University of California Press.

González, Rocío. 1999. "Testamentos de Jesús Urbieta." *Generación* 11, no. 25: 11.

Good, Carl, and John V. Waldron, eds. 2001. *The Effects of the Nation: Mexican Art in an Age of Globalization*. Philadelphia: Temple University Press.

Gramsci, Antonio. 1989. *Selections from the Prison Notebooks*. New York: International.

Green, James N., and Florence E. Babb. 2002. "Introduction: Gender, Sexuality, and Same-Sex Desire in Latin America." *Latin American Perspectives* 29, no. 2: 3–23.

Griswold del Castillo, Richard, et al., eds. 1991. *Chicano Art: Resistance and Affirmation, 1965–1985*. Los Angeles: Wright Art Gallery, University of California, Los Angeles.

Grobet, Lourdes. 2005. *Lourdes Grobet*. Mexico: Oceano.

———. 2006. Interview with author, February 27, Mexico City.

Gronk. 1997. Interview with Jeffrey Rangel, January 20 and 23. *Smithsonian Archives of American Art*. http://www.aaa.si.edu/collections/oralhistories/transcripts/gronk97.htm.

Grupo Mira. 1988. *La gráfica del 68: Homenaje al movimiento estudiantil*. 2nd ed. Mexico: Ediciones Zurda, Claves Latinoamericanas, El Juglar.

Grupo Proceso Pentágono. 1980. *Expediente: Bienal X. La historia documentada de un complot frustrado*. Mexico: Libro Acción Libre / BGP.

Grupo Suma. 1979. *La Calle*. Salon Nacional de Artes Plasticas. Sección Annual de Experimentación en México. Auditorio Nancional. Exhibition catalog.

———. n.d. "Grupo Suma CV 1976–1982." In Museo de la Estampa Archives, Mexico City.

Gutiérrez, Natividad. 1999. *Nationalist Myths and Ethnic Identities: Indigenous Intellectuals and the Mexican State*. Lincoln: University of Nebraska Press.

Hall, Stuart. (1990) 2001. "Cultural Identity and Diaspora." In *Social Theory: Continuity and Confrontation*, ed. Roberta Garner, 560–72. Peterborough, Ontario: Broadview.

Haraway, Donna. 1988. "Situated Knowledges: The Science Question in Feminism and the Privilege of Partial Perspective." *Feminist Studies* 14, no. 3: 575–99.

Hardy, Ernest. 2009. "Love Will Tear Us Apart: The Avant-Garde Faggotry of Bruce LaBruce." *Flaunt* 103: 102–9.

Henestrosa, Andrés. (1929) 1995. *Los hombres que dispersó la danza / A Nation Scattered by the Dance*, new ed., ed. Carla Zarebska, illustrated by Francisco Toledo. Mexico: Grupo Serla, Litografica Turmex, Promotora Cultural Sacbe.

Hernández, Ester. 2006. Lecture at the De Young Museum, San Francisco, September 30.

———. 2008. Interview with author, October 24, San Francisco.

Hernández, Judithe. 1998. Interview with Jeffrey Rangel, March 29. *Smithsonian Archives of American Art*. http://artarchives.si.edu/oralhist/hernan98.htm.

Híjar, Alberto. 1977. "Cuatro grupos a Paris." *Plural* 6, no. 73: 51–58.

————. 1985. "Afectar todo el proceso." Unpublished text written for the exhibition *De los grupos los individuos: Artistas plásticos de los grupos metropolitanos*. Mexico City: Museo de Arte Carrillo Gil.

————. 2001. Interview with author, March 28, Mexico City.

————, ed. 2007. *Frentes, coaliciones y talleres: Grupos visuales en México en el siglo XX*. Mexico: Casa Juan Pablos, Consejo Nacional para la Cultura y las Artes, Instituto Nacional de Bellas Artes, Centro Nacional de Investigación, Documentación e Información de Artes Plásticas.

Hinojosa, Oliverio. 1998. Interview with author, December 23, Mexico City.

Hirschman, Jack, ed. 2002. *Art on the Line: Essays by Artists about the Point Where Their Art and Activism Intersect*. Willimantic: Curbstone Press.

Holo, Selma. 2004. *Oaxaca at the Crossroads: Managing Memory, Negotiating Change*. Washington, D.C.: Smithsonian Books.

Instituto de Artes Gráficas de Oaxaca et al. 2007. Special issue, *La Patria Ilustrada*, no. 3. Reproduces selected texts and images about the Coalición Obrera Campesina Estudiantil del Istmo (COCEI) published in various media between 1972 and 1988.

Irwin, Robert McKee, Edward J. McCaughan, and Michelle Rocío Nasser, eds. 2003. *The Famous 41: Sexuality and Social Control in Mexico, c. 1901*. New York: Palgrave Macmillan.

Ittmann, John, ed. 2006. *Mexico and Modern Printmaking: A Revolution in the Graphic Arts, 1920–1950*. Philadelphia: Philadelphia Museum of Modern Art.

Jameson, Fredric. (1992) 2001. "Postmodernism, or the Cultural Logic of Late Capitalism." In *Social Theory: Continuity and Confrontation*, ed. Roberta Garner, 539–57. Petersborough, Ontario, Canada: Broadview Press.

Jaurena, Carlos. 2009. Interview with author, July 22, Mexico City.

Johnston, Hank, et al. 1994. "Identities, Grievances, and New Social Movements." In *New Social Movements*, ed. Enrique Laraña et al., 3–35. Philadelphia: Temple University Press.

Jordan, Glenn, and Chris Weedon. 1995. *Cultural Politics: Class, Gender, Race, and the Postmodern World*. Oxford: Blackwell Publishers.

Juana Alicia. 2000. Interview with Paul Karlstrom, May 8 and July 17. *Smithsonian Archives of American Arts*. http://www.aaa.si.edu/collections/oralhistories/transcripts/aliciaoo.htm.

————. 2006. Leture at Encantada Gallery, San Francisco, July 22.

Keller, Gary D., ed. 2002. *Contemporary Chicana and Chicano Art: Artists, Work, Culture, and Education*. Tempe: Bilingual Press.

Keller, Gary D., Mary Erickson, and Pat Villeneuve. 2004. *Chicano Art for Our Millennium*. Tempe: Bilingual Press / Editorial Bilingüe Press.

Lara, Magali. 1984. "Un comentario sobre el arte y las mujeres." *Fem* 9, no. 33: 33–34.

————. 2001. Interview with author, April 3, Mexico City.

Lee, Anthony W. 1999. *Painting on the Left: Diego Rivera, Radical Politics, and San Francisco's Public Murals*. Berkeley: University of California Press.

Lipietz, Alain. 1987. *Mirages and Miracles: The Global Crisis of Fordism*. London: Verso.

Lippard, Lucy. (1974) 1995. "The L.A. Women's Building." In *The Pink Glass Swan: Selected Feminist Essays on Art*, 84–88. New York: The New Press.

Liquois, Dominique. 1985a. *De los grupos los individuos: Artistas plásticos de los grupos metropolitanos*. Mexico City, Mexico: Museo de Arte Carillo Gil / Instituto Nacional de Bellas Artes.

———. 1985b. "Entrevista a Helen Escobedo." Unpublished text written for the exhibition *De los grupos los individuos: Artistas plásticos de los grupos metropolitanos*. Mexico City: Museo de Arte Carrillo Gil.

Llanos, Fernando. 2007. "Welcome to Manchuria and Its Peripheral Vision." In *Felipe Ehrenberg: Manchuria, visión periférica*, ed. Fernando Llanos, 12–15. Mexico, D.F.: Editorial Diamantina S.A. de C.V.

Lo, Ming-cheng M., Christopher P. Bettinger, and Yun Fan. 2006. "Deploying Weapons of the Weak in Civil Society: Political Culture in Hong Kong and Taiwan." *Social Justice* 33, no. 2: 77–104.

López, Sabino. 2006. Interview with author, March 17, Oaxaca, and March 25, Juchitán.

López Monjardín, Adriana. 1983. "Una etnia en lucha." *Guchachi' Reza* 18 (December): 5.

Lujan, Gilbert. 1997. Interview with Jeffrey Rangel, November. *Smithsonian Archives of American Art*. http://artarchives.si.edu/oralhist/lujan97.htm.

Maciel, David R. 1991. "Mexico in Aztlán and Aztlán in Mexico: The Dialectics of Chicano-Mexicano Art." In *Chicano Art: Resistance and Affirmation, 1965–1985*, ed. Richard Griswold del Castillo et al., 109–20. Los Angeles: Wright Art Gallery, University of California, Los Angeles.

MacMasters, Mary. 2000. "Eloy Tarcisio inauguró anoche exposición en la Galería de Arte Mexicano." *La Jornada*, July 13.

MacPhee, Josh, and Favianna Rodriguez, eds. 2008. *Reproduce y rebélate / Reproduce and Revolt*. Brooklyn: Soft Skull Press.

Malvido, Adriana. 1997. "Desaparecido: El Pintor oaxaqueño Nicéforo Urbieta." *La Jornada*, February 14.

Mandoki, Katya. 1980. "Potencial y problemática del trabajo artístico grupal." *Artes Visuales* 23: 33–35.

Manrique, Jorge Alberto. 2000. *Arte y artistas mexicanos del siglo XX*. Mexico: Consejo Nacional para la Cultura y las Artes.

Marcial Cerqueda, Delfino. 2006. Interview with author, March 24, Juchitán, Oaxaca.

Marcial López, Natalia. 2006. Interview with author, May 7, Oaxaca.

Marin, Cheech. 2002. *Chicano Visions: American Painters on the Verge*. Boston, New York, London: A Bullfinch Press Book, Little, Brown and Company.

Mariscal, George. 2005. *Brown-Eyed Children of the Sun: Lessons from the Chicano Movement, 1965–1975*. Albuquerque: University of New Mexico Press.

Marrero, María Teresa. 2000. "Out of the Fringe? Out of the Closet: Latina / Latino Theatre and Performance in the 1990s." *TDR* 44, no. 3: 131–53.

Martínez, Carlomagno Pedro. 2006. Interview with author, January 25, Oaxaca.

Martínez, Dionisio. 2001. Interview with author, April 28, Oaxaca.

Martínez, Elizabeth, ed. 1987. *El Arte de Rini Templeton / The Art of Rini Templeton:*

Donde hay vida y lucha / Where There Is Life and Struggle. Mexico City: Centro de Documentación Gráfica Rini Templeton; Seattle: The Real Comet Press.

——. 1991. *500 Años del Pueblo Chicano / 500 Years of Chicano History*. Albuquerque: South West Organizing Project.

——. 2008. *500 Years of Chicana Women's History / 500 Años de la Mujer Chicana*. New Brunswick: Rutgers University Press.

Martínez, María X. 2007. "The Art of Social Justice." *Social Justice* 34, no. 1: 5–11.

——. 2010. Personal e-mail correspondence with author, December 30.

Martínez Rentería, Carlos. 1999. "La cultura Istmeña en luz roja. Entrevista con Héctor Sánchez." *Generación* 11, no. 25: 6–20.

Mathis, Derrick. 2002. "Thought-Police Brutality." *Advocate*, January 22, 74–75.

Matus, Macario. 1981. "Momentos políticos de Juchitán." *El Sol del Istmo*, June 1, 4–5.

——. 1999. "¿Por qué Juchitán?" *Generación* 11, no. 25: 12–13.

——. 2006. Interview with author, April 27, Mexico City.

Mayer, Mónica. 1984. "Propuesta para un arte feminista en México." *Fem* 9, no. 33 (April–May): 12–15.

——. 2001a. Interview with author, March 21, Mexico City.

——. 2001b. *Sí somos muchas . . . y no somos machas: Textos sobre mujeres artistas*. Mexico: Ediciones al Vapor.

——. 2009. Interview with author, July 22, Mexico City.

Mayer, Mónica, and Víctor Lerma, eds. 2002. *Arte público en el archivo de Pinto Mi Raya*. Mexico: Pinto Mi Raya.

McCaughan, Edward J. 1993. "Mexico's Long Crisis: Toward New Regimes of Accumulation and Domination." *Latin American Perspectives* 20, no. 3: 6–31.

——. 1997. *Reinventing Revolution: The Renovation of Left Discourse in Mexico and Cuba*. Boulder, CO: Westview Press.

——. 1998. "*La Virgen* Meets the Salsa Police." *Peace Review* 10, no. 3: 321–27.

——. 2002. "Gender, Sexuality, and Nation in the Art of Mexican Social Movements." *Nepantla: Views from South* 3, no. 1: 99–143.

Medina, Cuauhtémoc. 2006a. "Pánico recuperado/Recovering Panic." In *Era de la discrepancia/The Age of Discrepancies. Arte y cultura visual en México/Art and Visual Culture in Mexico 1968–1997*, ed. Olivier Debroise, 90–103. Mexico: Universidad Autónoma de México.

——. 2006b. "Sistemas (más allá del llamado 'geometrismo mexicano') / Systems (Beyond So-Called 'Mexican Geometrism')." In *Era de la discrepancia/The Age of Discrepancies. Arte y cultura visual en México/Art and Visual Culture in Mexico 1968–1997*, ed. Olivier Debroise, 122–33. Mexico: Universidad Autónoma de México.

——. 2006c. "Publicando circuitos/Publishing Circuits." In *La era de la discrepancia / The Age of Discrepancies: Arte y cultura visual en México / Art and Visual Culture in Mexico 1968–1997*, ed. Olivier Debroise, 150–59. Mexico, D.F.: Universidad Autónoma Nacional de México.

Melucci, Alberto. 1996. *Challenging Codes: Collective Action in the Information Age*. Cambridge: Cambridge University Press.

Mesa-Bains, Amalia. 1991a. "Domesticana: The Sensibility of Chicana Rascuache." http://www.zonezero.com/magazine/essays/distant/zdomes2.html.

———. 1991b. "El Mundo Femenino: Chicana Artists of the Movement—A Commentary on Development and Production." In *Chicano Art: Resistance and Affirmation, 1965–1985*, ed. Richard Griswold del Castillo et al., 131–40. Los Angeles: Wright Art Gallery, University of California, Los Angeles.

———. 1999. "Patssi Valdez: Glamour, Domestic Ruin and Regeneration." In *Patssi Valdez: A Precarious Comfort / Una comodidad precaria*, ed. Elizabeth Ptak, 33–45. San Francisco: The Mexican Museum.

———. 2001. "Spiritual Geographies." In *The Road to Aztlán: Art from a Mythic Homeland*, ed. Virginia M. Fields and Victor Zamudio-Taylor, 332–41. Los Angeles: Los Angeles Museum of Art.

Metropolitan Museum of Art. 1990. *Mexico: Splendors of Thirty Centuries*. New York: Metropolitan Museum of Art and Bulfinch Press.

Meyer, Manulani Aluli. 2003. "Hawaiian Hermeneutics and the Triangulation of Meaning: Gross, Subtle, Causal." *Social Justice* 30, no. 4: 54–63.

Miller, Michael Nelson. 1998. *Red, White, and Green: The Maturing of Mexicanidad, 1940–1946*. El Paso: Texas Western Press.

Monsiváis, Carlos. 1984. Untitled speech. *Guchachi' Reza* 19 (June): 5.

———. 1993. Untitled essay. In *Oaxaca: Tierra de Colores*. Mexico: BANOBRAS. Exhibition catalog.

———. 1999. "Ya se va levantando el pueblo de la tierra." *Generación* 11, no. 25: 22–24.

Montes de Oca, Luis. 1999. "De De Gyves a De Gyves. 18 años de lucha continua." *Generación* 11, no. 25: 30–31.

Montoya, Malaquías, and Lezlie Salkowitz-Montoya. 1980. "A Critical Perspective on the State of Chicano Art." *Metamórfosis* 3, no. 1: 5–6.

Moore, George Mead. 2000. "Francisco Toledo." *Bomb* 70 (Winter): 114.

Morales Carrillo, Alfonso, et al., eds. 2004. *Héctor García*. Mexico: Turner Publications / D.G.E. Ediciones / Consejo Nacional para la Cultura y las Artes.

Morales, Felipe. 2009. Interview with author, July 18, Oaxaca.

Moreno Villareal, Jaime. 2000. "Native Land." In *Oaxaca Cuna del Arte / Oaxaca Land of Art*, 19. Mexican Cultural Institute, Washington, D.C. Exhibition catalog.

Mraz, John. 2009. *Looking for Mexico: Modern Visual Culture and National Identity*. Durham: Duke University Press.

Mullin, Amy. 2000. "Art, Understanding, and Political Change." *Hypatia* 15, no. 3: 113–39.

Muñoz, Carlos. 2007. *Youth, Identity, Power: The Chicano Movement*. London: Verso.

Muñoz, Víctor. 2001. Interview with author, April 4, Mexico City.

Museo Carrillo Gil. 1983. *Propuestas Temáticas*. Mexico: Museo Carrillo Gil. Exhibition catalog.

Museo de Arte Moderno. 2011. *No Grupo: Un zangoloteo al corsé artístico*. Mexico: Museo de Arte Moderno / Instituto Nacional de Bellas Artes.

Museo Dolores Olmedo Patiño. 2000. *Los 70: La llamada ruptura y gráfica internacional*. Mexico: Museo Dolores Olmedo Patiño and Universidad Autónoma Metropolitana. Exhibition catalog.

Naranjo, Rogelio. 2001. Interview with author, March 21, Mexico City.

Nelson, Stefanie. 2008. "Rebirth of the Cool." *Swindle Magazine*. http://swindlemagazine .com/issue12/the-ferus-gallery/.

Nevaer, Louis E. V. 2009. *Protest Graffiti Mexico: Oaxaca*. New York: Mark Batty Publisher.

Neville, Morgan, director. 2007. *The Cool School: How L.A. Learned to Love Modern Art*.

Noyola Isgleas, Iseo. 2006. Interview with author, April 26, Mexico City.

Ocharán, Leticia. 1984. "La Mujer en la gráfica Mexicana." *Fem* 9, no. 33 (April–May): 20–21.

Ochoa, María. 2003. *Creative Collectives: Chicana Painters Working in Community*. Albuquerque: University of New Mexico Press.

Olivera, Fernando. 2007. Interview with author, August 7, Oaxaca.

O'Malley, Ilene. 1986. *The Myth of the Revolution: Hero Cults and the Institutionalization of the Mexican State, 1920–1940*. New York: Greenwood Press.

Omi, Michael, and Howard Winant. 1986. *Racial Formation in the United States: From the 1960s to the 1980s*. New York: Routledge and Kegan Paul, Inc.

Pandolfi, Sylvia. 1998. Interview with author, December 18, Mexico City.

Patronato Pro Defensa y Conservación del Patrimonio Cultural y Natural del Estado de Oaxaca. 2000. *Oaxaca: La ciudad que sueñan sus pintores*. Oaxaca: Patronato Pro Defensa y Conservación del Patrimonio Cultural y Natural del Estado de Oaxaca.

Paz, Octavio. 1961. *The Labyrinth of Solitude: Life and Thought in Mexico*. Translated by Lysander Kemp. New York: Grove Press.

Pérez, Laura E. 2007. *Chicana Art: The Politics of Spiritual and Aesthetic Altarities*. Durham: Duke University Press.

Pérez Escamilla, Ricardo, curator, and Sylvia Navarrete, ed. 2003. *Estética socialista en México. Siglo XX*. Mexico: Instituto Nacional de Bellas Artes / Museo de Arte Carrillo Gil. Exhibition catalog.

Pinedo, María. 2006. Personal communication with author, July 13, San Francisco.

Poniatowska, Elena. (1971) 1992. *Massacre in Mexico*. Columbia: University of Missouri Press.

———. 1993. "Juchitán, a Town of Women." In *Zapotec Struggles*, ed. H. Campbell et al., 133–34. Washington, D.C.: Smithsonian Institution.

Quirarte, Jacinto. 1991. "Exhibitions of Chicano Art: 1965 to the Present." In *Chicano Art: Resistance and Affirmation, 1965–1985*, ed. Richard Griswold del Castillo et al., 163–80. Los Angeles: Wright Art Gallery, University of California, Los Angeles.

Rascón, Marcos. 1998. Interview with author, December 21 and 22, Mexico City.

Rippey, Carla. 2003. Personal e-mail communication with author, May 4.

Rius. 2004. *Las glorias del tal Rius*. Mexico: Grijalbo.

Rivera Salgado, Gaspar. 1999a. "Mixtec Activism in Oaxacalifornia: Transborder Grassroots Political Strategies." *American Behavioral Scientist* 47, no. 2: 1439–58.

———. 1999b. "Welcome to Oaxacalifornia." *Cultural Survival Quarterly* 23, no. 1: 59–61.

Rodríguez, Jesusa. 1999. Interview with author, August 7, Mexico City.

Rodríguez, Patricia. 2010. Lecture on Las Mujeres Muralistas, Counterpulse, San Francisco, January 20.

————. 2011. Lecture, San Francisco State University, April 11.

Rodríguez, Victoria Elizabeth, ed. 1998. *Women's Participation in Mexican Political Life*. Boulder, CO: Westview.

Romo, Tere. 1999. "Patssi Valdez: A Precarious Comfort." In *Patssi Valdez: A Precarious Comfort / Una comodidad precaria*, ed. Elizabeth Ptak, 9–31. San Francisco: The Mexican Museum.

————. 2011. *Malaquías Montoya*. Los Angeles: UCLA Chicano Studies Research Center Press.

Rosales, F. Arturo. 1996. *Chicano! The History of the Mexican American Civil Rights Movement*. Houston: Arte Público Press / University of Houston.

Rubin, Jeffrey W. 1997. *Decentering the Regime: Ethnicity, Radicalism, and Democracy in Juchitán, Mexico*. Durham: Duke University Press.

Ruiz Campbell, Obdulia. 1993. "Representations of Isthmus Women: A Zapotec Woman's Point of View." In *Zapotec Struggles: Histories, Politics, and Representations from Juchitán, Oaxaca*, ed. Howard Campbell et al., 137–42. Washington, D.C.: Smithsonian Institution Press.

Salas, Elizabeth. 1990. *Soldaderas in the Mexican Military*. Austin: University of Texas Press.

Sánchez, Alma B. 2003. *La intervención artística de la Ciudad de México*. Mexico: CONACULTURA / CENART, Programa Nacional Educación, Instituto de Cultura de Morelos.

Sánchez, Osvaldo. 2000. "El cuerpo de la nación. El neomexicanismo: la pulsión homosexual y la desnacionalización." *Curare* 17 (January–June): 138–39.

Sánchez-Tranquilino, Marcos. 1995. "Space, Power, and Youth Culture: Mexican American Graffiti and Chicano Murals in East Los Angeles, 1972–1978." In *Looking High and Low: Art and Cultural Identity*, ed. Brenda Jo Bright and Liza Bakewell, 55–88. Tucson: University of Arizona Press.

Sánchez-Tranquilino, Marcos, and John Tagg. 1991. "The Pachuco's Flayed Hide: The Museum, Identity, and Buenas Garras." In *Chicano Art: Resistance and Affirmation, 1965–1985*, ed. Richard Griswold del Castillo et al., 97–108. Los Angeles: Wright Art Gallery, University of California, Los Angeles.

Santiago Jiménez, Cándida. 2006. Interview with author, March 25, Juchitán, Oaxaca.

Saunders, Frances Stonor. 1999. *The Cultural Cold War: The CIA and the World of Arts and Letters*. New York: The New Press.

Schapiro, Miriam. (1972) 2001. "The Education of Women as Artists: Project Womanhouse." In *Feminism-Art-Theory: An Anthology, 1968–2000*, ed. Hilary Robinson, 125–26. Oxford: Blackwell Publishers.

Self Help Graphics. 2008. "Self Help Graphics Forced into Crisis by L.A. Archdiocese." July 11. http://selfhelpgraphics.blogspot.com/2008/07/self-help-graphics-forced-into-crisis.html.

Selz, Peter. 2006. *Art of Engagement: Visual Politics in California and Beyond*. Berkeley: University of California Press.

Sorell, Víctor A. 1991. "Articulate Signs of Resistance and Affirmation in Chicano Public Art." In *Chicano Art: Resistance and Affirmation, 1965–1985*, ed. Richard Griswold del

Castillo et al., 141–54. Los Angeles: Wright Art Gallery, University of California, Los Angeles.

———. 2002. "Orozco and American Muralism: Re/viewing an Enduring Artistic Legacy." In *José Clemente Orozco in the United States, 1927–1934*, ed. Renato González Mello and Diane Miliotes, 260–83. Hanover: Hood Museum of Art, Dartmouth College.

Stephen, Lynn. 2002. "Sexualities and Gender in Zapotec Oaxaca." *Latin American Perspectives* 29: 41–59

———. 2007. *Transborder Lives: Indigenous Oaxacans in Mexico, California, and Oregon.* Durham: Duke University Press.

Stevens, Mark, and Annalyn Swan. 2004. *De Kooning: An American Master.* New York: Alfred A. Knopf.

Storey, John. 2001. *Cultural Theory and Popular Culture.* Harlow: Pearson Education Limited.

Sullivan, Edward J., ed. 1996. *Latin American Art in the Twentieth Century.* London: Phaidon.

Tarcisio, Eloy. 2007. Interview with author, August 1, Mexico City.

Tekiner, Deniz. 2006. "Formalist Art Criticism and the Politics of Meaning." *Social Justice* 33, no. 2: 31–44.

Tibol, Raquel. 1992. *Confrontaciones.* Mexico: Editorial Sámara.

———. 1998. Interview with author, December 24, Mexico City.

———. 2003. "Pintura, escultura e instalaciones en las bienales de Monterrey." *Ganadores Bienal Monterrey.* Mexico: Museo Amparo. Exhibition catalog.

Tlacuilas y retrateras. 1984. "Tlacuilas y retrateras." *Fem* 9, no. 33 (April–May): 41–44.

Toledo, Francisco. 1986. *Lo que el viento a Juárez.* Mexico: Ediciones Era.

———. 1992. "Entrevista a Roberto Donís." *El Acaraván* 3, no. 10 (July–August–September): 47–51.

———. 2006. Interview with author, February 8, Oaxaca.

Urbieta, Jesús. 1996. Interview with Raquel Peguero. *La Jornada*, February 12, 28.

Urbieta, Nicéfero. 1998. Untitled essay. In *Nii R'ac Naai li Gusi' u / Los Sudores de la Casa del Rayo: Nicéforo Urbierta y artistas invitados; Sala de Exposiciones del Centro Médico Nacional siglo XXI, Mexico, D.F., marzo-abril-mayo de 1998.* Mexico: Instituto Mexicano del Seguro Social en colaboración con el Gobierno del Estado de Oaxaca. Exhibition catalog.

———. 2001. Interview with author, April 26 and May 1, Oaxaca.

Valdivieso, Domingo. 2006. Interview with author, February 18, Oaxaca.

Valerio, Robert. 1997. "Plástica oaxaqueña actual: Un acercamiento ligeramente sasgado." In *Historia del Arte de Oaxaca: Arte Contemporáneo*, vol. 3, 120. Oaxaca: Gobierno del Estado de Oaxaca, Instituto Oaxaqueño de las Culturas.

———. 1998. *Atardecer en la maquiladora de utopias: Ensayos críticos sobre las artes plásticas en Oaxaca.* Oaxaca: Ediciones Intempestivas.

Vargas, Angel. 1997. "Murió Jesús Urbieta, un pintor de sueños con los ojos abiertos." *La Jornada*, March 22, 21.

Vaughan, Mary Kay. 1997. *Cultural Politics in Revolution: Teachers, Peasants, and Schools in Mexico, 1930–1940.* Tucson: University of Arizona Press.

Vázquez Mantecón, Álvaro. 2006a. "Los grupos: una reconsideración / Los Grupos: A Reconsideration." In *La era de la discrepancia / The Age of Discrepancies: Arte y cultura visual en México / Art and Visual Culture in Mexico 1968–1997,* ed. Olivier Debroise, 194–99. Mexico, D.F.: Universidad Autónoma Nacional de México.

————. 2006b. La visualidad del 68 / Visualing 1968." In *La era de la discrepancia / The Age of Discrepancies: Arte y cultura visual en México / Art and Visual Culture in Mexico 1968–1997,* ed. Olivier Debroise, 34–39. Mexico: Universidad Autónoma Nacional de México.

Venegas, Sybil. 2008. "Brush with Life: Barbara Carrasco Powerfully Mixes Art with Race, Class, and Gender Politics." *Ms. Magazine* (Spring). http://www.msmagazine.com/spring2008/carrascoAll.asp.

Vera, Marcela. 2001. Interview with author, May 1, Oaxaca.

Von Blum, Paul. 1982. *The Critical Vision: A History of Social and Political Art in the U.S.* Boston: South End Press.

Wallerstein, Immanuel. 1989. "1968, Revolution in the World-System: Theses and Queries," *Theory and Society* 18, no. 4: 431–49.

————. 1992. "The Collapse of Liberalism." In *Socialist Register 1992,* ed. R. Millband and L. Pantich, 96–110. London: Merlin.

Weinstein, Dave. 2008. "Hello Cool World." CA *Modern* (Spring 2008): 4–7.

White, Edmund. 2006. *My Lives.* New York: Harper Collins.

Whittier, Nancy. 2002. "Meaning and Structure in Social Movements." In *Social Movements: Identity, Culture, and the State,* ed. David S. Meyer et al., 289–307. Oxford, England, and New York: Oxford University Press.

Wickham-Crowley, Timothy, and Susan Eckstein. 2010. "'There and Back Again': Questioning New-Social-Movement Analyses for Latin America and Reasserting the Power of Structural Theories." Paper delivered at the Twenty-Ninth International Congress, Latin American Studies Association, October 6–10, Toronto. http://lasa.international.pitt.edu/members/congress-papers/lasa2010/files/4278.pdf.

Williams, Lyle W. 2006. "Evolution of a Revolution: A Brief History of Printmaking in Mexico." In *Mexico and Modern Printmaking: A Revolution in the Graphic Arts, 1920–1950,* ed. John Ittmann, 1–21. Philadelphia: Philadelphia Museum of Modern Art.

Wolff, Janet. 1990. *Feminine Sentences: Essays on Women and Culture.* Berkeley: University of California Press.

————. 1993. *The Social Production of Art.* 2nd ed. Washington Square: New York University Press.

Ybarra-Frausto, Tomás. 1991. "Rasquachismo: A Chicano Sensibility." In *Chicano Art: Resistance and Affirmation, 1965–1985,* ed. Richard Griswold del Castillo et al., 155–62. Los Angeles: Wright Art Gallery, University of California, Los Angeles.

————. 1996. "The Chicano Movement / The Movement of Chicano Art." In *Beyond the Fanstastic: Contemporary Art Criticism in Latin America,* ed. Gerardo Mosquera, 165–82. Cambridge: MIT Press.

Zamudio-Taylor. 2001. "Inventing Tradition, Negotiating Modernism: Chicano/a Art

and the Pre-Columbian Past." In *The Road to Aztlán: Art from a Mythic Homeland*, ed. Virginia M. Fields and Victor Zamudio-Taylor, 342–57. Los Angeles: Los Angeles Museum of Art.

Zenil, Nahum B. 1999. *El gran circo del mundo*. Mexico: Museo de Arte Moderno. Exhibition catalog.

———. 2009. Interview with author, July 23, Mexico City.

Zermeño, Sergio. (1978) 1998. *México: Una democracia utópica. El movimiento estudiantil del 68*. Mexico: Siglo XXI.

Zolberg, Vera L. 1990. *Constructing a Sociology of the Arts*. Cambridge: Cambridge University Press.

INDEX

The letter *f* following a page number denotes a figure.

Anti-imperialism and international solidarity, 47–56; Chicano movement artists and, 48–52; Mexico City movement artists and, 47–48, 48f; Zapotec movement artists and, 53–56, 54f

Anzaldúa, Gloria, 83, 154–55; on *conocimiento*, 157–58; on *nepantla*, 157

Aquino, Arnulfo, 10, 25, 111; on movement demands and repression, 37; on rupture with Mexican School of Art in '60s, 106–7

Arriba y adelante (Ehrenberg), 109f

Artespectáculo: Tragodia Segunda (installation, Peyote y la Compañía), 112

Art in the United States, 16–17

Artists and social movement activism, 1–6; local particularities in, 12. *See also* Chicano movement art and artists; Mexico City movement art and artists; Zapotec movement art and artists

Asco Collective, 77, 81, 128–32, 143; cinema as stylistic influence on, 128–29; "No Movie" of, 81, 130–31, 131f; *Pie in Deface* conceptual work at LACMA, 135; style of vs. Los Four, 132, *144*; *Walking Mural* by, 129–30

Avalos, David, 134

Avila, Adam, 98–99

Aztlán, 6, 74, 80; exile of Mexico City artists to, 10–11

Baca, Judith, 74–75, 125, 146

Bakewell, Liza, 104

Balmy Alley Mural (Mujeres Muralistas), 126–27, 127f

Bañistas de Tehuantepec (Urbieta), 118–19, 119f

Barrio sensibility, 133–34

Barrita, Demetrio, 53

Barthes, Roland, 26

The Beatles, 152

Beau Geste Press, 138–39

Benjamin, Karl, 124

Bernal, Antonio, 35

Bhabha, Homi, 24

Bixee (López), 119–20, 120f

Black and White Mural (Gronk and Herrón), 128–29, 130f

Black Man and Flag (García), 35

Blanco, Alberto, 118

Brown-Eyed Children of the Sun: Lessons from the Chicano Movement (Mariscal), 35–36

Brown power, 72, 78

Bustamante, Maris, 63, 65–68, 112–13, 137; alternative ways of knowing and, 153–55; *¡Caliente! ¡Caliente!* performance piece by, 58–59, 59f; creation of Polvo de Gallina Negra by, 141; *960 Seconds* by, 167–68

Cactus, 68, 103–4, 110, 115, 160

Calavera (skeleton), 27, 132

¡Caliente! ¡Caliente! performance piece, 58–59, 59f, 136

California: Art World of, 124; Chicano alternative institutions in, 143–47; Chicano art students in '60s in, 125–26

California Cool, 101, 124

California Institute of Arts, 124

California movement artists. *See* Chicano movement art and artists

Camino a Guiengola (López), 29

Campbell, Bruce, 5

Campbell, Howard, 86, 88, 148–49

Campbell, Obdulia Ruiz, 90

Canción Mixteca (Hernández), 158–60

Carlomago, 10–11

Carrasco, Barbara, 11, 78–80, 79f, 132; Brown Power rhetoric and, 11; homophobia and, 80; *L.A. History: A Mexican Perspective* mural by, 80; *Self-Portrait* by, 80

Carrillo, Eduardo, 34

Carrillo, Héctor, 61, 69

Casa de la Cultura, 148–49

Castillo, Ana, 75

Catholicism, 86

Celebrate Pilsen! (exhibition), 99

Censorship of Mexican artists, 137

Centro de Investigaciones del Pensamiento Visual, 164–65

Cerqueda, Delfino, 29–30, 37, 85, 86f, 117–18, 121–22, 149

Cervántez, Yreina, 157

Chávez, César, 80

Chicago, Judy, 113, 124–25

"Chicana aesthetic," 133

Chicana lesbians, 80

Chicano Moratorium, 129–30, 145

Chicano movement art and artists, 1, 4–6, 9–10, 16–18, 23; anti-imperialism and international solidarity and, 48–52; art students in '60s and, 125–26; Brown Power rhetoric and, 11, 72; California and, 132–33; contributions of, to lasting social change, 168–70; cultural nationalism and, 72–73; debates over art and, 131; diversity of formal elements and, 18–19; *El Plan Espiritual de Aztlán* and, 152; environmental issues and, 45–46; immigration rights and, 45–46; Mexican nationalist symbols and, 33–36, 72; Mexican School of Art and, 18–19, 125–26; patriarchal cultural nationalism and, 78; political prisoners and, 40, 41f; student movement of '68 and, 23; in universities and art schools, 142–43; U.S. national imagery and, 35–36; visual biculturalism and, 133; working-class imagery and, 97–100, 99f; Zapata as symbol in, 34–35. *See also* Alternative spaces (Chicano); Aztlán; Feminist art and artists (Chicana)

Chicano movement's stylistic choices, 102–3, 124–32; in California art schools, 125–26; "Chicana aesthetic" and, 133; cultural negotiation and, 125–26, 128; debates over art and, 131; dismissal of, by Mexico City artists, 126; figurative nationalistic and traditional Mexican styles in, 132–33; international art movement's influences on, 124; ironic humor and, 111; Los Four style vs. Asco and, 132; Mexico City artists and, 111; visual narration of cultural negotiation and, 124; in work of Almaraz, 127–28, 129f; in

work of Asco Collective, 128–32; in work of Mujeres Muralistas, 126–27, 127f

Chicles, Chocolates, Cacahuates (Ehrenberg exhibition), 10

El Chopo Museum, 69

Cinema: black British and Caribbean, 4; as stylistic influence, 128–29

Circus self-potraits (Zenil), 69

Citizenship: Chicano movements artists and, 34, 45–46, 72; Eastern vs. Western bloc versions of, 46; Mexico City movement's artists and, 14, 26, 28; Zapotec movement's artists and, 29–33, 43. *See also* Anti-imperialism and international solidarity

Coalición Obrera-Campesina-Estudiantil del Istmo (COCEI), 10; demands for autonomous citizenship and, 43; disappearances of militants in, 37–38; dominance of, 147–48; *Guchachi' Reza* journal, 30, 43, 46, 88–89, 149; jailing and torturing of women in, 90; lack of women in leadership positions and, 92–93; loss of prestige of, 151; *Oaxaca en pie de lucha* songbook, 54–55; photo of rally of, 43, 44f; posters inspired by state repression of, 37–38, 39f; resistance to Mexican regime by, 14–16; Templeton's work with, 11, 20, 97–98, 98f; Toledo on, 151; women and homosexuals in, 89–90; Zapotec women at rally of, 83–84, 84f. *See also* Zapotec movement art and artists

Collective identity formation, 2, 4–5, 59, 85–86

Conflicto de Tiempo (Tarcisio), 160–63

Congreso de Artistas Chicanos en Aztlán (CACA), 44

Conocimiento, 156–58

Coordinadora Internacional de Mujeres en el Arte (ComuArte), 142

El Corno Plumado (poetry journal), 105–6, 138, 152

Cosijopi (López), 29, 30f

Counterculturalism of '60s, 153–54

Counterhegemonic visual discourses, 12

National and patriotic symbols (Mexico),
23–36; Chicano movement artists and,
33–36, 72, 77, 112; demystification of, 26;
Mexican flag as, 33, 70, 71f, 72; Mexico
City artists and, 24–28; taco as, 68; toma-
toes as, 159–60; in work of Zenil, 69–70,
71f; in works of Hinojosa, 70; Zapata and,
24; Zapotec movement art and artists and,
29. *See also* Eagle; Nopal cactus; Virgin of
Guadalupe
National and patriotic symbols (U.S.), 25–26,
45–46; Chicano artist's use of, 35–36, 45, 72
National Fine Arts Institute (INBA), 138
Neo-expressionism, 127
Neoindigenism, 73–74, 74f
Neo-Marxism, 139–40
Neo-Mexicanism, 70, 112
Nepantla, 157
Nieto, Rodolfo, 15, 117; as influence on Zapo-
tec movement artists, 117–18
960 Seconds (Bustamante), 167–68
No Grupo: *¡Caliente! ¡Caliente!* performance
piece by, 58–59, 59f; vs. El Frente, 140;
wrestling culture poster of, 113, 114f
"No Movie" (Asco), 81, 130–31, 131f
Nopal cactus, 68, 103–4, 110, 115, 160
Nopal installation (Bustamante), 68
No Pasarán (Olivera), 90, 91f
Noriega, Chon, 146
Nudes, 92–93
Nuestra Madre (López), 74–75

Oaxaca, 1, 8–10, 14–15, 170; ethnobotanical
garden in, 54–55, 162–63. *See also* Coali-
ción Obrera-Campesina-Estudiantil del
Istmo (COCEI); Zapotec movement art
and artists
Oaxacan School of Art, 118. *See also* Zapotec
movement art and artists
La Ofrenda (Hernández), 76, 76f, 100
Olivera, Fernando, 20, 21f, 23, 54, 54f, 85, 90,
91f
Olympic Games in Mexico (1968), 7, 108, 110;
logo for, 20, 21f

O'Malley, Ilene, 26, 60
The Oppresor (Montoya), 35, 36f

Panamérica (Mujeres Muralistas), 50, 51f
Patent for the Taco (Bustamante), 68
Patiño, Adolfo, 111–12
Paz, Octavio, 61, 117
Peasant Shoes (Van Gogh), 160
Pecanins sisters, 137
Pelado, 94
PEMEX, 45, 114
Pentágono (Grupo Proceso Pentágono), 40,
64
Pérez, Laura, 73, 157
Peyote y la Compañía, 111, 139; *Artespectáculo:
Tragodia Segunda* installation by, 112; juve-
nile sexuality of, in *La Regla Rota*, 63; kitsch
of, 134; Virgin of Guadalupe installation
piece by, 27, 28f
Phallocentrism, 61–62, 68, 70, 136
Photography, 83–84, 84f; of COCEI rally, 43,
44f; state repression and, 38–40; of work-
ing class, 98–99
Pie in Deface (Asco), 135
Pineda, Victor, 37–38
Pinto Mi Raya Gallery, 141
El Plan Espiritual de Aztlán, 152
Political prisoners, 37–39, 38f, 39f; Chicano
movement artists and, 40, 41f; COCEI
women as, 90
Pollock, Jackson, 101–2, 124, 128
Polvo de Gallina Negra, 67, 113
Poniatowska, Elena, 84–85, 90
Pop art, 101, 107, 109, 109f, 112–15, 124
Pop culture: in Chicano/a movement art, 111;
in Mexican feminist art, 112–13, 114f; as sty-
listic influence, 128–30
El Porno Show (Bustamante), 63; suspension
of, by government, 137
Political art, 160
Portrait of the Artist as the Virgin of Guadalupe
(López), 75
Posada, José Guadalupe, 27, 132; caricatures
of, 41; men arrested in scandal by, 60–61

Talamante, Olga, 40, 41*f*

Taller de Arte e Ideología (TAI), 48, 48*f*; Virgin of Guadalupe collage-mural by, 27

Taller de Grabado Rufino Tamayo, 122–23

Taller de Gráfica Popular, 106

Tamayo, Rufino, 15, 117–18

Tarcisio, Eloy, 160–63

Teatro de la Capilla, 142

Tehuana women, 83–86

Templeton, Rini, 11, 23; cloth banner for COCEI of, 20; working-class images and, 95–98, 98*f*

Tengo Sed (Méndez), 103

Tenth Youth Biennial (1977), 42

Tepito Arte Acá, 94–95, 96*f*, 114

Three Eagles Flying (Aguilar), 72

Tibol, Raquel, 105, 117

Tijuana Black Velvet Canvases, 127–28

Toledo, Francisco, 4, 8, 15, 86–88, 87*f*, 117; Casa de la Cultura and, 148; on COCEI, 151; creation of alternative spaces in Oaxaca and, 147–51; downside of influence of, 150; Elisa Ramírez Castañeda and, 10, 87–90; ethnobotanical garden and, 162; influence of, on Zapotec movement artists, 117–18, 121–23; political prisoner portraits by, 38, 39*f*; Roberto Donís and, 122–23; series on Benito Juárez by, 30–33, 31*f*; stylistics of, 116, 116*f*

Tomatoes as symbol, 159–60

Tonantzin (Aztec deity), 74–76, 76*f*, 156

La Tormenta figure, 82, 82*f*

Torres, Salvador Roberto, 124, 133; *Viva La Raza* painting by, 33

Transnational capitalism, 160

Undocumented (Montoya), 46

United Farm Workers, 9, 75; Almaraz's work with, 128; Barbara Carrasco and, 78, 80; Chicano artists' use of eagle of, 33

Uprising of the Mujeres (Baca), 74

Urbieta, Jesús, 86; *Bañistas de Tehuantepec* by, 118–19, 119*f*

Urbieta, Nicéforo, 85–86, 148, 163–65; criticism of Roberto Donís by, 123; difficulties of, with COCEI, 148; nudes of, 92–93

U.S. cultural imperialism, 105, 108, 112

U.S. flag, 35–36, 45–46

Valdez, Pattsi, 76–77, 129–30, 135; "No Movie" and, 130–31, 131*f*; in *Walking Mural*, 129–30

Valerio, Robert, 118

Vallejo, Demetrio, 37–38, 38*f*, 89

Venegas, Sybil, 78

Vera, Marcela, 93, 163–65

Vietnam Aztlán (Montoya), 51, 52*f*

Vietnam War, 25

Villa, Francisco, 60

La Virgen de Guadalupe Defendiendo los Derechos de los Xicanos (Hernández), 34

Virgin of Guadalupe, 24, 26–28, 28*f*, 156, 160; in Chicano artwork, 33–34, 75–77, 76*f*, 129–30, 132

Vista del Valle de México de 1492 a 1992 (Tarcisio), 160–61

Visual biculturalism, 133

Viva La Raza (Torres), 33, 124

Walking Mural (Asco), 129–30

Wallerstein, Immanuel, 6, 152–53

Warhol, Andy, 124, 160

White, Edmund, 101

White Corridor (Escobedo), 110–11

Wickham-Crowley, Timothy, 2

Wolff, Janet, 3

Womanhouse, 124

Working-class imagery and identification, 94, 96*f*; in Chicano movement art, 97–100, 99*f*, 134; comparison of, between movements, 94, 97; Mexican photojournalism and, 97; in Mexico City art, 94, 95*f*, 96–97, 114; Rini Templeton and, 95–98, 98*f*; working-class women and, 96–97; Zapotec photography and, 97

Works Progress Administration (WPA), 16

Wrestling culture, 113, 114*f*

Ybarra-Fausto, Tomás, 133–34

Zapata, Emiliano: in Chicano art, 34–35; in Mexican art, 24; murals of, 60; in Zapotec art, 28–29

Zapotec movement art and artists, 4, 6–12, 14–16; breaking of, with Mexican School, 15; continuing vitality of, 150–51; environmental issues and, 46; ethnic identity and, 14–16; images of Zapotec women and, 84–85, 90, 91*f*; literacy and Zapotec language and, 42–43, 151; vs. Mexico City, 15–16; national imagery and, 29; Oaxacan art students and, 121–22; portraits of political prisoners by, 37–39, 38*f*; renaissance in, 9; resistance art, 29, 30*f*, 43, 44*f*; solidarity and, 53–56, 54*f*; student movement of 1968 and, 23; Taller de Grabado Rufino Tamayo and, 122–23; Templeton's work with, 97–98, 98*f*; working-class imagery and identity in, 97; Zapata and, 28–29. *See also* Alternative spaces (Oaxaca Zapotec); Coalición Obrera-Campesina-Estudiantil del Istmo (COCEI)

Zapotec movement's stylistic choices, 116–23, 116*f*; influences on, 117–18, 122–23; non-Western margins in, 116, 116*f*, 123; political influence of Toledo on, 121–23; political meaning through ancestral memory and ethnic identity and, 120; politics of student movement and, 120–23; in works of López, 119–20, 120*f*; in works of Toledo, 116, 116*f*; in works of Urbieta, 118–19, 119*f*

Zárate, Luis, 85, 162

Zenil, Nahum, 68–70, 71*f*, 89, 142; national and patriotic imagery of Mexico and, 69–70, 71*f*; *Oh Santa Bandera* by, 70, 71*f*; self-portraits of, 69

Zermeño, Andrew, 45

EDWARD J. MCCAUGHAN is professor and chair in the Department of Sociology at
San Francisco State University.

Library of Congress Cataloging-in-Publication Data

McCaughan, Ed, 1950–
Art and social movements : cultural politics in Mexico and Aztlán / Edward J. McCaughan.
p. cm.
Includes bibliographical references and index.
ISBN 978-0-8223-5168-9 (cloth : alk. paper)
ISBN 978-0-8223-5182-5 (pbk. : alk. paper)
1. Arts and society — History — 20th century.
2. Social movements — Mexico — History — 20th century.
3. Social movements — United States — History — 20th century.
4. Artists — Political activity.
5. Art — Political aspects.
I. Title.
NX180.S6M39 2012
700.1'030972 — dc23 2011036574